TOULOUSE-LAUTREC

PHAIDON

Frontispiece. LA GOULUE, DANCING. (Detail of Plate 72)

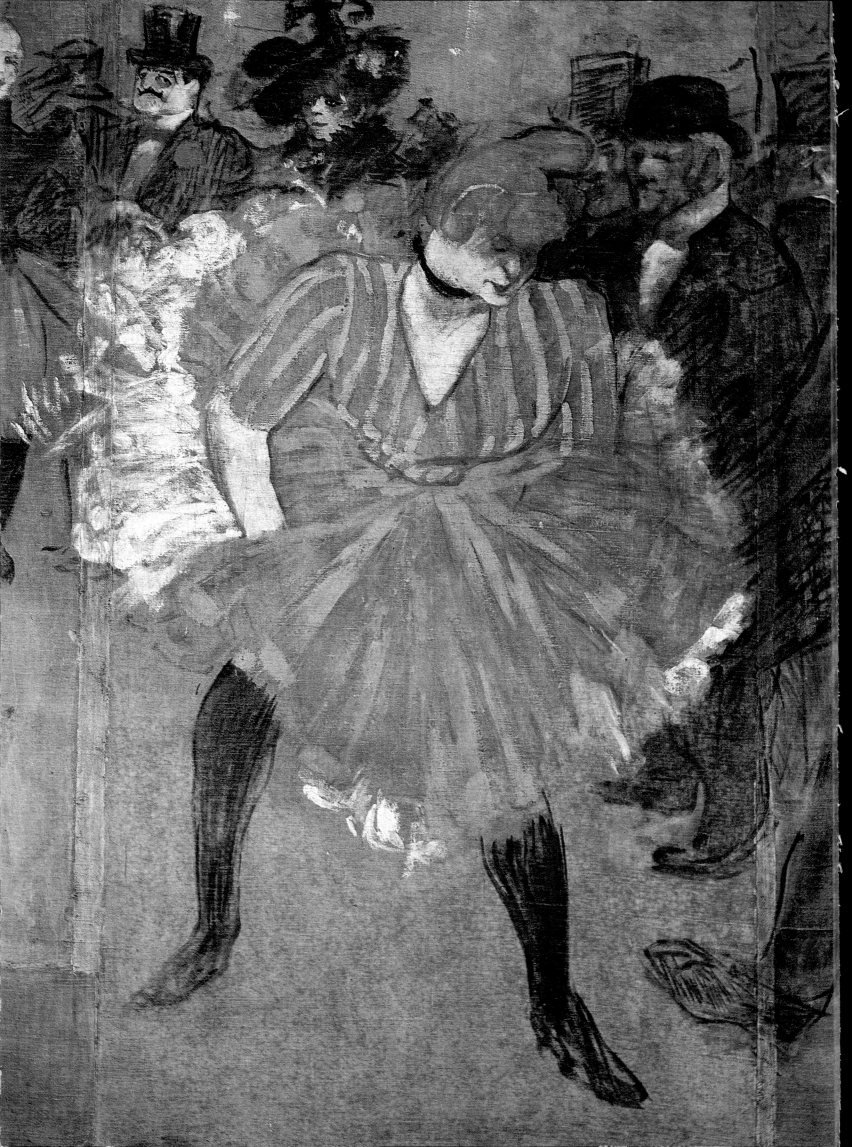

TOULOUSE-LAUTREC

BY F·NOVOTNY

WITH 163 ILLUSTRATIONS

PHAIDON

© 1969 PHAIDON PRESS LTD · 5 CROMWELL PLACE · LONDON SW7

PHAIDON PUBLISHERS INC., NEW YORK

DISTRIBUTORS IN THE UNITED STATES: FREDERICK A. PRAEGER INC.

111 FOURTH AVENUE, NEW YORK, N.Y. 10003

LIBRARY OF CONGRESS CATALOG CARD NUMBER: 69-19808

TRANSLATED FROM THE GERMAN

BY MICHAEL GLENNEY

SBN 7148 1386 9

LAY-OUT AND DESIGN BY ELLY MILLER

MADE IN GREAT BRITAIN

PRINTED BY BEN JOHNSON & CO LTD · YORK · ENGLAND

Preface

MUCH, INDEED MOST of what has been written about Toulouse-Lautrec deals with his biography and the people and events which went to make up the story of his life. The most important source for all serious biographical studies – such as those by Gerstle Mack and Henri Perruchot – is Maurice Joyant's two-volume work on the artist, based on the first-hand experience of a long friendship. Other first-hand accounts have come from Arsène Alexandre, Paul Leclercq, Frantz Jourdain, Thadée Natanson and Yvette Guilbert. Naturally, as always happens, the personality which emerges from all these accounts and memoirs is only a vague, uncertain and contradictory image – an illusion next to the certainty, the reality and the immediacy of the work. The interest in biographical facts is justified, but there is also a need for an anti-biographical study.

The outward events of Toulouse-Lautrec's short life are soon enumerated. Henri-Marie-Raymond de Toulouse-Lautrec-Monfa was born at Albi on 24th November 1864. There is a host of anecdotes about his father's eccentric habits and crazy practical jokes, which have usually been recounted in the literature on the artist with much glee and little critical examination. However, even after making allowances for literary embroidery a good deal of fact probably remained. Above all Count Alphonse de Toulouse-Lautrec was a fanatical horseman and hunter, who took it for granted that his son would follow him in these sporting pursuits. The son really did inherit an interest in sport from Count Alphonse, but it never went further than an interest, because almost from the start he was rendered physically incapable of indulging in it, not only after the accidents which made him a cripple. This was caused by twice breaking his legs, one shortly after the other, at the ages of thirteen and fourteen. After that the father showed little interest in his son's development; of his art he understood nothing. Lautrec's relationship with his mother was different. Although she too remained ignorant of his art, she was very attached to him and Lautrec was very close to her all his life.

Just as Lautrec's physical life was marred almost from its beginning, the brighter side, his talent, was also apparent at a very early age: even as a child it was obvious that he would be a painter. His tuition under the animal painter René Princeteau (1843-1914) contributed to the development of his early style. He probably learned just as much from Princeteau as from his studies, beginning in 1882, at the studios of Léon Bonnat and Fernand Cormon in Paris. There he learned no more than the basic

techniques and his real masters among the painters of his time were two others – Degas above all and then Forain.

Around the mid-eighties he gradually gave up working at Cormon's studio and settled down in Montmartre. For ten of the remaining fifteen years of his life he worked in his own studio in the rue Caulaincourt, close by the Montmartre cemetery. Round the corner were the gardens of 'Père Forest', a curious enclave of nature on the fringe of the metropolis, where Lautrec often painted open-air portraits. Quite near were the dance-halls and cabarets on the outer boulevards, chief of them the 'Moulin Rouge', also Aristide Bruant's 'Mirliton' and the 'Elysée Montmartre' and it was not far up the hill to the 'Moulin de la Galette' and other dance-halls and cafés on the 'Butte'. Night after night Lautrec was to be seen in these places, generally visiting several in a night one after the other. The street, too, was just as important as the show to be seen inside the cabarets. In the years between 1885 and 1890 the street played a significant part in his art, when he illustrated some of Bruant's ballads about various districts of Paris with pictures of streetwalkers to which he gave the titles of Bruant's songs, *À Batignolles*, *À Montrouge*, *À Grenelle* and so on. Later this slightly literary genre was abandoned, he used the 'proletarian' as subject-matter less and less and it finally disappeared altogether. This was not, however, a decisive change. It only seems to signify that the artist kept more and more closely to visible reality and he employed his imagination and invention ever more exclusively on the treatment of the actual material that passed before his eyes in the colourful Parisian night-life. There he sat, with the world of entertainment seething round him, hedged in by a circle of friends. It is said that after many a night such as this he would go straight from one of these dance-halls to the lithographic studio and start drawing. Much of these stories is probably a mixture of romantic awe and the reverence accorded to artistic legend, rather like the stories of the Chinese artists who painted their brush-drawings when they were drunk, but that is no reason to disbelieve them completely. Even when one knows that in Lautrec's case the procedure was often exactly the opposite: many of his lithographs were only completed after a great deal of precise and thorough preliminary studies. This more normal method of working was undoubtedly more frequent. Simultaneously he always kept up the work on his oil paintings, especially portraits.

Lautrec's way of life inevitably led to a critical situation. Towards the end of February 1899 he was taken to a sanatorium for nervous diseases at Neuilly-sur-Seine to undergo a cure for alcoholism. Throughout the period of his mature artistic activity, which is recognisable from his work as beginning shortly after the middle of the nineties, the artist's physique was in the process of destruction. Only a complete change of personality could have stopped it. A way of life that would have overtaxed a much sounder constitution, in particular the increasing consumption of hard

liquor, had to keep him physically and mentally fit enough to achieve a most remarkable level of artistic output; for Lautrec's capacity for work was abnormal. In quantity alone it indicated a very high degree of toughness and stamina.

At first the stay in the sanatorium produced successful results. Soon Lautrec was well enough to start work again. While in hospital he painted a portrait of his warder, a few portrait studies of fellow-patients, a lithograph, one or two designs for fans, but principally the series of drawings inspired by the circus. However, this work did not mean that his physical condition had improved. Quite the contrary; the success of his cure at Neuilly was short-lived. Lautrec resumed his old way of life and soon he was in a worse state than before.

He felt his end approaching. The friends who saw him off at the station in July 1901, when he left by train with Viaud to take the cure at Taussat-les-Bains near Arcachon, where he had often stayed before, sensed that this was the last farewell. They tell of a hurried ordering and tidying of his effects during his last months in Paris. While at Château Malromé, where he was taken in a hopeless condition to his mother, he tried to finish the portrait of *Viaud as an Admiral*, but failed; three weeks later, on 9th September, came the end.

Fig. 1. SELF-PORTRAIT CARICATURE.
Drawing, c. 1890. Private Collection

Fig. 2. THE ARTIST'S UNCLE: COUNT CHARLES DE TOULOUSE-LAUTREC.
Drawing, 1882. Albi, Musée Toulouse-Lautrec

Toulouse-Lautrec

MORE THAN SIXTY YEARS AGO, in 1904, shortly after Toulouse-Lautrec's death, Hermann Esswein published a small monograph – or more precisely an extended essay – on the painter. It is an intelligent study, still well worth reading today, although it largely consists of a defence of 'decadent' art, and this concept, together with his justification of what it stood for, and still stands for, no longer has the same significance. The foolish error of confusing form and content, i.e. the mistake of blaming the artist who portrays it for the dubiousness of his subject-matter has fortunately, along with many other misconceptions which arise from it, become much less common. When looking at Lautrec's work people still feel, of course, a certain sensual frisson at his depiction of the demi-monde of fin-de-siècle Paris, and this attitude is not 'wrong': it is merely a naïve, superficial stage in experiencing an art which on closer inspection proves to be an extremely complex one. Anyone who primarily interprets Lautrec's pictures as an accurate representation of the period, as a portrait from life, has not realised that he already has a preconception, influenced by the art itself, by the whole concept of 'Toulouse-Lautrec', which has a feed-back effect on to the objects it depicts.

As to Lautrec's complexity – there is first of all the artist's own distinctly uncomplicated pleasure in the glitter and hurly-burly of the things which drew him nightly to cabarets, dance-halls, theatre and circus. Next, and at a deeper level, there is his fascination with the animal nature of his subjects which emerges, curbed or unbridled, harmless or disturbing, in the precisely-caught movement of a body, in the tenseness of the girl riding bareback, in the racing cyclist, in the frenzied ecstasy of the acrobatic dancer. Yet he catches with equal precision a tell-tale glint in the eye, a momentarily distorted mouth, a dozing man flopped over a café table. By now we are in the realm of psychology and the artist's expressive range is thereby the more profound. It is reflected in countless scenes of everyday life – if only in the artificial world of the entertainment business – reproduced without pathos, indeed with pointed restraint, but often, too, artistically heightened by its setting, namely by the trappings of stage and cabaret. In one outstanding example of Lautrec's graphic work, in his drawings of Yvette Guilbert on the stage, the reality of the actress and the illusion created by her acting are merged into an indissoluble unity.

In all these shades of expression and in more besides – in an interplay of light-hearted irony, feverish excitement and outbursts of demonic force, Lautrec's work, expressed though it is in terms of the artificial and the

unnatural, creates a complete image of human nature. A very peculiar image, certainly, in the narrowness and specialisation of its subject-matter, but this is easily explicable, in part by the circumstances of the painter's life. At the same time one should not be too ready to look for direct causality in the conditions of his life; it requires no apology and for none of the characteristics of Lautrec's art – whether those on the surface or those in the depths below – do we any longer need to advance a justification of 'the art of the nerves', as Esswein thought it necessary to do in his analysis. Although today, by contrast, we are rather too ready to reassure ourselves that Lautrec is 'classic', the question of whether in this context one can use the term 'decadence' is still worth asking. If so, then Chekhov was a 'decadent', the one artist whose view of mankind, whose attitude to mankind, in certain specific aspects more closely resembles Lautrec's than any other. There are, of course, many other contemporaries with whom one might compare him – Munch, for instance, comes to mind when one

Plate 96 looks at the lithograph *Au petit lever* from the *Elles* portfolio; Wedekind; Strindberg. They, however, were explicit moralists, whereas Lautrec's attitude is superficially amoral and only on closer examination does it reveal itself as involuntarily yet inevitably moral. Lautrec belongs to the category of moralists *malgré eux*. The moral content of his painting lies essentially in its objectivity, than which nothing could be more evocative or more expressive. Objectivity was his ambition and this was one of the fundamental aims of his painting from life. He did not see the bizarre, vulgar, perverse or corrupt elements in his subjects primarily with the eye of a curious analyst. He simply regarded them as manifest forms of the instinctive drives. This amoral, aesthetic view of the instinctive element in man is his dominating characteristic, it is his most common, his determining attitude to his subjects, which he of course chose as the most striking examples to illustrate his viewpoint.

This is why, like Wedekind, he loved the circus, and is the forefather of that series of artists who have produced so many variations on the mystique of the circus, through whom the pierrot and the clown have emerged as a particular theme of modern painting. Although the most typical characteristic of this genre – the ambiguity of the mask, the fascination and the symbolism of the grotesque – was admittedly not very marked in Lautrec, this is mainly because his more naturalistic forms are still unaffected by the abstractions of automatism and are pervaded with the organic vitality of physique and line. It is this which gives the depiction of his chosen subjects a peculiarly fascinating power.

Lautrec has been compared with de Maupassant. The comparison has considerable validity, as in the ruthlessness of his observation which at times borders on cynicism. Outwardly, it would be possible to illustrate de Maupassant with Lautrec's lithographs, but this parallel is extremely superficial. For all their apparent difference, Lautrec and Chekhov are far

more compatible. In the relation between form and content, in their way of depicting people with a maximum economy in terms of form, Chekhov's writing and Lautrec's drawing have much in common. The fact that they were contemporaries is also detectable. They correspond even more, however, in the oblique angle of their moral and emotional attitude to the problem of man; there is, too, a fundamental link in their tendency towards pessimism and passivity – which, nevertheless, always conceals a reverence for life and, frequently, compassion. Related, too, is a feeling basic to both artists' work – a sadness, often only implicit yet all-pervading; that particular kind of omnipresent melancholy which arises from an artist's view of the surface phenomena of the life of civilised man at the turn of the century. In Chekhov's writing it emerges more obviously, occasionally amplified to a scream, whereas with Lautrec it is often only latent in his line-drawing, though rather more evident in his use of colour. It represents in embryo what in subsequent artists was to become, together with the rejection of naturalism, the subject-matter of most modern art. (This inner connection with Chekhov suggests another: a different kind of human portrayal, found in Gogol and Dostoyevsky which, for all its realism, shades off into the pathetically religious and which has its closest counterpart in the portraits of Van Gogh.)

These few scattered hints at his characteristic features should be enough to provide an answer to the question as to what was new in Lautrec's art, at least in so far as the new element which he introduced into art is confined to his subject matter and does not refer to his technique. Lautrec greatly expanded the expressive range of painting by bringing firmly into its orbit certain aspects of human behaviour; these mostly derive from everyday life, like lounging at a bar, watching the circus from a box, facial expressions of tension and blasé indifference among the demi-monde in dance-halls, brothels and night-clubs. This was not, of course, the first time that this relatively limited yet inexhaustibly rich thematic world had been portrayed, although much of it was quite new: before Lautrec it would be hard to find anything comparable to the smiling gesture of Marcelle Lender in the coloured lithograph of 1895, the impudent strut of a Cécy Loftus or Yvette Guilbert's glance at the audience *Plates 93, 86, 50* as she bows; and where, before Lautrec, is the same expressive power to be found in a wink, in an impertinent look, in a snub, in a weary or a lecherous glance? There are things here which are missing even in Daumier's work. They are not to be found before Lautrec, just as certain elements of the psychological novel could not have been used in an earlier literary age. Lautrec's work is full of sensations and overtones of this kind. He was capable of depicting the delicate sense of pleasure from watching an actor's pompous gesture; the monumental yet comic grandeur of an *Plate 65* actress in antique costume; the sight of a girl riding bareback towards the spectator, or of a passing jockey – and yet without loading it with the *Plate 122*

romantic pathos which similar scenes have in the work of his forerunners such as Daumier. It can no longer be called Impressionism, although he is developmentally linked to it by something of Impressionism's subtlety of emotional response. In all other respects Lautrec, with his exclusive use of human subjects, is far removed from Impressionism. He expressly rejected landscape painting, the true sphere of Impressionism. With his concentration on people and his unambiguously realistic attitude to the depiction of them and their surroundings, Lautrec has inevitably been labelled a chronicler of his epoch. In his work, modern urban man was first portrayed in great art. It may seem odd to us that this portrayal should bear the stamp of the classic. This is partly because the city is still depicted as a purely mental landscape, solely in human terms and in a pre-technological age. Much has been added since Lautrec's day, above all the steadily growing impact of technology, but the physical and emotional portrait of urban man was largely caught and fixed in Lautrec's paintings, lithographs and drawings. The essentially metropolitan paradox of excitability and melancholia, monotony and hunger for life, hectic gaiety and genuine or feigned indifference, in a range of the most subtle gradations, constitute the psychological subject-matter of his art.

Yet the word 'chronicler' should be used with reservations. However strong the element of realism in his painting may be, however evocative and precise his illustration of latent emotion, it should always be borne in mind that his depiction of this fin-de-siècle Parisian world of pleasure is by no means mere illustration: this is to be found much more plainly in other and lesser artists within Lautrec's orbit – Steinlen, Ibels, Willette – and even in a great artist such as Degas. The image created by Lautrec's *œuvre* has become a reality through his own formation of it and we *take* it to be a portrait of the epoch; Lautrec has not only bequeathed us an artistic image – his art has in turn formed our view of what the 'fin-de-siècle' was really like.

So far mention has only been made of his themes, their content and the view of life that emerges from them; nothing has been said of his technique. What of Lautrec's form, the graphic and painterly idiom in which he expressed himself?

The effect of a work of art and the means by which it is achieved form an inseparable unity – a superfluous remark yet always in need of repetition. The more closely and inseparably content and form are interwoven, the more the form partakes of the intellectual content, the greater the impact of such works. This, we feel, is a criterion of their artistic intensity. Does not every line of Rembrandt's drawings and etchings on biblical themes breathe humanity and compassion, just as Goya's *Disasters of Wars* series expresses the artist's revulsion? Lautrec's graphic work deserves comparison with art of this calibre. Not only do his drawings surpass his

paintings quantitively, but from a certain period onward all Lautrec's paintings are strongly influenced by graphic techniques.

In 1880, when Lautrec was sixteen, he painted his first pictures, which form a distinct group within his total *œuvre*. The most marked characteristic of these pictures, which he painted under the guidance of the painter of horses, René Princeteau, is a violent, overheated agitation, a nervous, flickering restlessness both in figure-painting and in the impasted brushwork. In this technique and in his jerky lighting these pictures are reminiscent of Monticelli's heavily expressive romantic pointillism. The picture of the *Mail Coach at Nice* in the Petit Palais collection is typical, also *Plate 1* in its subject, of this group of early paintings. Soon afterwards Lautrec turned away from this rather wild and subjective technique. In its place came a radically different approach to figures and to landscape – which at *Plates 2, 3* that stage he still regarded as a worthwhile subject – guided by an ambition to achieve the greatest possible objectivity and literal realism in a cool, technically sound and educated style. One great model which was long to remain influential in Lautrec's work is clearly detectible – Degas. Clearly modelled and contoured figures serve as the basis for a subtle, modified Impressionism, expressed both in the delicate treatment of light and in a refined, minutely structured brushwork. In his paintings of this period, i.e. in the early eighties, graphic line plays the same part that it does in Degas' work at this time: it remains confined to the plastic aspect of the figures and occurs hardly anywhere as an autonomous element of technique, which was ultimately to become such an essential feature of Lautrec's painting. His treatment of colour in these pictures is similar. Modified Impressionism implies restraint in colouring, and his colours have neither the luminosity nor the fully developed chromaticism of Impressionist painting, nor are they treated as the constituents of a specific expressional idiom. The fundamental difference vis-à-vis his immediately preceding pictures is clearly shown by a comparison of the *Mail Coach* *Plate 1* with a picture related in subject-matter, the *Calèche* from the William *Plate 3* Coxe Wright Collection. With its many shades of brown, murky green and flakily applied highlights the little picture has something of the feel of the 'Paysage intime'. A slightly different, though equally delicately graduated tonality with bright but subdued colours, especially a curious chalky green, marks the overall character of an extensive group of pictures depicting workmen at Céleyran and some landscapes in the countryside *Plate 2* surrounding this château, which belonged to his family. In many respects the colouring of these pictures are reminiscent of Bastien-Lepage and a parallel can even be found in Ferdinand Hodler's landscapes in the years around 1880.

After a short time another complete change took place in Lautrec's painting. His graphic work came to predominate and with it a very different approach to colour. Unaffected by this radical departure, how-

ever, a certain category of paintings always remained fundamentally linked with those early and not truly 'Lautrec-like' works. This is his long series of portraits; their common feature is a pictorially realistic, old-masterly objectivity of the kind which characterised his early works of the first half of the eighties and which in portraiture he thereafter developed to the highest degree.

They represent an extensive group, distinct from the graphics and paintings of the 'other' Lautrec. The difference, although not in itself unusual, is significant and so are the methods used in his strictly representational, comparatively 'professional' portrait painting. The element of draughtsmanship, though evident, is nevertheless restrained and this gives them a feeling of calm, distinction and timelessness. It makes no difference whether they are portraits of Lautrec's aristocratic relations and his many friends or of female models and women from the *maisons closes*. One of the distinctive features of these portraits is that something of the sitter's or of the artist's environment is always painted in – the lobby in a *Plate 60* famous portrait of Dr. Gabriel Tapié de Céleyran, a cousin of Lautrec's; *Plate 7* pictures stacked against the studio wall; a bedroom by the sober light of day. It is a kind of narrative characterisation, in which a faint echo is heard from Lautrec's 'other' world, the 'demi-monde' painting which is the best-known aspect of his work. Yet his 'demi-monde' paintings are dominated by the exact opposite of restraint, calm and reticence: they muster every device of frenzied, even excessive graphic vitality, bold short-cuts and violent colour-contrast which, although differently orchestrated, also constitute the essential idiom of Lautrec's lithographic work. *Plate 19* In a painting of 1888, *The Circus* in the Chicago Art Institute, where a girl bareback rider is performing under the direction or the ringmaster,

Figs. 3 and 4. DRAWINGS FROM A SKETCH-BOOK, 1880–1. Chicago, Art Institute

Fig. 5. PORTRAIT OF THE ARTIST'S MOTHER.
Drawing, 1882–3. New York, Slatkin Galleries

this type of 'draughtsman's painting' is already fully developed several years before the actual start of his lithographic work and represents the prelude to that stage in Lautrec's painting which is best studied in conjunction with his graphics.

The beginnings of Lautrec's work are to be found in life-sketches of humans and animals which he drew when little more than a child, soon after the two accidents in which he broke his legs and which made him into a stunted cripple. The most amazing thing about these sketches, a large quantity of which have been preserved, is their skill in the portrayal of movement, particularly in his many studies of horses and riders. The *Cahier de Zig-Zags* dating from 1881, a short diary of a stay in Nice containing sixteen pen drawings, demonstrates a waspish, grimacing style of caricature still marked with dilettantism and which scarcely contains a hint of Lautrec's mature draughtsmanship. When later drawings are found to have a certain resemblance to these early experiments, they are notes or shorthand caricatures used for gathering material. In the lithographs of his last years some similarly bad-tempered or impatient, uncontrolled pieces of drawing are occasionally to be found in the otherwise disciplined style of his graphics.

This group of early drawings constitutes the graphic counterpart to the violent, hectically agitated oil paintings of the same period, of which the *Mail Coach at Nice* is a characteristic example.

Lautrec's paintings of the next few years, those naturalistic pictures from Céleyran marked by such calm objectivity, also has its counterpart in his graphic work – a style of drawing to be found in a series of portraits

Figures 3 and 4

Plate 1

Fig. 6. À SAINT-LAZARE. 1885

Plate 6
Figures 2 and 5

of his relatives, lively crayon drawings influenced by painting techniques, from his student period with Bonnat and Cormon between 1882 and 1884. These still appear as the timid experiments of a beginner. The main feature of these life-studies is the painstaking and effectively deployed treatment of light; there is not a trace in them of the urge towards pure line or of those draughtsman's devices of abbreviation and condensation hinted at in his early attempts and which finally became the foundation of his graphic technique.

By the mid-eighties he had developed a personal style of drawing. It was a thin, hard outline filled out with occasional hatching. A few illustra-

Plate 15
Figure 6

tions in *Paris Illustré* of 1888 still show this style, as does the cover design for the sheet-music of Aristide Bruant's song *À Saint-Lazare* in 1885. Even this piece of graphic work lacks what was later to be such a decisive element in Lautrec's line, namely its power of creating physical presence, the organic life present in even the most vigorously simplified outline. That miraculous draughtsman's gift of abstraction that is essential to all great graphic art, in which simplification and reduction do not diminish the degree of realism but only concentrate it, is still lacking in these drawings. In them, on the contrary, graphic abbreviation actually reduces the realism. If one compares a drawing like that for the song

Figure 6
Plate 36

À Saint-Lazare with a later print such as *The Englishman at the Moulin Rouge* of 1892, one realises the gap between endeavour and achievement. In those drawings of the eighties one can also clearly detect Lautrec's efforts to achieve a graphic line that would print as effectively as possible;

Fig. 7. PORTRAIT OF CHARLES MAURIN. Etching, 1898

the result of this was a somewhat strained use of line whose wiry contouring does not really go much beyond the mannered stylisation of certain contemporary illustrators.

The course of Lautrec's development as a draughtsman in that decisive second half of the eighties cannot be described briefly. Since his lithographs are the only part of Lautrec's *œuvre* which have been properly catalogued – the list of drawings in the second volume of Maurice Joyant's great work is no more than a useful preparatory study, due to a lack of sufficient illustrations – no general survey of the development of Lautrec's autograph drawing is yet possible. To this practical difficulty is added another, which is functional: Lautrec's drawings fall into a number of categories, different in purpose and correspondingly different in form. Besides his sketchnotes, in which an attitude, a movement, an odd piece of clothing, the tiny detail of an actor's gesture or a face, may be pinned down – and even these range from casual detail to masterpieces of succinct virtuosity – there are also highly detailed studies of animals and people, especially portraits, that are very precise and finished. Most of the nine portrait etchings, which date from 1898 – Lautrec's only etchings – are also of this kind. In yet another category are his sketches for lithographs, and finally, the culmination of it all, there are the lithographs themselves.

Such variety, combined with this interrelationship between autograph drawings and prints, is as a rule found only among born graphic artists who know how to use printing process. For all the sense of improvisation which is fundamental to Lautrec's draughtsmanship, his lithographs have a special character which notably distinguishes them from his

Figure 7

autograph drawings. This is only natural; how otherwise could Lautrec have been one of the re-discoverers of lithography if the actual technique of printing had not given him a special insight into the potentiality of the medium. In some of his prints, which are, as it were, lithographic sketches, this appears as little more than the unavoidable limitations of the technique, just as now and again the design methods dictated by lithography are to be found in his autograph drawings. Apart from this, his lithographs as a whole represent a separate artistic idiom which is not only distinct from drawing and painting but actually enhances the formal techniques of both those media: in lithography both colour and line reach a new perfection – the former of more emphatic, often bold simplification, the latter of still more glittering richness. Even those familiar with Lautrec's complete work must admit this, even though they may appreciate his painting and those genres in which his graphic work is less extensively represented, such as his crowd scenes, the group of portraits of the artist's friends or the women from the *maisons closes*. Of course in lithography the intensification of colour is achieved by reducing its range; for obvious reasons the gamut of colour in painting is wider. Consequently Lautrec's use of colour can only be studied fully by taking his painting into account.

Lautrec's first lithographs date from 1891. Loys Delteil's complete catalogue of Lautrec's graphic work contains, including the etchings mentioned, 371 numbers; a few lithographs have also been discovered subsequently; these have been included in Adhémar's *catalogue raisonné*.

The close connection between painting and prints is seen with particular clarity in another distinct and extensive group of works. A large number of the drawn or painted preliminary studies for lithographs and posters have been preserved – casual sketches, studies of detail, tracings, and studies painted with the petroleum-based colours used for lithography – which are often in a highly finished state and can be classified as paintings, because with Lautrec there is no strict dividing-line between 'real' paintings and painted sketches. The fully finished painting of the

Plate 33

dancing women in the Prague National Gallery, dated 1892, was completed five years before its lithograph version and the painting of the *Clowness Cha-U-Ka-O at the Moulin Rouge* in the Reinhart Collection at Winterthur is two years earlier than its corresponding lithograph. Obviously these are not just preliminary studies for lithographs; the lithographs are rather a translation of the painting into another medium. Yet one cannot exclude the possibility that the painted version was created with lithography in mind and that this was the artist's real aim. One can never be sure, because only a few of these preliminary studies, precursors or variants, are dated. Usually they are ascribed to the year of their corresponding lithograph. This method, however, is an over-simplification. Whilst it is certain that the painted versions preceded the lithographs,

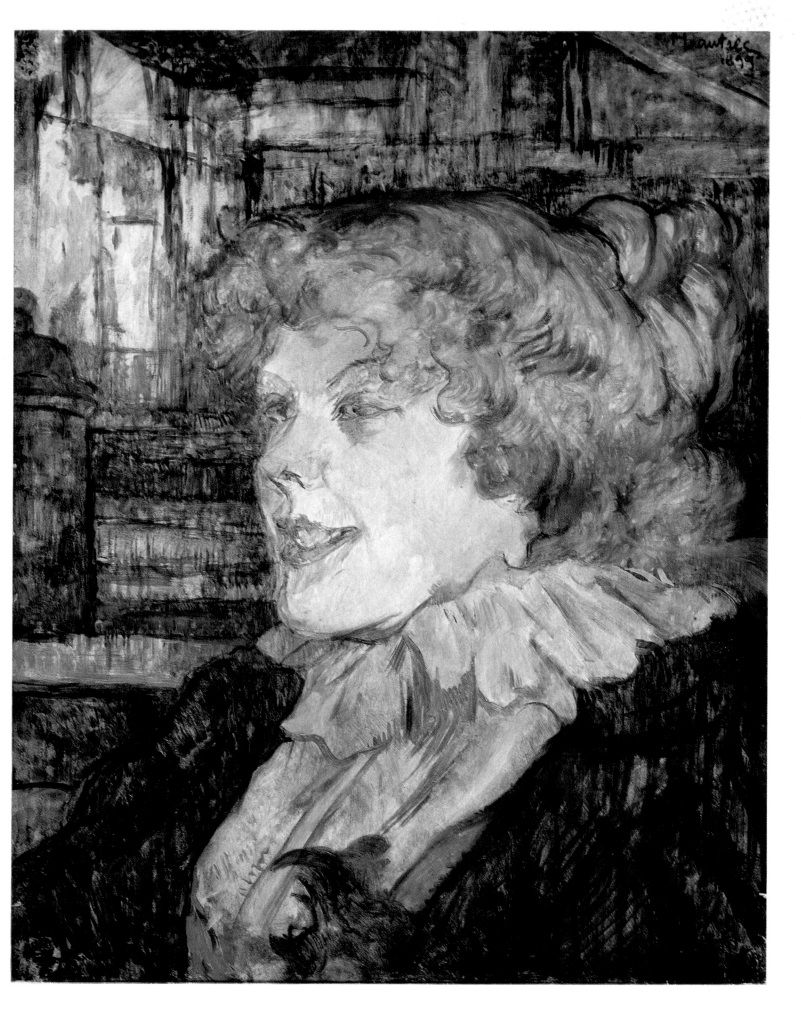

THE ENGLISH GIRL FROM THE 'STAR' AT LE HAVRE. 1899. Albi, Musée Toulouse-Lautrec

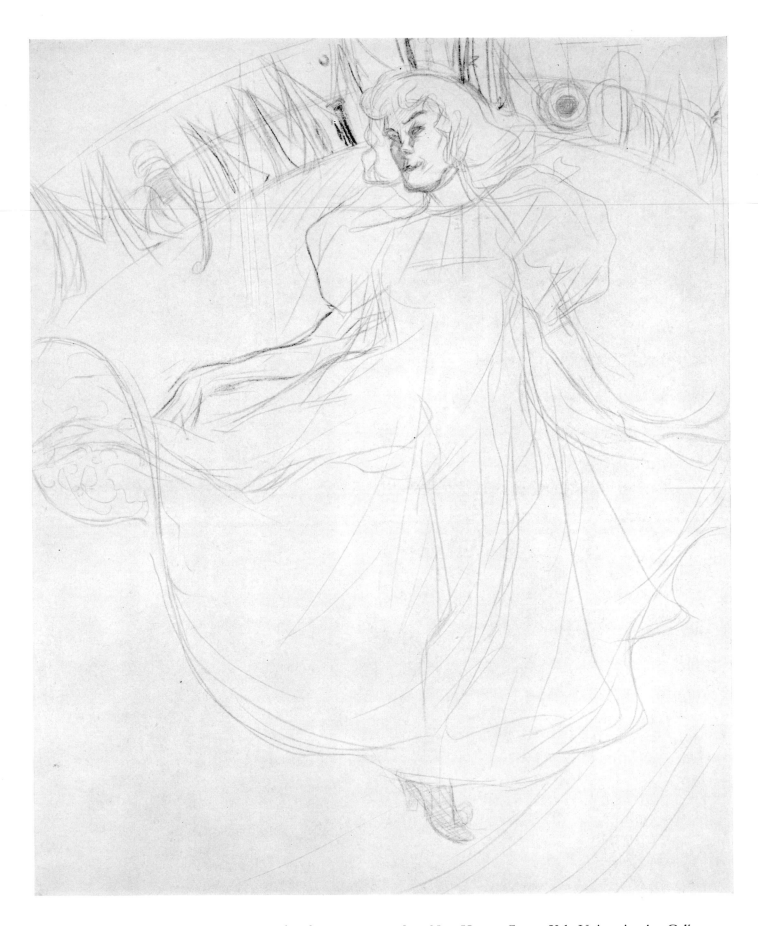

Fig. 8. MAY MILTON DANCING. Drawing for a poster, c. 1895. New Haven, Conn., Yale University Art Gallery

it is most significant that there is no sign, as one might expect there to be, of a gradual development towards the pictures' final lithograph form – on the contrary, in almost none of the traceable instances of this kind are there any fundamental deviations between the different versions. From the beginning the pictorial composition seems to have been fixed in its ultimate form. There is never any change in the disposition of figures as between cartoon and lithograph, the outlines of all the figures and all the essential architectonic features of plane and space are unchanged. Lautrec occasionally worked on a picture *after* the lithograph was made, by further painting. This was presumably done on occasions as a trial for a polychrome version of the lithograph. There is, for instance, a painted cartoon of the print *The Jockey* – which corresponds exactly to the lithograph – as *Plate 122* well as an over-painted copy of the print. Other instances are the hand-coloured prints of the lithographs showing the veil-dancer, Loie Fuller. *Plate 41*

Even when lithographs like the *Dancers at the Moulin Rouge*, the *Clowness Cha-U-Ka-O* and the *Grand Box* are duplicates of paintings, the *Plates 80, 103* unaltered retention of the painted composition is significant. Here, in the connection between cartoon and lithograph as in that between the painting and its lithographic interpretation, the composition is merely repeated, in a form presumably fixed at an early stage (otherwise more widely differing variants would exist) and then, as it were, retrospectively confirmed.

In one respect the change to a graphic medium is a radical one. It implies, as I have said, simplification and abridgement. When proceeding to a lithograph, Lautrec's skill in reducing and concentrating the plastic qualities of the painted design, whilst keeping them within the precisely retained outlines of the painting, results in text-book examples of virtuosity in translating painterly techniques in depth into an idiom of pure silhouette. Thus from the study of Mr. Warrener's head in the Albi *Plate 37* Museum, with its iridescent multi-coloured layers of brush strokes in shades of pink-red, yellow, violet and blue emerges the uniformly lilac-brownish silhouette of the lithograph. (Only once, in the lithograph of the *Plate 36* *Dancing Women at the Moulin Rouge*, does the artist's graphic technique approach that of the oil painting, just as one imitates one musical instrument with another.)

In a preparatory sketch for the poster of May Milton, its linear structure *Figure 8* corresponding exactly to that of the poster, the naked figure of the dancer is even drawn in beneath the outline of her loose costume in order to be sure of getting her foot in the correct position for her outlandish pose. Such careful preparation of the formal elements may seem surprising at first sight, although there is nothing special about them; one should never assume that such vibrant, economical form is the result of inspired improvisation. The formative processes of this artist's work were undoubtedly as complex as the wealth of variety in his drawings.

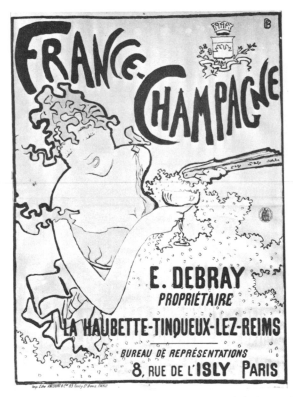

Fig. 9. Bonnard: FRANCE-CHAMPAGNE. Poster, 1891

Plate 23

Figure 9

It is a *poster* which marks the beginning of Lautrec's uninterrupted work as a lithographer, the 1891 poster for the Moulin Rouge – actually for *La Goulue*, because she is named in the headline and in the picture she alone is a figure of flesh and blood, interposed between the huge grey ghost of Valentin, the 'boneless man', and the shadowy coal-black outline of the row of spectators. This poster inevitably attracted the attention of knowledgeable people who soon realised that it was the start of a new age of poster art, that this was really the first modern poster. (In books on the poster published as early as Maindron's in 1896 and Sponsel's in 1897, posters by Lautrec are exhaustively treated.) Today it is regarded as the classic incunabulum of poster art. To be absolutely fair one should add that it had an immediate predecessor: Pierre Bonnard's poster for *France-Champagne*. The essential feature of modern poster technique, that the true poster must be an art of pure, flat planes, is already in effective use in this poster by Bonnard with its gracefully convoluted lines and compellingly simple colouring, a delicately modulated champagne tone. It is easy to see why this poster, as Thadée Natanson points out, attracted Lautrec's attention and was partly responsible for his decision to become a poster artist. He is also said to have regarded Chéret's posters very highly. Chéret's posters certainly stand out from contemporary work, not only by their gaiety but because the autonomy of this new art form was at least adumbrated in his gay, artificial, frivolous colouring and disregard of spatial realism. There is, of course, very little connection between Lautrec's poster style and the rather stereotyped 'rococo' of this sort of poster. Even Lautrec's first poster is an enormous advance on the

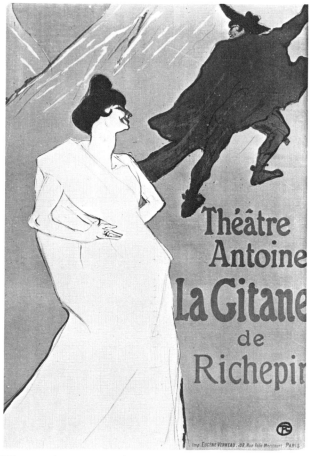

Fig. 10. 'LA GITANE'. Poster, 1900

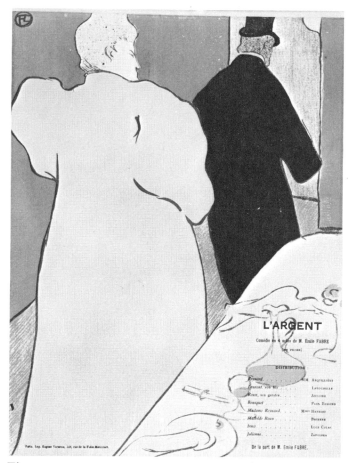

Fig. 11. A LADY AND A GENTLEMAN. Lithograph, 1895

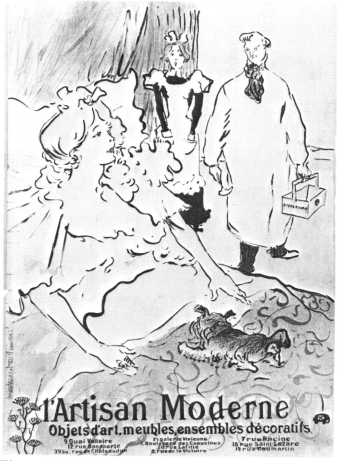

Fig. 12. 'L'ARTISAN MODERNE'. Poster, 1894

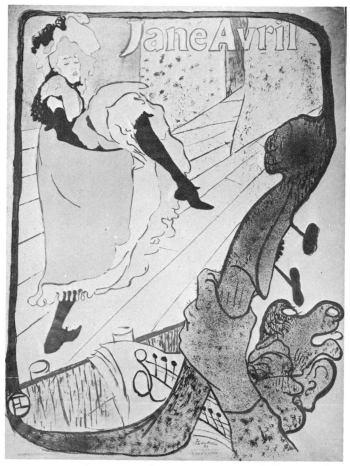

Fig. 13. JANE AVRIL AT THE 'JARDIN DE PARIS'. Poster, 1893

France-Champagne poster. This is not so much due to the weaknesses in Bonnard's sheet (such as his method of outlining the figures with a thick black line and the champagne froth with a thin line); the decisive factor is much more in the rich interplay of movement and spatial relationship, as well as the meaning which Lautrec was able to convey with his use of flat planes.

Foreground, middle distance and background are suggested in firmly delineated levels, as in a stage set, and the eye assesses the picture's spatial depth in two leaps. This sharply cadenced perspective corresponds to the gradations of realism which I have already mentioned: the whirling dancer, La Goulue, is depicted partly in great detail – her face and hair – partly with a strongly evocative technique of abbreviation which manages to suggest both solidity and movement; the figure of Valentin by contrast is schematic and insubstantial, whilst the audience is largely a decorative means of filling in space. The element of fantasy and unreality in this snake-like man absorbed in his dance is enhanced by the yellow shape at the left-hand edge, a ring of lamps, which hangs lower than Valentin's head. Treated as an oversized close-up these lamps on their own, like the figure of Valentin, would have been a naturalistic element in the composition, but here their very size produces the reverse effect. The lines of this feature, reminiscent of the serpentine flick of a whip-thong, is a piece of *expressionist* shorthand alongside the *representational* movement of the dancer. It is also strongly indicative of perspective and leads towards the dancer in a curve that starts at Valentin's outer arm and is linked with the over-proportioned hand below it. The entire composition is full of tense curves. Most admirable of all is the way that La Goulue's dance movement, precarious yet secure thanks to its speed, is conveyed by being drawn in a series of outlines and axial lines which are braced and fortified by contrast with the solid profile of the male figure.

Yet this first poster still lacks the perfection which Lautrec soon achieved in other posters. Multiple-tone colouring is used; Valentin's silhouette, for example, although coloured in a single pinkish-grey is given several gradations of tone by spraying-on, which led to enormous difficulties in production. However, it was on artistic and not merely technical grounds that Lautrec progressed towards simpler colouring. On the other hand, he later avoided such extreme simplification as the black blob of the audience (except in the poster *Au pied de l'échafaud*, where there is a silhouette of mounted soldiers in the background, although in this case its repetitive uniformity combined with the grimness of the theme has another function).

Plate 36 In the coloured lithograph *The Englishman at the Moulin Rouge* of the following year, which was not intended as a poster but is essentially a poster in style, even these minor faults have been overcome. This print is

one of Lautrec's most important works and is particularly representative of his art. Here, too, there is a figure made of a one-colour silhouette. It is even more daring, lacking even those faint gradations of sprayed-on colour; there is nothing ghostly about it, but its deep colouring, like a Negro against a bright background, seems to overpower everything that is lighter in tone. This violet man is nothing more than a flourish of one colour alongside others, the result of an extraordinarily bold stroke of imagination. An unbridgeable gulf divides this perfect combination of bright, gay colours from the routine garishness of other contemporary posters, although compared with the colour tones of most of Lautrec's works, this one is particularly festive and cheerful. It is, of course, much more than a mere game played with colours: the effect of this lithograph is of painting 'à plat' transferred whole into another medium, like a Manet of poster design. Naturally the absolute psychological neutrality of the three figures contributes to this; more than is usual with Lautrec they are purely existential creations.

The treatment is quite different in the illustration to Victor Jozes' *Reine de Joie*, a genuine poster, which is on the same level as the lithograph *Plate 26* of *The Englishman at the Moulin Rouge* and which also dates from 1892. *Plate 36* Here, too, there is the same limitation of material – in contrast to the *La Goulue* poster – and concentration on a few succinct coloured silhouettes, *Plate 23* completely homogeneous planes of yellow, red, black and white. There is no variation in the treatment of the various objects and materials in the picture. Everything is achieved by a softly flowing line which manages to suggest a maximum of space and movement. This method is even employed in the colour-structure, as all contours and outlines are in colour – red for the figure of the woman, green for everything else, including the lettering. This adds to the differentiation of the four colours used in the large planes and simultaneously enhances the overall unity of effect. (This was an innovation which has since become an absolutely basic element of all poster art.) Thus a normal compositional device of painting has been fully adapted to a flat-plane medium. Van Gogh used coloured outlines in an equally radical fashion in painting, but in the narrower field of prints Lautrec had no previous examples of this method to follow; it is not to be found where one might think it most likely, in Japanese prints, or in posters before Lautrec's time. Here and there – particularly in some of Chéret's posters, starting in 1890 – there are hints of the coloured outline, but he does not exploit it artistically as Lautrec does. Brilliant, gaudy colours and a playful use of rhythmic curves in the leaves of the flowers are employed to depict the ill-matched couple and the man next to them who is waiting apathetically for his food (a variant of this man is the dandy in the *Maison d'Or*). This contrast between its decorative splendour of *Figure 14* execution and the subject-matter of the scene is a witty artistic joke but it is more besides – Lautrec's special way of seeing things, his 'amoral' pic-

torial methods are revealed more clearly than in almost any other work.

A word should now be said about Lautrec's attitude to Japanese art. Lithographs like the two just mentioned are unthinkable without the Japanese woodcut. This is nowhere more clear than in the trio at the 'Moulin Rouge' with its delicate exoticism and its non-naturalistic colouring – quite apart from the violet man. There is nothing special about Lautrec's admiration for the Japanese; all the artists of his time admired them. Generally speaking the influence of the Japanese woodcut is felt in a number of quite distinct aspects – the startling use of perspective in selected areas of the composition, the absence of shadow, the dominant role of bright colours. Yet Lautrec was chiefly inspired by the overall effect of the Japanese woodcut, whose essentially graphic character was close to his own temperament. At the same time no one else so completely adapted the nature of the oriental woodcut for his own specific purpose. What distinguishes the Japanese woodcut from even the most closely related prints by Lautrec is the very ornamentality of the Japanese print. Ornamentation, as a concentration and heightening of decorative art, is always latent in the Japanese woodcut in varying degrees. When used indirectly, the crucial element is the way in which the ornament achieves its effect while remaining concealed, such as a repetitive pattern distributed over an apparently random composition; often, however, it is used quite openly and directly, where it can become a strongly emotional expressive element. There are related features in Lautrec's graphic work. *Figure 15* A face, for instance, like that of May Milton on the 1895 poster, has no

Fig. 14. AT THE RESTAURANT 'MAISON D'OR'. Lithograph, 1897

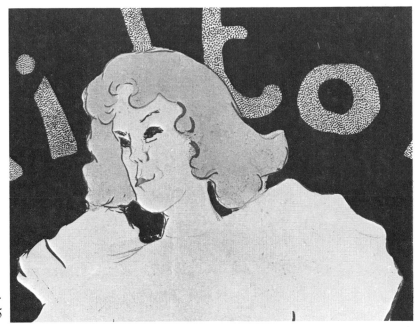

Fig. 15. HEAD OF MAY MILTON.
Detail from the poster, 1895

real predecessor; no such 'shorthand' technique in the use of curves to indicate the anatomical structure of planes in a face is to be found in previous European painting and he undoubtedly learned the use of this combination of decorative planes and spatial structuring from the Japanese. In some of the heads by Utamaro, for instance, there is the very similar device of putting the lips in side-profile into a face that is otherwise in three-quarters-profile. It is their rounded, calligraphic quality, comparable to the intrinsic ornamentality of a spray of blossom, which gives Japanese heads of this kind their flowerlike calm and detachment. Yet the same also applies to the deliberately expressive faces in the Japanese woodcut, which are more immediately comparable with Lautrec's work. The highly expressive faces and bodies of Sharaku's pictures of actors, for instance, owe their expressive content to their ornamental quality – a threatening face is a threatening ornament, a cheerful face a cheerful ornament. There is no pronounced ornamental effect in Lautrec. This divergence emerges above all in the difference between Lautrec's line and that used by the Japanese. Even the comparatively firm, regular and protracted curve which Lautrec uses so frequently, above all in his posters, in reality quivers with unrest, it winds and twitches even in places where it is not actually depicting movement. Although its technical function is the same as with the Japanese, namely the indication of spacial relationships and much else by means of outline and silhouette, Lautrec's specific use of line is nevertheless far removed from the firm, even, ornamental character and frequent rigidity of the Japanese; Lautrec certainly encloses his shapes with an uninterrupted outline, but there are always slight variations in the thickness of the stroke and alternations of thickening and thinning. An example of this is the lithograph of *The Englishman at the Moulin Rouge*, despite its many elements of *japonaiserie*. This more 'European' outlining

Plate 36

technique gives a different quality of life and solidity to the composition than that achieved by the Japanese.

It would seem that what distinguishes Lautrec's decorative manner from that of the masters of the Japanese woodcut is the Frenchman's power – which characterises without idealising – to generalise movement or spatial relationships and everything that stems from these factors into something universal. He appears to be able to express the very essence of a movement, such as passing by or walking away, even in such a decorative composition as the lithograph of the lady and gentleman at the restaurant table (the programme for *L'Argent*), because his particular technique always conveys an organic vitality, whereas the formal severity of the Japanese woodcut scarcely ever permits it to express such effects.

Figure 11

How little Lautrec was concerned with ornament, even in a more superficial sense, is obvious wherever he had to put in ornamental borders or the like, such as on a few programmes and wrappers or in the 1893 poster for the *Jardin de Paris* depicting Jane Avril dancing. The border, which grows out of the bass fiddle, is an unsuccessful hybrid of realism and ornamentation. Lautrec lacked the imagination to invent ornament, further proof of how his design method was bound up with the depiction of reality. Even the uniformity of his style of lettering used on various posters shows this. The letters, enveloped in a viscous line, which Lautrec normally used for this purpose, are neutral and are obviously drawn, without any pretentions to originality, from his own variants of the fashionable display-typefaces of the time; it is worth noting, however, that at least in certain cases this flowing outline is the same colour as in the picture into which the lettering is set. This produces a very effective affinity between picture and lettering. Probably the most successful example of such unity is the *Reine de Joie* poster. The slack, wavy outline of the fat man's tailcoat and the concave flourishes in the still-life, particularly the glass jug, harmonise with the shallow curves of the lettering, in particular in the parallelism between the outline of the jug and the 'd' and the 'J' of the script above it.

Figure 13

Plate 26

Admittedly the design quality of his use of silhouette is not always so strong; the duel effect of decorative planes and spatial illusion does not always interact so well as in the *Reine de Joie* poster, the *May Milton* poster or *The Englishman at the Moulin Rouge*. May Belfort's scarlet dress in the 1895 poster, for instance, whose shape rises behind the footlights in the softly curving folds reminiscent of far-eastern statuary, is a little empty compared with, say, the giant silhouette of Aristide Bruant's black cloak in the poster of 1893. And the entire silhouette of the second Jane Avril poster is inclined even more towards the purely decorative.

Plates 26, 36, 85
Plate 84

Plate 47

Only in two posters did Lautrec use lighting in place of contrasting planes as his key design element; this was in the poster for the magazine *L'Aube* in 1896, where his emphatically posterlike style gives way to a more

pronounced naturalism. In the other case, the poster advertising a novel in the *Dépêche de Toulouse* of 1892, he distributes the candlelight over the body of a hanged man in sharply contrasted patches of light and shade. This poster is one of his weaker pieces of work.

Taken as a whole, however, his posters, for all their stylistic emphasis on planes of flat colour, employ as wide a gamut of graphic techniques as do his other lithographs, and it is no exaggeration to say that each of his posters has its own style. There is the monumental, fresco-like block of a single figure in the posters for Aristide Bruant, May Belfort, Jane Avril and May *Plates 47, 84, 85* Milton, which is either placed against a complete void or whose spatial frame is only added as a sketchy extension of the figure itself. Especially when illustrating several people, however, space is used most tellingly; usually in the special form of partial close-ups; this is found in interior settings (*Reine de Joie, Divan Japonais, L'Artisan Moderne, The Chap Book*) *Plates 26, 30* or in street settings such as the *Babylone d'Allemagne* or *La Vache* *Figure 12* *Enragée*. Besides the massive, outlined shapes of those towering figures, there is his use of the sensuous, vibrant silhouette drawn with masterly sureness – for example the portrait of Jane Avril in the 1892 poster for the *Divan Japonais*, the absolute quintessence of the fin-de-siècle woman; then *Plate 30* there is the exuberant interplay of bouncing flourishes and curves, whose vivacity is half-comedy, half-demonic (*L'Artisan Moderne*, the English *Figure 12* poster *Confetti*, the poster for the photographer Sescau, all dated 1894, *Plate 63* and *La Troupe de Mademoiselle Eglantine* of 1896). Alongside a quivering web of lines and flickering, multiple colours suspended in great empty spaces – perhaps the finest example is the sketch-design for the poster for Sloane's book on Napoleon in 1895 – there are the shorter, tenser curves rigidly braced within the rectangle of the frame, as in the *May Milton* *Plate 85* poster, for instance. And in the last of his posters, designed for the performance of *La Gitane* at the Théâtre Antoine in 1900 – this one and the *Figure 10* 1899 Jane Avril poster were both created after a long break in his poster-designing career – there is a controlled mastery of the use of the most varied formal devices. Normally Lautrec thought it proper to use only a single graphic technique in each poster; here on the other hand, alongside a clearly articulated composition with a pronounced diagonal tension and inter-axial stress and the simple stratification of three shades of colour, the figure of the woman is drawn in with particular finesse and nuance. With this, in a sense, a cycle has been completed: at the start of his series of posters there is a multiplicity of techniques, not yet completely subjected to an overall unity of composition, which preceded his achievement of stylistic simplicity in poster design; then, at the end, comes a rich scale of gradations which is harmoniously subordinated to a basic simplicity.

When Lautrec began his work as a poster artist, he revolutionised the medium and set it off on a completely new course. (In neither his painting nor his other graphic work did he exert anything like such an immediate

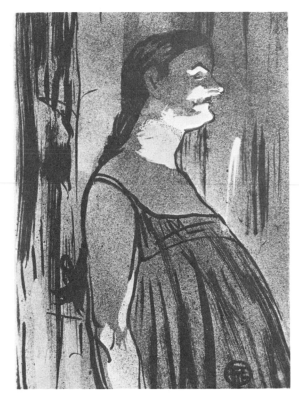

Fig. 16. MADAME ABDALA. Lithograph, 1893

influence.) To this day his best posters have forfeited none of their effectiveness and are still regarded as models of the use of the medium, even disregarding such concepts as the 'immutable rules' of poster design. They contain nothing of the rigidity and flattening effect of geometrical design which, although it gave new impetus to poster art, was later also to prove so harmful. They precede the irruption of technology into poster art, which forces us into always having to stress that a poster can *also* be a work of art. They are not yet mechanical products but organic products and their shorthand decorative idiom is a pure, self-sufficient art form and is not, as so often happened later, a mere construction of the elements of an art form.

With his thirty posters Toulouse-Lautrec founded a new art, whereas with his other lithographs he was merely carrying on an old one. His was a famous 'chapter' in the history of lithography as an art-form. He is plainly linked with the most significant of the 'chapters' which preceded *Plate 64* him, namely Daumier. *Nicolle at the Gaité Rochechouart* for instance, or *Figure 16* *Mme Abdala*, are the unmistakeable offspring of certain of Daumier's caricatures of actors, in their quality as examples of the graphic technique of lithography. The print of Nicolle, incidentally, obviously contains a conscious reference to lithographs by Daumier, because the strongly Daumier-esque combination of a silhouette of velvety blackness with a background of warm half-tone enlivened by sketchy drawing, together with certain peculiarities of the crayon-strokes in the face and background is exceptional in Lautrec's lithography. Looked at more generally, how-

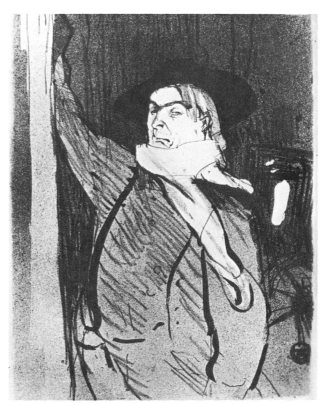

Fig. 17. ARISTIDE BRUANT. Lithograph, 1893

ever, this print, too, fits into the series of lithographs with a distinctive feature which stylistically links all Lautrec's early lithographs into a group. This feature is a relatively copious use of chiaroscuro. The period of this style is 1893 and part of 1894. Admittedly he also uses another style at this time, for instance in the drawing *En quarante!* or in the print of *Marcelle Lender and Baron*, just as certain of his posters and polychrome lithographs also prefigure later styles, but in his monochrome prints this other, more painterly technique, predominates by far. 'Chiaroscuro' in this context means that many half-tones – mostly sprayed on – and extended areas of shadow are used to fill out the rectangle of the picture as far as the edge of the lithograph stone, and thus produce an enclosed area of darkness from which the figures stand out as patches of light.

But there is also a more subtle application of this chiaroscuro, used in its older sense of figure-modelling by the use of tonal shades. This is found in those bright drawings with a great deal of space left white, in which the delicate modelling is restricted to small areas of curvature on the face. The two lithographs from *L'Escarmouche: Pourqoi pas . . .* and *Lender et Brasseur*, also a print like the profile portrait of Yvette Guilbert from the *Café-Concert* portfolio, all done in 1893, are examples of it. Their common denominator is that line as such is not yet the dominating force that it later became in, for instance, the scene showing Yahne and Antoine in *L'Âge Difficile* of 1895 or even in the print *Brandès and Leloir at 'Cabotins'* of 1894. Although line may outwardly seem to be the principal medium in the portrait of Yvette Guilbert, the important thing is that it is a line

Plate 48

Plates 52, 67

Plate 98

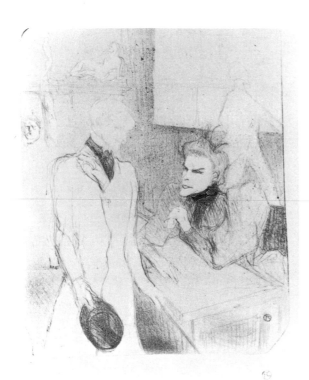

Fig. 18. BRANDES AND LE BARGY IN 'CABOTINS'.
Lithograph, 1894

which achieves its effect in conjunction with the fine patches of shadow round the nostrils and round the eye as adjuncts to the shadows used for modelling effect, therefore a line that is fundamentally different from the loose, wayward or enervated lines of his later drawings. Compared with these it has more physical weight. Even such an apparently flat feature as the gorgeous blob of the dark bow on this drawing also has this greater substantiality.

This technique, which goes hand in hand with a markedly compact, precise pictorial quality is a continuation of the lithographic tradition of the classic period of Daumier and Gavarni. Lautrec is, of course, only related to them in the degree to which his highly individual new technique is at all comparable with theirs. The tonal gradations of flat planes, which Lautrec largely achieved by making at that time particularly extensive use of the spray; a most versatile line; strong characterisation of the subject matter – all this is given a special surface glitter by Lautrec's use of lithography, compared with which the artist's later graphic techniques give an effect of a greater spiritualisation. In several of his early prints there is also an inner relationship with Lautrec's poster style of those years, for example in the menu-sheet with the *Modiste* or the *Ultime Ballade*. In prints like these the greatest similarity is with his last poster, the poster for *La Gitane*, because in that the adoption of a restrained linear technique produced the interaction of powerful, big shapes and fine detailing mentioned above.

Plates 46, 62

Figure 10

In its early stages Lautrec's graphic style was a refined variant of his poster style; at any rate there was less difference between these two media than in later years. Then his posters and his graphics moved further and

further apart and Lautrec's abandonment of poster design altogether in 1896 is an aspect of this development.

If one were to name one work characteristic of this early style, it might well be the scene from *Les Femmes Savantes*, dated 1894. If only for its truly magnificent deployment of all the resources of the graphic medium, it is one of Lautrec's masterpieces in this technique.

The black garments of Trissotin as he recites poetry are a graphic equivalent of such bravura achievements as Frans Hals' or Velazquez' black-on-black painting. A dark welter of patches, strands and streaky black cascades of lines in clouds of velvety, warm, dark grey form a delicate mass, so attractive in purely optical terms that one would be tempted to admire it for its formal effect alone were its representational skill not equally brilliant in evoking the elaborate fantasies of silk and lace in baroque costume, from which the legs protrude as rigid shapes. Minute details enhance the delicacy of the whole, such as the little erased patches on the cuff, the arm of the chair and the inside surface of the heel of the shoe. To the left of this cloudy, dark mass there emerges the pale outline of the hand, whose affectedness is emphasised by the fact that it is 'in negative' against the black background, whereas the other hand by contrast is represented by a bold, witty kind of linear hieroglyph. (Lautrec's skill in drawing hands, with or without gloves, which is at its finest in an example like this – or, for instance, in the hand of Marcelle Lender in the 1895 coloured lithograph; the hands of La Goulue and Valentin dancing together; of the two women dancing in the picture in the Prague museum; or in the right hand of the customer in the *Maison d'Or* – can only be compared with Velazquez or Manet.) The contrasts also extend into the larger elements of the picture: the minutely detailed figure of Trissotin is followed by the white, sharply-lit silhouette of the second figure standing out against the evenly sprayed-on pale grey of the background, against which the third figure is almost invisible. This gradation in contrasts is echoed in the picture's treatment of space: the two figures on the right are seen in profile, whereas the actor in the foreground is in a three-quarters profile attitude which is lent an added spatial richness by the angle which hides part of the chair-leg. Even Lautrec seldom managed to combine such perfect spatial articulation with such convincing use of incomplete figures.

Another of the picture's virtues is the treatment of lighting. The figure in the foreground is gently lit by the footlights, which are slightly less emphasised than in Lautrec's other stage scenes, in which as a rule the rather sketchier lower halves of his figures are shown as brilliantly lit. The result in this case is not dramatic, but the effect of the magical glow of the warm stage lighting that suffuses the whole scene like haze is all the more intense. In the treatment of the figures this is achieved by artistic means which are tangibly evident in one instance only – in the faint shading of

Plate 66

Plate 93
Plate 61
Plate 33
Figure 14

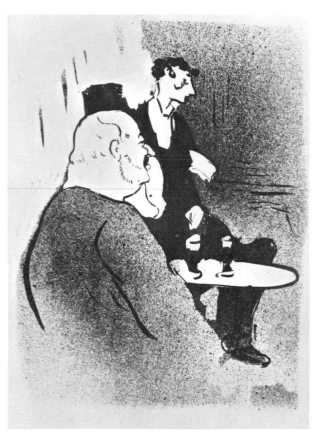

Fig. 19. 'DUCARRE AUX AMBASSADEURS'. Lithograph, 1893

the wig of the littérateur together with the dim blocked-in shadows on the
backrest of the armchair; these have the effect of making Molière's
features, framed in curls, seem to be brightly lit from below. Apart from
this, the impression of festive brilliance is suggested by no more than the
merest touches of brightness on the pair of crossed legs and on the arm-
rest, and by the overall chiaroscuro exemplified in the contrast of shading
between the first and second figures.

There is a further analogy between the richly contrasted formal struc-
ture of this picture and the complex nature of its subject-matter. It is a
sort of apotheosis of the theatre. The feel of the stage and the theatrical
atmosphere has been captured with a power equal to the vividness of
Menzel's *Memories of the Théâtre Gymnase*. One is reminded of this picture
because in both works an impressionistic image of reality is raised by the
imaginative intensity of its execution into a statement in visual terms about
'theatre' in general. In both works the vital element is the treatment of
lighting. Both pictures glorify the stage by glorifying stage *lighting*. At the
same time Lautrec's lithograph includes a hint of irony in the artist's
attitude to the theatre – in the portrait on the wall, which is a scribbled
caricature and thereby serves as a contrast to the actor in the foreground,
who is depicted without irony, and the two women in the audience who
share the element of deadpan humour implicit in the contrast. Here, too,

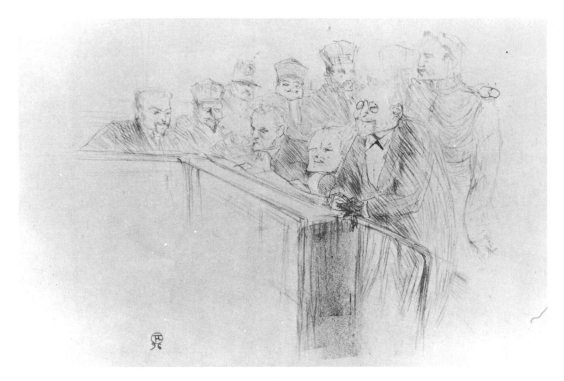

Fig. 20. SCENE FROM THE TRIAL OF ARTON. Lithograph, 1896

there is a subtle gradation both in the formal graphic structure and the treatment of lighting.

The drawings which followed this style of the early nineties are often related to it in the way that the sinews and nerves of an anatomical dissection are related to the surface beauty and vitality of bodies in motion. Yet although the scope of Lautrec's graphic vocabulary is correspondingly reduced, he does not have any less to say. It is merely the well-known process of artistic concentration and the increasing economy of the virtuoso performer.

To take a related example from the same art-form, there are similar features in the development of Daumier's graphic work from his sharply contrasted sculptural style to the pared-down draughtsmanship of his late phase in which he used a single graphic technique of restless, vivid, flickering, interweaving line. Admittedly it is only in its direction that Daumier's and Lautrec's development correspond. Its scope is very different in the two cases: relatively narrow with Lautrec, in keeping with its short time-span, whilst with Daumier it is very large. To illustrate the distance which separates the stylistic extremes in Lautrec's lithography, one might contrast the *Folies Bergère* scene of 1893 on the one hand with the print *At the 'Hanneton'* on the other.

The difference is particularly striking if one looks at the treatment of similar subject-matter. In 1894 Lautrec decorated Gustave Geffroy's book on Yvette Guilbert with sixteen marginal illustrations (known as the 'French Series') and a jacket-design and in 1898 there appeared a second

Figure 21

Plate 53
Figure 22

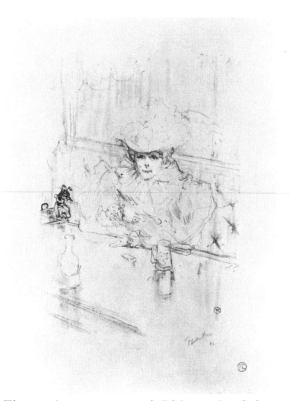

Fig. 21. 'AU HANNETON'. Lithograph, 1898 Fig. 22. YVETTE GUILBERT, BOWING. Lithograph, 1894

series of pictures of Yvette Guilbert performing various numbers in her repertoire, the so-called 'English Series'. The drawings of the 'French Series' are embellished with all the richness that printing techniques could supply. The olive-green printing ink (a favourite of Lautrec's at the time; it is not found in later works) is alive with subtle, dusky half-tones which combine with patches of bright light and with the dark shapes of Yvette's long gloves to produce the most beguiling contrasts. In most of the drawings this effect is produced by generous use of the spray, but even where the more draughtsmanlike technique of dense hatching is used, as in the eighth illustration, it serves the same end of producing a richly graduated, interweaving gamut of tones. Even the contrast between the sharp delicacy of the lines of printed text and the pictorial structure of the drawings, which extend into the type-area, is utilised, making the book into a very characteristic example of a certain genre of turn-of-the-century book illustration.

Plates 104, 106, 107 The 'English Series' differs slightly from the earlier version in its basic premises. Although superficially linked to the book, the 'French Series' of drawings for Geffroy's volume have a special illustrative quality in that they do not really 'illustrate' the text but express a subject-matter of their own and thus have an independent narrative value. The on-stage action plays a bigger part than in the later series and here there are scenes show-ing several figures. In the 'English Series' on the other hand, with the exception of the last print, Lautrec does not even attempt to reproduce

whole figures. Here the great diseuse is shown in a series of close-ups in which there is a minimum of stage trappings and only the face and an occasional hand are used for expressive effect. This limitation and selectivity in layout is paralleled in the draughtsmanship. In the earlier series the detail is in every way richer, both in the figure-drawing and the treatment of lighting effects. But in the later series he does not need to use detail in order to produce lighting effects that are equally brilliant. Indeed in Lautrec's later graphic technique there is even more light because the intrinsic brightness of his extremely loose, relaxed line by itself produces the effect of space lit by warm stage lighting; light and the bodies it illuminates have become inseparable, whereas in the 'French Series' the lighting as such is much more explicitly evident. The later drawings, therefore, say the same thing as the earlier ones but in calmer, unemotional and therefore more controlled language. The lithographs of the earlier years bear the same relation to the 'English Series' as a conscious, aphoristic virtuoso style bears to an idiom which no longer allows its techniques to obtrude. He uses no spray but fine-grained, delicate, freehand hatching and in the one instance where broader areas are shaded by this means, i.e. in the last print in the series, the effect is more veil-like and not a method of accentuating contrasts. The creamy-yellow shading, too, of eight out of the nine prints, adds to this effect.

But the later period, with its greater freedom and refinement of technique, does not imply a more abstract treatment of the subject-matter. The basic theme is the same, there is as much psychological, optical and material reality as ever; even the irrational element that lurks within Lautrec's realism is actually more marked in the earlier rather than the later works. If, for instance, you place the *La Soûlarde* print from the *Plate 107* 'English Series' alongside the 1893 portrait of Yvette Guilbert, which are *Plate 52* similar enough to invite comparison, the treatment of space in the earlier print appears less naturalistic than in the later one. At first sight the large empty areas of white in the earlier print do have the feel of space visualised impressionistically, of emptiness with an illusory quality whose effect is enhanced by the suggested glare from the footlights. Yet this is not the only way in which this picture can be interpreted: a stronger element than this illusion is in fact the expressive power of the profile of the single figure. This adds another significance to the empty planes used to denote space, so that they still indicate space but no longer in a realistic, impressionistic sense. Instead we now perceive this flat whiteness as having an additional expressive quality – the quality of spatial emptiness, which allows the profile figure to stand out in all its solid immediacy. In the later profile head of *La Soûlarde* there is nothing like it; the technique *Plate 107* has been modified though not weakened. Harshness, emphasis and pathos have become superfluous and when compared with this rendering the earlier drawing seems to retain, along with its greater hardness of line, a

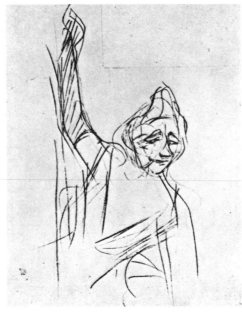

Figs. 23 and 24.
IMPRESSIONS OF
YVETTE GUILBERT.
Drawings, 1896.
Paris, Louvre,
Cabinet des Dessins

slightly heavy-handed treatment of the subject which actually serves to heighten the contrast with the empty space. Total unity of matter and manner was achieved in the later print.

As a counterpart to the dual significances of the empty space in the first portrait lithograph of Yvette Guilbert, one should mention the dual function of the lighting in a print from the 'English Series': in *Linger longer, Loo* . . . the artist also shows the brilliant light of the footlights whilst at the same time achieving a heightened sense of the unreality of this 'infernal' kind of lighting.

Plate 106

There is, of course, no very marked gap in time between the two styles. Of the last drawing for Geffroy's book, of Yvette Guilbert bowing towards the wings, there exists a variant which, in its concentration on pure draughtsmanship (with water-colour shading) and on expressive precision, differs from the richer technique of the 'French Series' and is closer in spirit to the later series. Yet it was probably not drawn after 1893; if anything it predates the version made for the book.

Figure 22

Plate 50

Certainly the 1895 portrait of Marcelle Lender (*Marcelle Lender debout*) already demonstrates in full the characteristic technique of Lautrec's later period, both in draughtsmanship and colouring.

Plate 93

Her elegant dress is suggested by a restless, fragile yet immutably solid shape made up of crowded, overlapping lines, hatching and arabesques, which alternate between sharp tension and limpness and which seem in places to be endowed with a hysterical life of their own. How the innocent grace of a woman's dress is not only conveyed by this construct of wiry flourishes, grey rags and threads but also given a hint of uncanny ghostliness at the same time is a kind of perverse application of artistic technique with which we have become thoroughly familiar since Lautrec's day (compare, for example, Kokoschka's graphic work). But in Lautrec's time

this was not so. There are indeed plenty of examples from Lautrec's own work in which graphic elements of intrinsic grace and elegance are used to represent exactly these qualities when depicting beautiful clothes and materials, as in the dress and hat in the picture of the *Modiste*, Marcelle Lender's dress in *Madame Satan*, the duo in *Fortunio's Song*, the half-length portrait of Marcelle Lender and even Trissotin's dress in *Les Femmes Savantes*. Yet the drawing of Lender's dress, as she stretches up with sensual mockery, reflects the same quality as her expression with its bared teeth and its nervous, treacherous smile on the brink of hysteria. Her triumphant face rears above the footlights and, with its distortion by being seen from below, and the animal-like glitter in the eye above the arching, highlighted cheek, the artist seems to have adopted the most appropriate prospective for the moment he has chosen. The whole picture glows as though with a feverish temperature, in which one sees everything with unnatural sharpness yet blurred by a deceptive haze. In its final version the print was overprinted with two colours which veil the drawing in exactly this kind of haze – a sallow, faded red and a dull olive-green. Simple though it is, this combination of colours has a complex significance. A pair of fashionable colours are chosen to typify the subject, yet the choice raises them from the level of 'taste' to the dignity of the artist's expressional palette, without being fully transmuted – like a dress painted by some impressionist – through incorporation into the actual pictorial structure. The morbid quality of these two colours is ambiguous: one does not know how far they are to be ascribed to the real dress and how far the colouring is purely expressional. It is of course to a large degree expressional and this extends into the remotest detail of the printing process, such as the way in which the two overprinted colours blur the line at various points and create ambiguous tonal mixtures.

For once one can say that Lautrec has not taken shelter behind the theatre but that reality has gained the upper hand over the theatre.

The colours of this print stand in the same relationship to the colours of Lautrec's early coloured prints as do the technically more restrained yet highly expressive drawings of his later years to the superficially more elaborate draughtsmanship of the preceding period. Silhouettes in colour such as those in the lithographs *The Englishman at the Moulin Rouge* and the programme for *L'Argent* tally not only with the smoothly sinuous line of these drawings but also with the white, grey and black silhouettes of certain monochrome prints, such as the scenes from *Phèdre*, from the *Folies-Bergère* and from *Faust*. Equally, the linear articulation of the colouring corresponds in feeling to the style of draughtsmanship in the later drawings.

Of course one should not contrast the two styles in quite such simple terms. Even in the later drawings Lautrec makes generous use of the spray and of firm, regular silhouettes, as in the lithographs of the clowness

Plate 36
Figure 11

Plate 55

39

Plate 80

Cha-U-Ka-O, for example. However these silhouettes differ markedly from those in the earlier prints in that, unlike there, they are not surrounded by an outline. This and the frequent use of blank spaces creates that feeling of weightlessness which – in contrast to the often very large areas of flat colour which should in fact produce a rather ponderous effect

Plate 103

(e.g. the figure of the woman in the *Grande Loge*) – makes the coloured prints of the early nineties so particularly attractive.

Plate 97

A work like the coloured lithograph for the catalogue of artistic posters has another, and distinct, style. At least as important as the bold use of outlining and heavy strokes are the swathes of smaller strokes and hatching, which flow across the pictorial structure in two main directions. The dominant flow is the one moving from lower right to upper left through the diagonal created by the posture of the woman. The intensity of these nervous, pulsating movements even have the effect of forcing the hatching of the left-hand half of the wall out of the vertical. The diagonal line of the man's body, particularly the attitude of the legs, acts as a strong counterflow to this movement. This forceful method of expressing movement by bundles of violently agitated, undulating lines carried to the point where they distort proportion and anatomy – particularly in the woman's face and in the man's distorted body, some of which should be visible over the woman's right shoulder – is often found in Lautrec's work.

There is also a special and somewhat different characteristic in the colouring of this print: the clash of colour between the woman's hair and the sugary pinks of the wall and the divan is at once a means of expressing the atmosphere of this 'chambre séparée' scene and of making an ironic comment on it. This is an attitude to the subject-matter which expresses both fascination and superiority.

Plates 80, 90, 95, 96, 99

The *Elles* portfolio, published in 1896, contains in eleven lithographs a whole catalogue of Lautrec's graphic styles, of which there are almost as many as there are prints, including several more than those already mentioned. These scenes from the life of the women in brothels (with which Lautrec was thoroughly familiar, as he took lodgings in one of them at various times) are the graphic counterpart to the long series of paintings

Plate 69

on this theme, which include such masterpieces as the oil painting *Dans le salon* and its pastel version, both in the Albi museum, or the painting

Plate 76

Ces Dames in the Budapest Museum of Fine Arts. The inclusion of this cycle of lithographs into a bound portfolio, with the faintly bookish and literary overtones which are inherent in this method of publication, is an exception in Lautrec's printed graphics. In this series of prints there are a number of little narrative touches, made to be sure with the greatest delicacy, which, in comparison with Lautrec's usual dispassionate attitude to reality, may be called 'literary'. This is inherent both in the pictures themselves which give the effect more of poetically evocative vignettes and less of representational images, and in the cohesion of the

whole. This only extends beyond the continuity of location in so far as two of the women appear in two separate prints and the range of the subject-matter is contained within the bounds set between the title-print and the last print in the series. The basic mood of the title-print, which shows a woman arranging her hair in front of a mirror, is relaxed, almost cheerful. A tinge of irony is provided by the still-life in the foreground composed of an armchair draped in feminine underwear and with a top hat on the seat. However, these narrative hints are visually counterbalanced by the captioning of the picture: the title-word 'ELLES', beneath which Lautrec has placed a large, bold version of his famous monogram reminiscent of a Japanese sword-guard, acts as a counterweight to the elaborate still-life in the lower foreground.

Plate 95

In the final print *Lassitude*, on the other hand, showing an exhausted woman lying sprawled on the bed, the emotional content is much greater in scope: the print expresses shock and compassion, odd though such words may sound when applied to Lautrec. It would not be a true Lautrec if even here he did not assume the mask of cool objectivity and, above all, of seductive formal beauty. In this case, however, these attitudes do not take the form of ironic contrast. How soft is the atmospheric tone of this print can best be judged by placing it alongside the breakfast-time conversation piece *Au petit lever*. One would expect the two works to be divided in time by the turn of the century. So much else of his art – that aspect of it that is concerned with conventional beauty, with an aesthetic appreciation of the surface of life – is thoroughly nineteenth century in spirit. The unforgettable silhouette of the fat 'madam' of the house, that monster with a bird's head on an elephant's body – in the other print of the series in which she figures she is shown from the front as looking quite kindly – is nevertheless, though blocked in with startling simplicity, closely related in technique to Lautrec's more usual economy of line. But the expressive way in which, in the blanket beside her, he uses the technique of blank spaces, goes far beyond the formal conventions of the late nineteenth century: the pathos of her pale hands is vividly underlined by leaving them as bare, negative, blank spaces in the red mass of the blanket. The bizarre heap of cushions beside it is given added force by its outlines. The oblique line of the upper edge of the bed running from the corner of the picture to the girl's head creates a harsh dissonance with the layered structure of the rest of the picture built up of profiles, although to conform with the latter it has been bent out of true perspective – a device which serves to add a further element of unease to the scene. The frivolous ornamentation on the wall and blanket does not modify the harsh, vaguely threatening effect of the whole, but instead heightens it by contrast.

Plate 99

Plate 96

No other print in the series carries such an emotional charge, recalling as it does the numb horror of Edvard Munch's pictures. The other prints are only variations on moods of much less tension, mostly of the early

Fig. 25. THE SPIDER. From Renard's
Histoires Naturelles. 1899

Plates 80, 96

morning atmosphere in rooms heavily draped with carpets and hangings. The expressive range is very diverse, presumably on purpose. (These eleven prints also vary in quality.) As in the polychrome print *Au petit lever*, the lithograph of the seated clowness is built up of gossamer-thin coloured outlines which appeared to have drifted together on to the paper. The most important element in the picture is the widely spread pair of legs which gives the picture spatial depth. Its blackness creates a flat impression, like a shadow cast on a wall, and stands out in contrast to the bright shape of the arms. Two of the prints are monochrome drawings; in another two a red chalk drawing is combined with olive-green paper to produce a muted, schematised effect; in three others the grey lines of the drawing are enlivened by a few sparse, pale colours – bright yellow or blue.

The print of the *Woman in Bed* has already been mentioned; its characteristic features are its heavily drawn outlines, mainly comprised of shadowy interwoven lines, and rich hatched shading, which are mostly confined within concave areas and are sharply distinguished from the areas of light. This compact and apparently quite naturalistic manner is found only occasionally in the lithographs of the first half of the nineties; after 1896 it is more frequent and in the crayon drawings of his circus series of 1899 it has become almost his sole technique.

This style is also used in a few of the illustrations to Jules Renard's *Histoires Naturelles* of 1899, although with different effect. Most of these animal drawings reveal little of Lautrec's powers of draughtsmanship. They remain at a mediocre level of illustrative naturalism; only in an un-

Figure 25

published variant of the jacket drawing and in the picture of the spider,

in which both the beast's anatomy and its essential character – its hairiness, its twitching movements, in a word its spiderishness – are evocatively expressed in the sinuous line-drawing, does the quality of his freehand draughtsmanship really emerge. Curiously enough the naturalistic treatment of all the other animals in the book is singularly un-free and cramped. In general Lautrec seems to have been inhibited by his subject matter whenever he drew animals (as he also is in his landscapes drawn for the sheet-music covers of some of Dihau's *Mélodies*). The one exception to this are his drawings of horses. In his lithographs Lautrec makes the same use of line as for the human figure, indeed his horses' heads sometimes display the same mastery of physiognomy as his human faces. The way in which a horse will turn its melancholic head with casual curiosity at something as it passes by is demonstrated with a sharpness almost of caricature in the lithograph of *A Jockey on his Way to the Scales;* in the poster *Figure 26*
to advertise the book about Napoleon, Lautrec found a unique graphic means of conveying in quivering line the snorting and twitching of horses' nostrils. On the whole his skill in depicting equine movement approaches that of the master he so admired – Degas. The best examples of this in his lithographs are several racecourse pictures, which form a group with other pictures of horses of the year 1899.

Neither the drawings to Renard's animal stories nor the marginal pictures to Geffroy's book on Yvette Guilbert are illustrations in the conventional sense, as are the pictures which Lautrec drew in 1898 for George Clemenceau's book *At the Foot of Sinaï*. These drawings are not charac- *Plate 112*
teristic of his best work; they, too, show that he was not gifted with the *Figure 27*

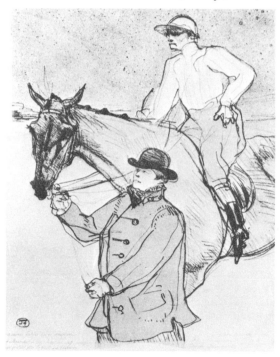
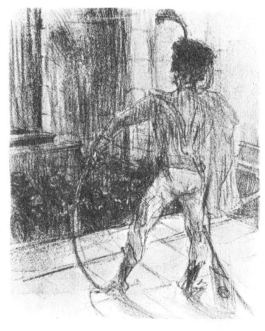

Fig. 26. JOCKEY ON HIS WAY TO THE SCALES. Lithograph, 1899 Fig. 27. AT THE FOOT OF SINAÏ. Lithograph, 1897

kind of inventive imagination that is independent of the artist's own visual experience, yet they also attest to the general truth that even the weaker productions of a great draughtsman contain much that is graphically of great quality.

Also included under the heading of illustrations are his jacket designs for books and sheet-music, of which Lautrec drew a great many. His song covers were mostly done for compositions by Désiré Dihau, and these can be grouped in two main series; the *Vieilles Histoires* to words by Jean Goudezki published in 1893, and Dihau's fourteen compositions to poems by Jean Richepin which, as already mentioned, were published two years later under the general title of *Mélodies*. Lautrec's five contributions to the earlier series are among the best achievements of the initial period of his lithographic work, whereas the cover-designs for the *Mélodies* are on the whole weak. Several of his book jackets are equally poor.

A further comparison of Lautrec's graphic work in all its rich stylistic variety with his painting of the period after the late eighties shows, as might be expected, a development that is analogous though with specific differences natural enough in an artist to whom the actual *techniques* of painting and graphics meant so much. Even in such a characteristic genre as his 'graphic painting' there is, as in the lithographs, a huge range of finely graded variations of emphasis which he employs with great verve to accentuate and highlight his compositions; at the same time he also has recourse, again as in his lithographs, to techniques that make powerful use of blurring and opaqueness. Where colour is concerned, both approaches often tend to be employed with greater intensity in his painting, giving it a harsher, sharper tone than his lithography. The colours are either loud, even poisonously bright and violent, or – with all their turbulence – full of melancholy and gloom. There are three large, crowded canvases which are the most striking examples of this dark side of his painting: the two almost monochrome pictures for La Goulue's show-booth of 1895, in the Jeu de Paume in Paris, and the *Dance at the Moulin Rouge* in the McIlhenny Collection in Philadelphia. This early picture, of unusually large proportions, is more significant, and is altogether one of the masterpieces of Lautrec's painting. It prompts the question which of the aspects of such a dance scene – the glitter, the noise, the madness – has here been captured. Clearly none but the madness. The picture is dominated and permeated by the grotesque and the sinister. This is most strongly noticeable in the scurrilous treatment of several of the figures, such as the man in the far left foreground whose crude, stiff outline recalls children's drawing, or in the fragmentary profile of the second of the two women in the foreground; but even where this caricature-like simplification is not used, and the figures remain naturalistic, there is much that is peculiar. Not only do the expressions of dancers and spectators have a rigid, mask-like blankness that contrasts strongly

Plates 72-74
Plate 57

44

with the gaiety of the dance-hall scene, but even the setting is curiously bare and drab, once more inviting comparison with Munch. This is most striking in details such as the heavy shadows cast by the dancing couple – vague and limp, yet firmly outlined (like the clothes of the spectators), they seem a physical part of the figures themselves. In general the negative treatment of lighting and the picture's sallow, drab colours in what is ostensibly a scene of enjoyment give a strong sense of parody.

In essence this picture is close to another major work of Lautrec's painting, the 1892 picture of the two women dancing which is in the National *Plate 33* Gallery of Prague. Although the figures in this picture are free of that ghostly distortion and the dancers' faces have the calm expressions of Lautrec's portraits and the picture is painted from an altogether richer palette, yet this scene too is overlaid with a veil of oppressive unease. It is most clearly expressed in the streaks of indeterminate blue, green and brown in which the bodies of the dancers seem to be drowning. The other and stronger colours, with their iridescent effects, have merged into those dark blue-grey areas in the foreground. The only strong contrasts to these colours are the red of Jane Avril's jacket and a milky white strip to the right of her. A peculiarity of this picture is the great variety of greens – rich grassy green on the floor; yellowy green on the balustrade and in the shadow of the right-hand dancer's hand, and a green that is almost blue in the pointillist-type background. This is a particularly subtle case of the use of a colour which one can almost say was a favourite colour of Lautrec's. In the 1888 portrait of Jeanne Wenz, one of the first portraits of his *Plate 10* mature period, the background is an even dull bluish green, although wavy in its application, which is something like a dirty verdigris. He also uses a sharp poison-green, just as he employs other sharp colours. Poisonously bright colours like scarlet, carmine and bright pink crop up frequently, sometimes juxtaposed in contrast, sometimes embedded in restrained, muted colours. These harsh colours are often consciously and provocatively vulgar and used in large flat patches. In this sphere of pure colour, with its alternating shrill and muted tones, Lautrec's art is far removed from external reality. It is here, too, that it is furthest removed from Impressionism, although it shares in what was historically the most important achievement of Impressionism – the liberation of colour. This is not a paradox, because the radical freedom of colour won by the Impressionists was used by Lautrec for quite different purposes. The colours of Impressionism are completely subject to the dictates of optics; they must always, at least theoretically, be colours that the artist has *seen*. Even when an isolated colour diverges widely from reality, its interaction with neighbouring colours is supposed to add up to a total effect that is optically realistic. However personal an artist's interpretation of colour-structure in an Impressionist picture may be, however bold the results achieved by the use of unbroken colours, the ultimate aim of its colouring

is always one of truth to reality and no amount of sophistication can conceal this fact. If an Impressionist wants to show the onlooker that this or that apparently grey patch in a landscape is 'actually' violet or green, this gesture in itself determines the basically naturalistic character of the picture, even though the use of violet or green might be called for on grounds that had nothing to do with optics, such as composition, which demanded the use of brighter, stronger colours.

By comparison Lautrec's colours are not to the same degree, even in the Impressionist sense, colours which he has seen. At its most typical his colour is a stylising method of projecting an inward vision. With Lautrec the red of the sawdust ring or of a box at the circus – which if painted by an Impressionist would only seem red because it would be actually made up of other colours which merge and interact – is a 'real' raspberry red, or rather a red of a different order of reality – the 'circus colours' of Lautrec's imaginative vision. Colours of this sort have an affective relationship to the images which are conjured up by the magic inherent in certain words for colours. A title of a picture, such as 'Woman with Yellow Hat' or 'The Blue Door', creates in the mind's eye the vision of a yellow or a blue which have nothing to do with the colour of any concrete object or with realistic depiction. Even a yellow hat painted by Velazquez, Frans Hals or Manet would not be of exactly that yellow that our imagination sees when stimulated by the words 'The Yellow Hat', because a colour of this kind is a purely objective colour whereas it is the very essence of Impressionism to demonstrate that objective colour is a function of atmospheric colour. Lautrec's colour, on the other hand, is to a very great extent objective colour, especially in his lithography; it is less markedly so, though still distinct from the Impressionist use of colour, in his oils. Although it lacks absolute material realism, its objectivity stems from its sensuous power and from the precision of its ability to select, simplify and typify. Colours of this sort belong to a fantasy-world and it is this quality which links them with those images aroused within us by verbal association. They are signal-colours that have almost the power of symbols, capable of reproducing that 'yellow hat' of our imagination, at least in so far as a painted colour can do so; no real colour, of course, will ever exactly correspond to a colour evoked by verbal stimulus.

The analogical relationship between colour and speech, which constantly recurs in any attempt to achieve empathy with the art of Lautrec, is not only characteristic of his treatment of colour but also of the connection between it and his graphic work. Here the links between drawing and colour are obvious. The affinity between line drawing and speech does not need to be recalled. With Lautrec it is particularly close. Some of the effects produced by his graphic shorthand for such things as a frivolous woman's hat, Yvette Guilbert's gloves, the still-life on a restaurant table or an ornamental piece of theatre décor, are, like his colours,

Plates 26, 53, 62

46

comparable with the elemental power of verbal magic – a concentrated vision that always shades off into the fantastic, that is always striving towards a simpler, more directly perceived beauty than can be found in the thing itself. It is comparatively rare and most unusual for a colour to possess a special affinity with the.evocative power of words. In the whole range of expressive media colour, like music, is the furthest removed from conceptual speech.

The aims of Lautrec's use of a colour of that sort are plain enough. They are a means of portraying life. They therefore also aim at psychological portrayal and that includes the dark underside – the threat to life. The techniques of Impressionism were inadequate to convey the oppressive grimness of many of Lautrec's dance scenes – such as that mentioned above – with their implicit *danse macabre* overtones. This side of *Plate 57* Lautrec's art is akin to the spirit of early, 'classical' Expressionism; it borders on the artistic territory of Van Gogh, Munch or Ensor.

If such an important element in Lautrec's art as his handling of colour is so far removed from Impressionism's use of colour, we may ask why, apart from a basic tendency towards realism, he is called an Impressionist at all. There are three reasons – his selection of an unexpected visual angle on the subject which gives the picture its immediacy; his virtuosity in depicting movement; and as a general principle his use of 'shorthand' techniques. These are the obvious characteristics which link him with Impressionism. Today, however, we are more strongly aware of what separated him from the movement, of what made him an outsider. Lautrec's contradictory relationship with Impressionism is particularly clear in his treatment of light. In his pictures there is only one kind of lighting that he reproduces with exactitude, namely footlights. This is often done with great precision, although not in all his stage scenes; he frequently uses no more than a clever device which merely suggests stage lighting, or dispenses with it altogether. Daylight painting in the open air – as in his portraits which he painted in Père Forest's garden, or in his *Plate 20* interiors – is seldom shown as such; it is usually implicit in the general brightness of the colouring.

In this respect Lautrec made no attempt to rival his avowed exemplar, Degas. However much Degas may have liked to keep aloof from the Impressionists, in one thing he was undeniably an impressionist himself, and that was in the way he painted light. He succeeded in uniting a perfection in drawing and modelling figures, inspired by Ingres, with the ability to depict strong light, whether natural or artificial. In doing so his technique went as far as any Impressionist, as in many of his 'foyer de danse' scenes where the figures of the ballerinas simply become shadowy silhouettes against the light, or in his late pastels which are smothered in a welter of hot colour (without, however, sacrificing any of the precision of his highly simplified figures). This overwhelming predominance of

light over the human figure is entirely in the spirit of Impressionism. It is the very *raison d'être* of this style of painting. But it is on this point that Lautrec, whose art concentrates exclusively on human beings, diverges radically from Degas, whatever else may link them – as, in particular, their extremely advanced and eccentric use of space and thus equally unusual composition.

Where, however, similarity of subject-matter results in a likeness between the two artists, this does not necessarily imply an inner relationship or concordance in their art. Above all they did not share the same attitude to people. Uncompromising, merciless objectivity in drawing the human figure is common to both, but when it comes to psychological insight, whether superficial or profound, then their ways part. Degas' cool reserve is contrasted with Lautrec's latent sympathy; he may be astringent and harsh, but never cold and detached as Degas can be.

Different, too, are their attitudes to erotic subject-matter. It has sometimes been said of both painters that in view of the subject-matter of many of their pictures, their treatment of it is singularly unerotic. This is true, although more so in the case of Lautrec than of Degas. In many of Degas' pictures of women bathing or after a bath there is an aura of physical sensuality, of animal beauty, which can certainly be called erotic by comparison with Lautrec's work. It is extraordinary that in his many scenes from dance halls and from the *maisons closes* there is scarcely as much as an undertone of erotic sensuality though this would seem almost impossible to avoid. Physical beauty – even 'the beauty of ugliness' – in the gleaming fleshly glories of naked bathers needs Degas' sort of naturalism to express it; naturalism of this kind was always somehow alien to Lautrec's art, rooted as it is in draughtsmanship. More – his personal graphic language somehow translates everything erotic in his subject-matter into a limbo between dream and reality. It is pointless to attempt to look for the cause of this or ask how far this technique was determined by his personal attitude. As in all great graphic art, form and content are one. Degas' late pastels show a predominance of form over content; the figures are no more than diagrammatic. To see how different the two artists are one need only compare these pastels with one polychrome *Plate 105* lithograph, *Elsa, dite La Viennoise*, one of Lautrec's masterpieces of lithography. However much Degas may surpass nature in the flaming colours of his late pastels, this technique is still bound to the Impressionist way of seeing things and is no more than an extreme heightening of superficial, physical beauty. Lautrec's interpretative technique, in a print such as *Elsa*, is utterly different in kind. The equally great intensity and heightening of colour, which lends this daughter of joy the gentle brilliance of a butterfly's wings, removes this image from reality in a way quite different from Degas, into a region where colour and line combine to suppress any sense of eroticism. This applies to all Lautrec's work:

48

this particular technique tends to neutralise any latent eroticism much more effectively than in his other pictures of women, often caricature-like in their distortion, where he seems bent on purposely making them ugly. (There is a parallel with two earlier artists: Gavarni's portraits of the 'Lorettes' with their gay sensuality, grace and warmth, compared with a man of related temperament – Constantin Guys, who is closer to Lautrec's attitude in this domain; he must have had a considerable influence on Lautrec as a painter of 'manners and morals' although there is no direct evidence of this.)

This is of course only one aspect of Lautrec's interpretative style, which happens to be particularly noticeable in his graphic work. It is instructive to study variants of his graphic technique of the period from the middle of the eighties to the end, with a few examples of their variations in subject-matter.

We have already discussed the early group, with its compact draughtsmanship and its crowded subject-matter, in the illustrations to *Paris Illustré* and to Bruant's songs; mention has also been made of the early lithograph style of the first half of the nineties, the illustrations to *Vieilles Histoires*, *Le Café-Concert* and *L'Escarmouche*, with their richly graduated tonal values of light, half-tone and dark. But this period also produced lithographs such as the stage scenes from *Une Faillite* (1893) and *L'Âge Difficile* (1895) in which his graphic technique is much more sparing, dispensing with pictorial density and painterly contrasts of black and white. Each of the two prints shows the figure of Antoine, making a similar gesture, palely outlined, strongly lit by the footlights, almost dissolved in

Plate 15
Figure 6

Plates 40, 52, 48,
55, 56, 64, 65, 67
Figure 28
Plate 98

Fig. 28. ANTOINE AND LELOIR IN 'UNE FAILLITE'. Lithograph, 1893

49

Fig. 29. MÉNU HÉBRARD. Lithograph, 1894

light. In both prints the figure is contrasted with another; in one case with the dark back view of his partner, in the other with the equally transparent shape of the actress Yahne. Here, the wittily accentuated contrast is provided by the quivering black shapes of her feathered hat, her collar and her little parasol. The difference between the purely graphic structure of these two prints and Lautrec's other, detailed, painterly technique, is paralleled by the difference in the way he presents a theatre scene. In these two scenes the effect of the stage lighting is much more than purely optical; it gives the pictures a magic, visionary quality. (The same quality is in the brush drawing of a stage scene with Lucien Guitry and Jeanne Granier, dated 1895, in which the actor's sinister, beast-like profile is exaggerated by several degrees.) Nothing of this kind was possible with his more detailed painterly technique. In a stage scene such as *Brasseur's Entry in 'Chilpéric'*, for instance, the ridiculous pomposity of the actor's entrance is caught with vicious delight, with the floorboards under the hoofs of his scraggy white horse and with the limelight highlighting the comic absurdity of the actor's expression; the scene of *Madame Caron in 'Faust'* is as funny as a parody of an opera. This spare, slightly caricature-ish style is also found in some of his autograph drawings where it produces an even stronger effect than when it is transferred to lithography. But in a print such as the *Ménu Hébrard* it is also used with unabated vigour. This has – which is rare in Lautrec – a cutting, sarcastic bitterness which prefigures much that is found in the graphic art of the twentieth century, such as the imitation of children's drawings that is used with the same diabolical ferocity as many present-day cartoonists. This style of drawing is also to be found in places in the scenes from the trials of Arton and Lebaudy.

Another kind of graphic expression is found in drawings such as *A Arménonville* or the drawings for *Le Rire*, for example '*Chocolat*' dancing

Plate 87

Plate 78

Figure 29

Figure 20

Plates 89, 94

50

in the bar and the posters for *L'Artisan Moderne* and *Simpson's Bicycle Chains*. A curious severity and a rather dry use of line are their distinguishing characteristics and make this perhaps the most unusual and most personal – also the most mysterious – of all Lautrec's graphic styles. The powerful effect of this astringent, ascetic technique almost eludes definition. In his painting, a picture which obviously shares this quality is *La Goulue at the Moulin Rouge* of 1891. No draughtsman's tricks of abstraction or shorthand are used, but the picture has that same oppressive chill. The humanity of the subject is muffled and suppressed and although the figure is depicted plainly enough its message is less a human one than one of emotion aroused by the mystery of human nature (which is not necessarily a gloomy or melancholy emotion).

Figure 12

Plate 42

Many drawings and paintings of the last years of his life show a striking change in Lautrec's art. In his graphic work it is chiefly evident in the cycle of thirty-nine scenes on the theme of 'The Circus', which Lautrec drew in hospital at Neuilly-sur-Seine in the spring of 1899. These drawings are in various media, mainly coloured chalks. Several of these drawings depict objects in a grotesquely unreal manner and all of them are executed in a style which makes them completely unlike a real circus. Only a very weird circus could have produced this curious set of *artistes* rehearsing and performing their tricks. The strange and problematic character of these drawings has always been felt by sensitive observers – in the introduction to the first folio of reproductions of the drawings Arsène Alexandre felt obliged to defend them against the accusation that the artist was mad – but most people have been too easily satisfied with the two rather superficial explanations that have been put forward. The first is that Lautrec drew these scenes completely by heart and without using preliminary sketches. This is said to be the reason for the many unnatural proportions in his human and animal figures and in his treatment of space. The other reason was said to be the artist's nervous condition, which was held responsible for these same distortions, because his usual expertise in handling figures and spatial relationships seems to have deserted him.

Plates 114, 120, 121

Figures 30, 31

Neither of these explanations need be totally rejected, yet neither are by any means entirely satisfactory. Lautrec's creative method, which was so closely bound up with his immediate sensory perception of reality, was faced with a task as difficult as certain of the illustrations and jacket designs. These circus drawings were even more difficult, at least when it came to handling space, because of the extraordinary difficulty in finding a means of showing a section of the circus-ring in perspective. Many of the drawings show a piece of the ring and in these smooth curves, above all when a *flat* section of the ring is chosen, Lautrec expresses an intensity of movement which far surpasses the purely illustrative function of showing a portion of the edge of the ring. But these curious effects do not

Fig. 30 and 31. THE REHEARSAL; PAS-DE-DEUX. Two drawings from the 'Circus' cycle. 1899

Figure 30

merely result from a failure of the artist's optical memory; artistic factors are, of course, in play as well. These curves have an expressional function of great intensity and are often the only aids to spatial illusion. It would be equally wrong to explain away the disproportion in the figures as due to purely non-artistic causes. It should not be necessary to point out that there is a valid artistic intention behind the bizarrely misplaced proportions in a drawing such as the girl practising her riding. Even the horse is strangely proportioned and becomes a colossal beast surmounted by the unproportionally small figure of its rider. Most of the horses depicted in these pages are enormous, yet even the riders, small in relation to the animals, seem like giants.

Quite as marked as these peculiarities is the style of drawing, above all the strong plasticity and deep shadows of all the individual figures. Their outlines are compact and stand out firmly against the blank whiteness of foreground and background. It gives the impression that the individual figures as well as the composition is only being held together by a con-vulsive effort.

In this sense Lautrec's derangement is acceptable as an explanation: in this difficult exercise in figure composition he saw the means of tackling a crisis which was artistic as much as nervous and of combating the threat of insecurity and instability which is detectable in two or three drawings which he completed shortly before his stay in the sanatorium. One of these is the lithograph with the parrot and the dog, dated 8th February 1899. It shows the traces which drunkenness and illness left in Lautrec's work and

this cycle of 'Circus' drawings illustrates the means with which he tried to resist them. But even these means had an artistic root. Earlier in this study, the print of the woman lying in bed from the *Elles* portfolio was cited as an example of this peculiar form of figure-drawing. In the 'Circus' series these peculiarities are even more strongly marked. The figures bulk much more sharply against the yawning emptiness of the surrounding space and this gives the figures a sense of pitiless isolation which, expressed in many different ways, is profoundly characteristic of Lautrec's figure treatment. Linked with this is the sense of demonic strength which Lautrec gives to the surrounding space. This can be gauged by comparing these drawings with the exaggerated treatment of real space in the galloping perspective of racing jockeys in the lithograph *The Jockey* of 1899. Many of the figures in the 'Circus' series seem to be saturated with shadow and where the shadowing is particularly strong the figures often appear to merge together. With these dark areas and with the tense, strained curves he creates a graphic structural pattern of an intrinsic formal quality the like of which is scarcely found anywhere else in Lautrec's drawing. The quality of this work is significant; the necessity of drawing freehand from memory might so easily have resulted in a purely sterile play with the elements of graphic technique, but instead the compulsion drove Lautrec to a peak of mastery of a particular aspect of his graphic style.

Plate 122

These drawings also represent the ultimate products of his fantasy. Nowhere else in Lautrec's work, or at least not to such an over-mastering degree, is there so much that is grotesque, distorted and sinister. There is something nightmarish in the grim solemnity of the riding act and its monstrous horses, haunted by menacing clowns. It often seems as if the outwardly rigid features are shuddering, as in certain exotic dance movements where the dancer is twirling round so fast that he appears to be still. One cannot avoid the comparison with the hallucinatory visions in the most fantastic of Goya's etchings. These circus scenes are Lautrec's 'Proverbios'. It is not improbable that recollections of Goya played some part in the creation of these drawings. Lautrec, by the way, did a lithograph jacket-design for a volume of Goya's etchings *The Disasters of War*.

The 'Circus' series has much in common with the rest of Lautrec's work. The dark grounds from which their grotesque, sinister vitality emerges is used in earlier works, but its intensity is something new and unusual. These drawings are perplexing not only because of their subject-matter but because they are so very different in kind. Many of the qualities of the earlier works have been lost, the total effect is uneven, There is a lack of that fascinating tension between form and content which brought a realistic art such as Lautrec's to its height. Their exceptional nature is also shown by the fact that Lautrec did not keep to this style for long; it was not the ultimate wisdom that crowned his career. From it he moved on to what was to be a short-lived, magisterial calm, more marked in his paint-

ing than in his drawing, in a series of large, monumental paintings. This series, small in number, of pictures from the last two or three years of his life, is very varied in kind and quality. 1899 was the year of the portrait of the *Englishwoman from the 'Star' at Le Havre*, bright and sparklingly alive, graced with all the brilliance of his careful painterly composition. A little later – in 1900, according to Joyant – Lautrec painted another of his best portraits, the portrait of a gentleman (which is now in Munich) in dark, heavy colours with an effect of apparent exaggeration to more than life-size which recalls certain portraits by Van Gogh. This picture, too, is highly disciplined and subtle in its painterly execution (as is the big 1899 lithograph of the two galloping jockeys – probably later than that sinister, fluttering drawing *Parrot and Dog* – and his last poster, for *La Gitane*, done in 1900, whose composition and detailed execution are indissolubly fused). Among the weaker, obviously faltering pictures of this group of monumentally simplified paintings, a few more important and extremely strange works stand out, above all the stage scenes from *Messalina* in the Bordeaux Opera; *The Violinist Dancla*; three scenes with figures, painted in the Bois de Boulogne; the *Examination at the Medical Faculty of Paris*, and a few portraits – *André Rivoire*, *La Modiste* (*Mademoiselle Margouin*) and the large unfinished portrait *Viaud as an Admiral*.

Facing page 18

Plate 110

Figure 10

Plate 124

Plate 123

It is clear that these monumental works owed much to several of the violent, powerful compositional ideas in the 'Circus' drawings and that the calm of this final period contains an element of inhibiting numbness. Indifference to certain of the visual delights which attracted him in the past is apparent. In these pictures of massive, looming figures in silhouette there is no room for the exuberant play of brilliant linear structure and movement. There is a certain sense of finality about them. With an odd pathos, with scarcely a flicker of sarcasm, but on a note of tragedy his life's work came to an end – or rather, this note, which had always been there, rang out louder at the end.

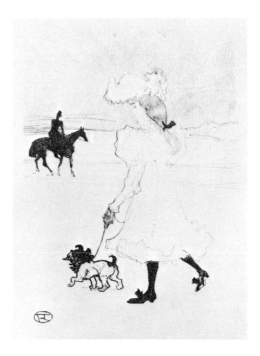

Fig. 32. GIRL WITH DOG
('AU BOIS').
Lithograph, 1897

The Illustrations

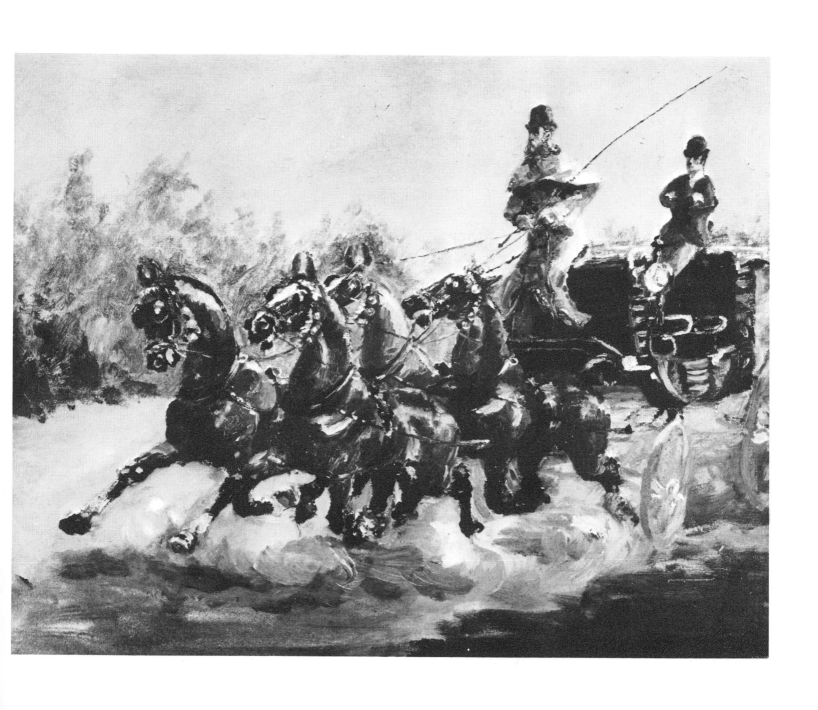

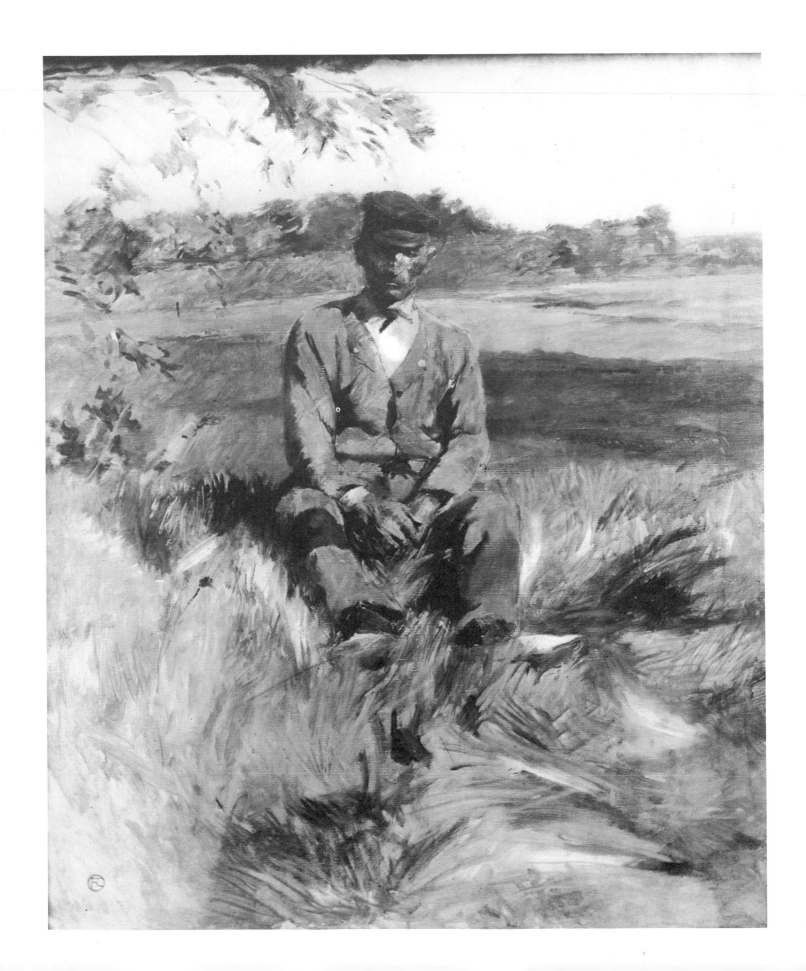

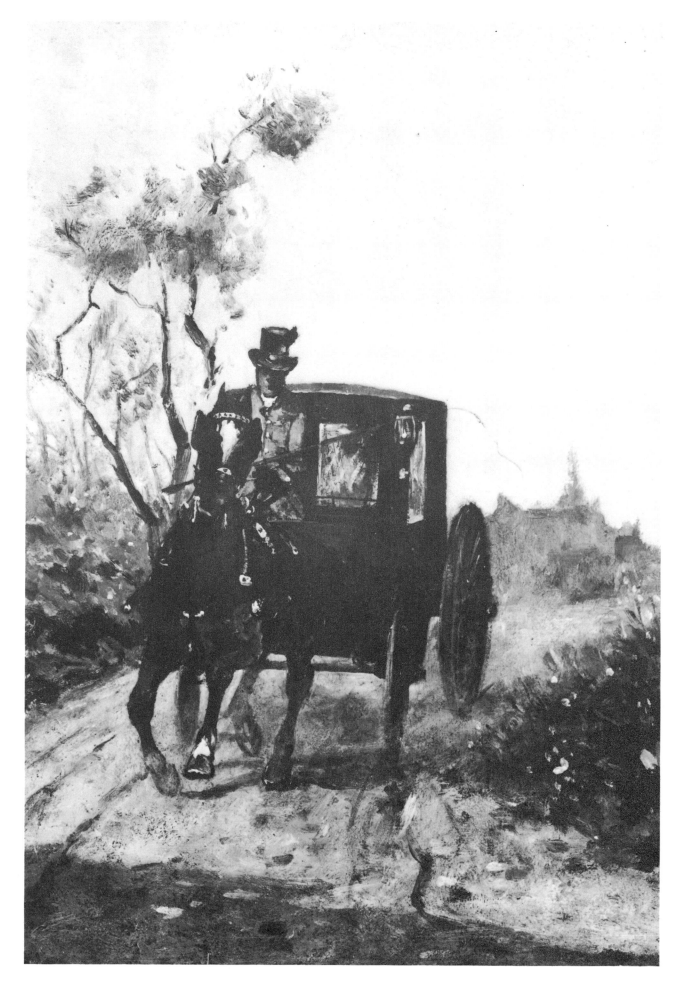

3. COACH AND HORSE. c. 1881. Philadelphia, Mr. and Mrs. William Coxe Wright

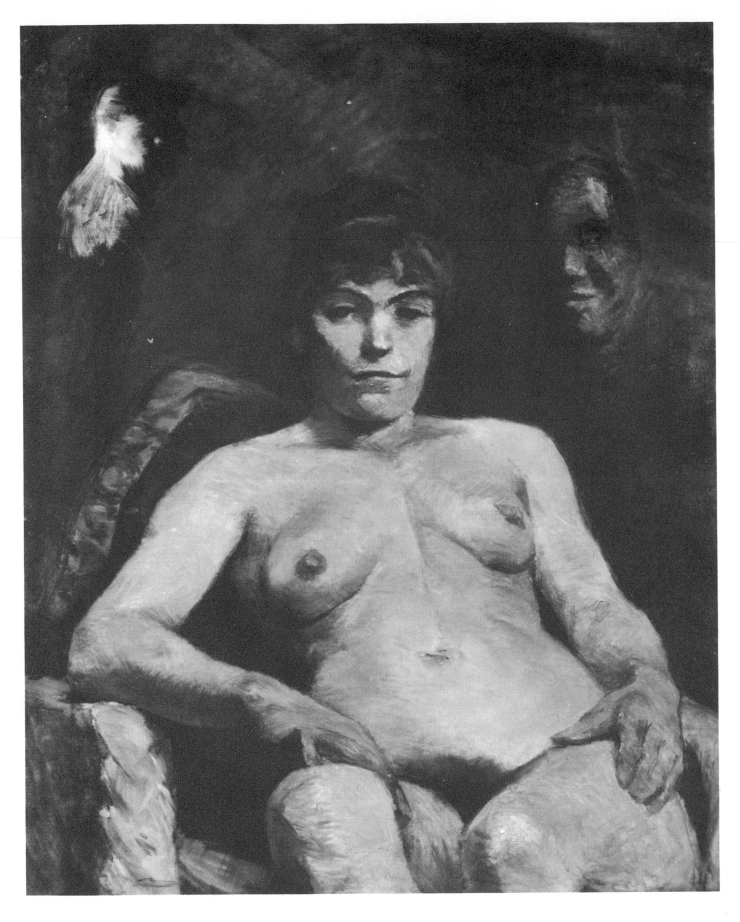

4. FAT MARIA ('LA GROSSE MARIA'). 1884. Wuppertal, Von der Heydt-Museum

5. THE ARTIST'S MOTHER AT BREAKFAST. c. 1883–4. Albi, Musée Toulouse-Lautrec

6. THE ARTIST'S UNCLE, AMÉDÉE TAPIÉ DE CÉLEYRAN. Drawing, 1883. New York, Slatkin Galleries

7. GIRL IN THE ARTIST'S STUDIO. HÉLÈNE V. 1888. Bremen, Kunsthalle

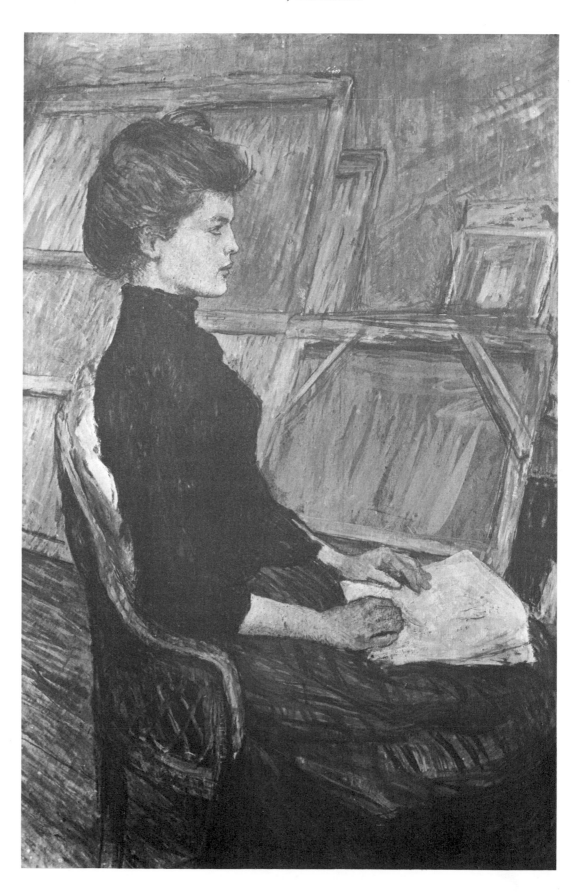

8. THE LAST FAREWELL ('LE DERNIER SALUT'). Drawing, 1887. Albi, Musée Toulouse-Lautrec

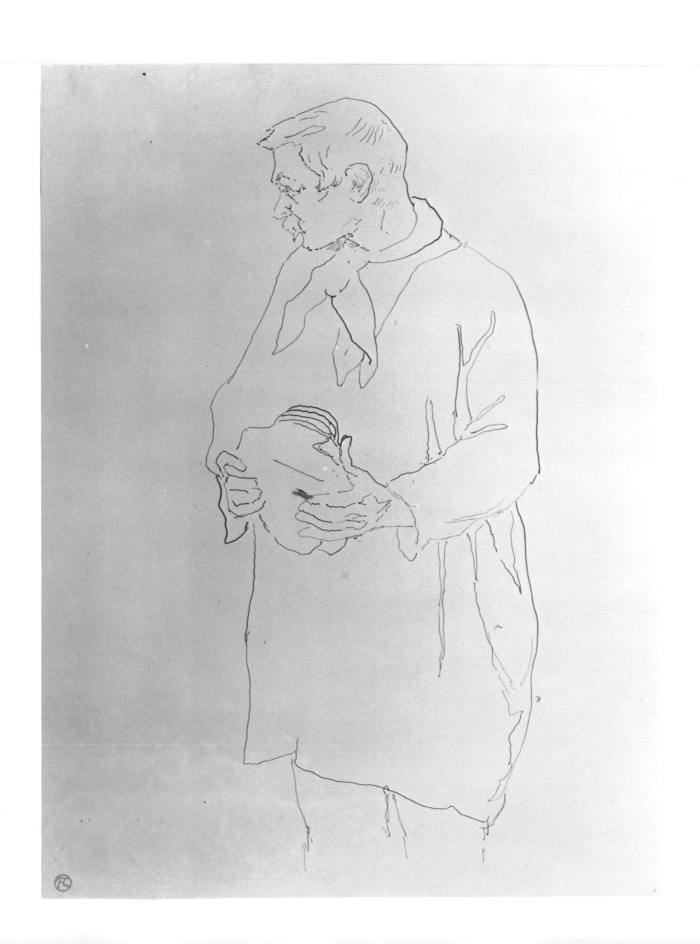

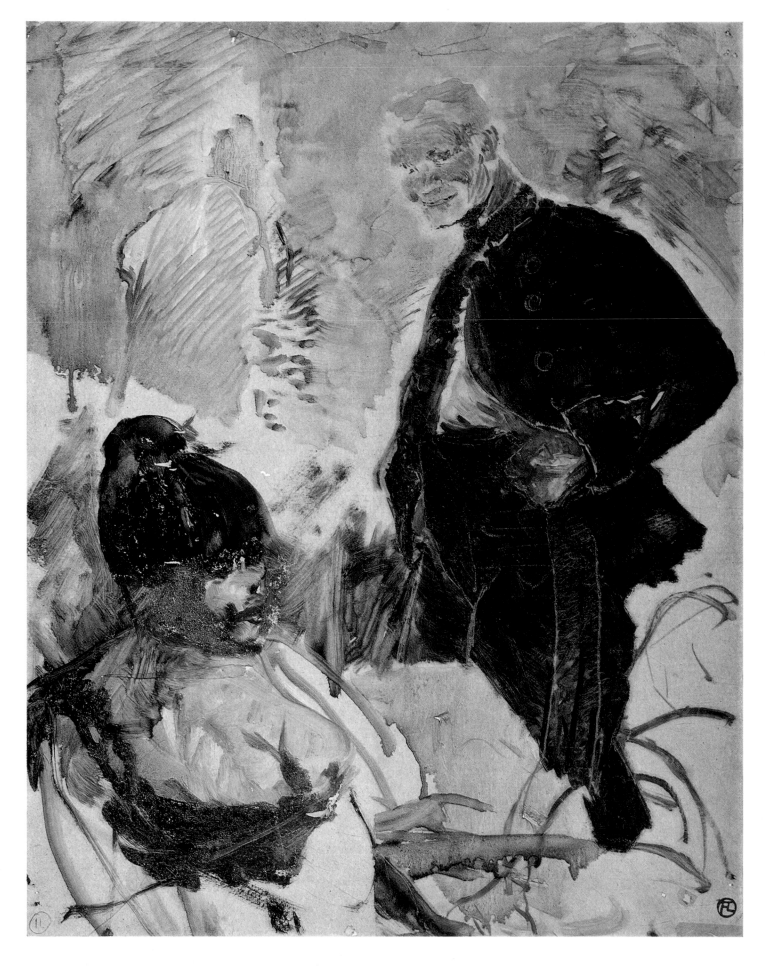

9. ARTILLERYMAN AND GIRL. c. 1886. Albi, Musée Toulouse-Lautrec

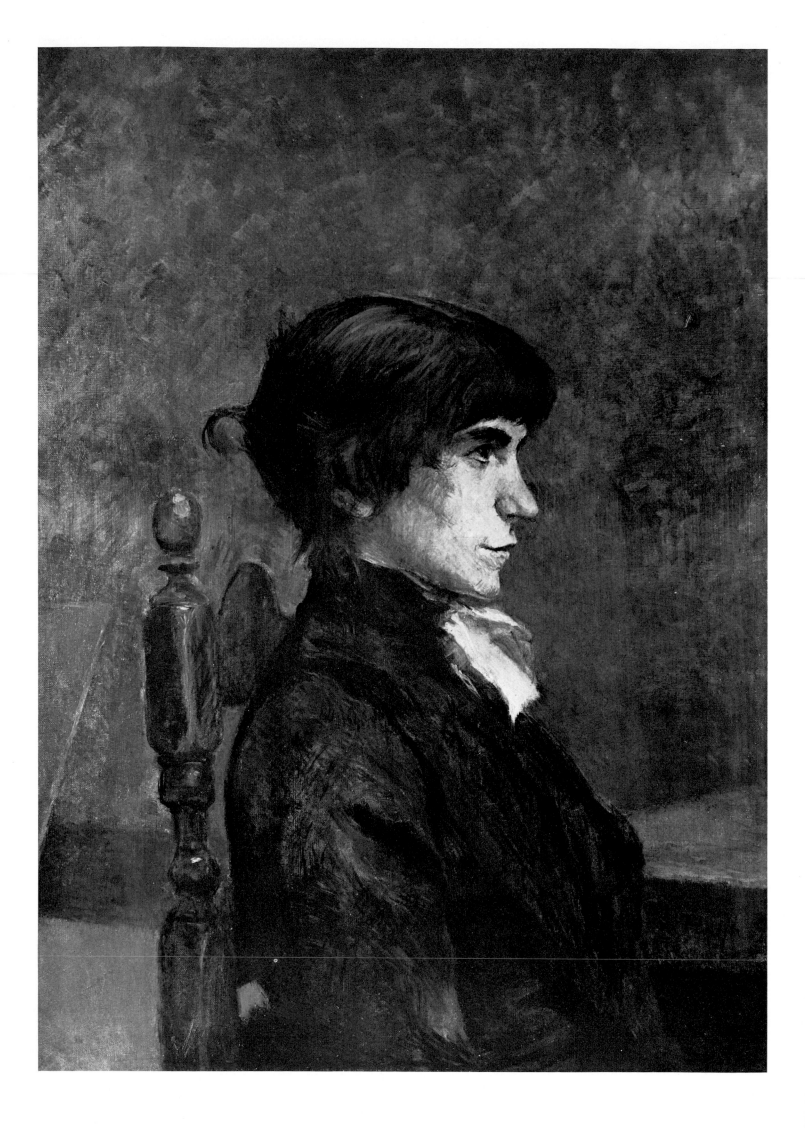

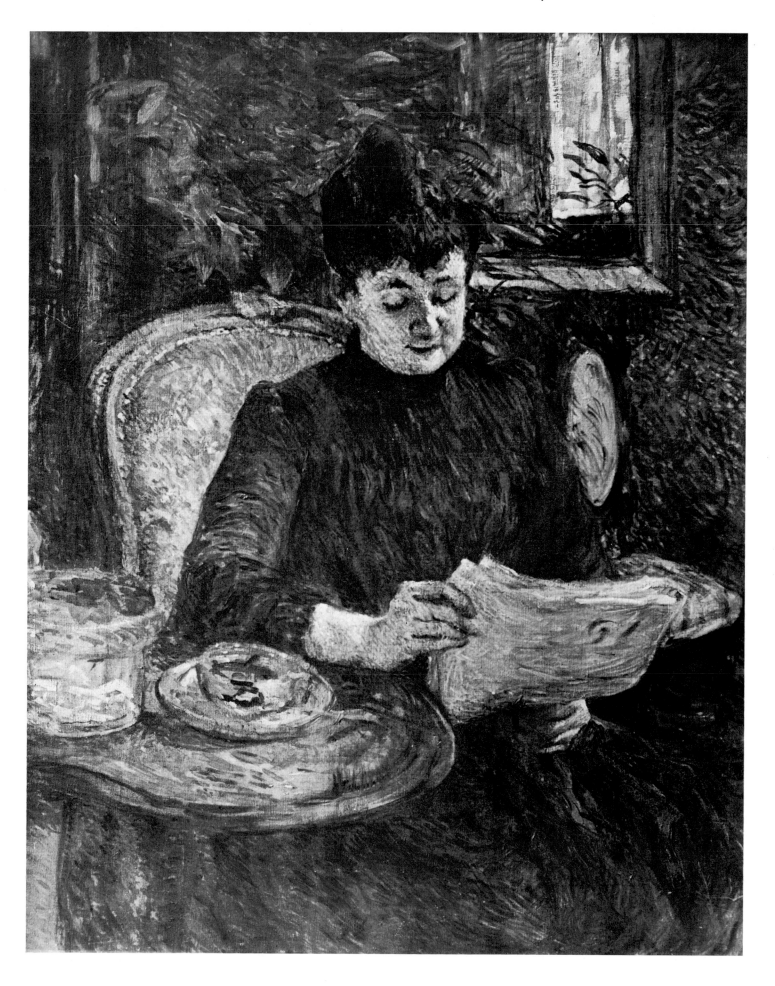

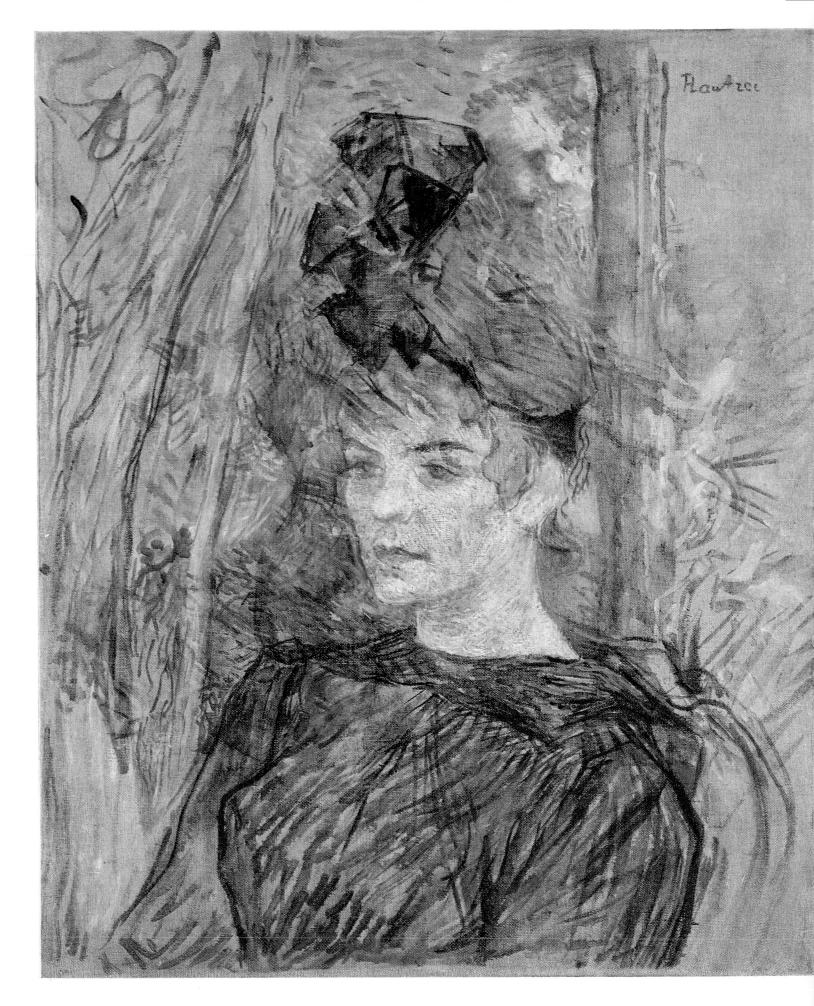

12. SUZANNE VALADON. 1886. Copenhagen, Ny Carlsberg Glyptotek

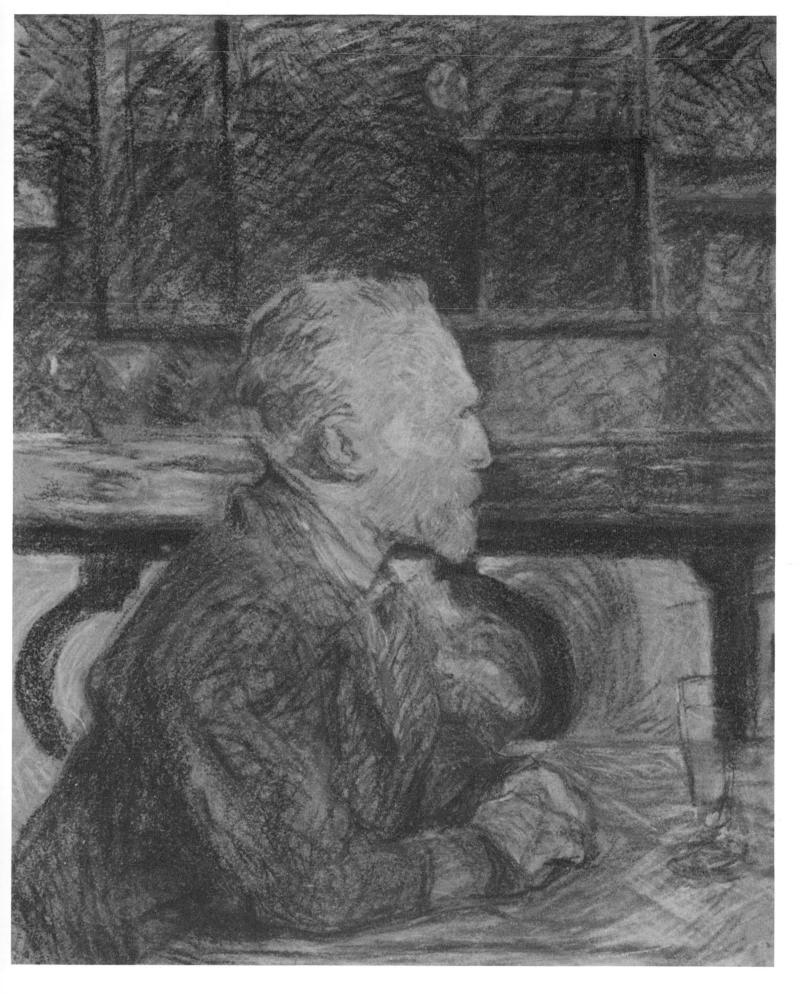

13. VINCENT VAN GOGH. Pastel, 1887. Amsterdam, Stedelijk Museum

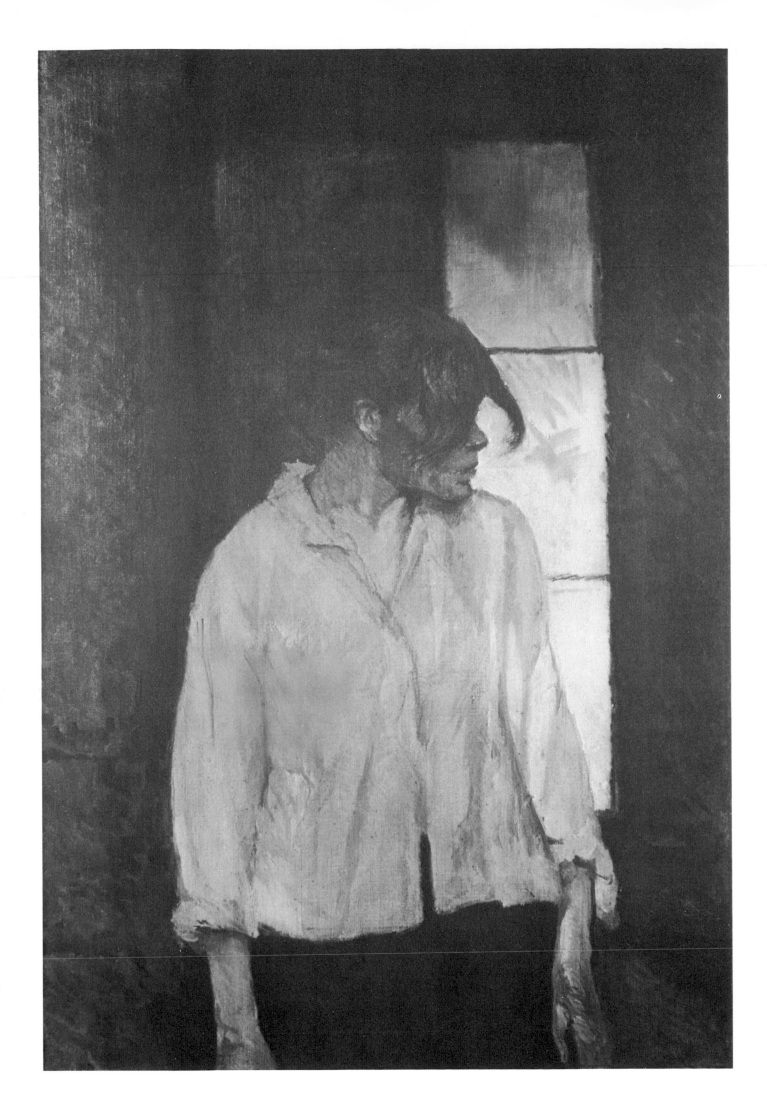

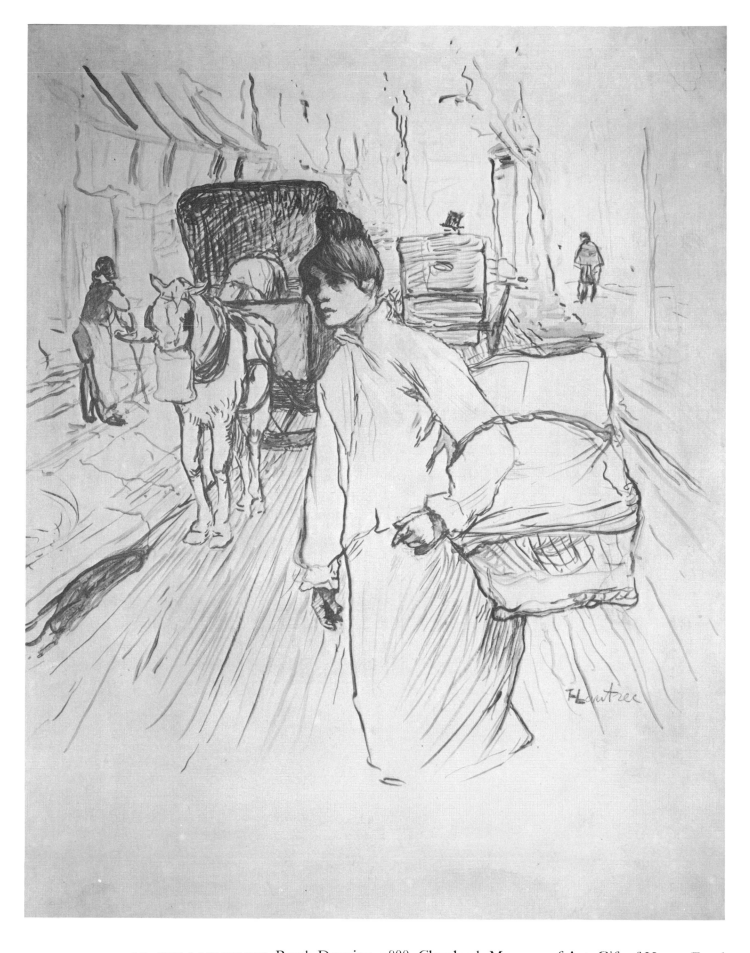

15. THE LAUNDRESS. Brush Drawing, 1888. Cleveland, Museum of Art, Gift of Hanna Fund

14. 'À MONTROUGE. ROSA LA ROUGE'. 1888. Merion, Pa., Barnes Foundation

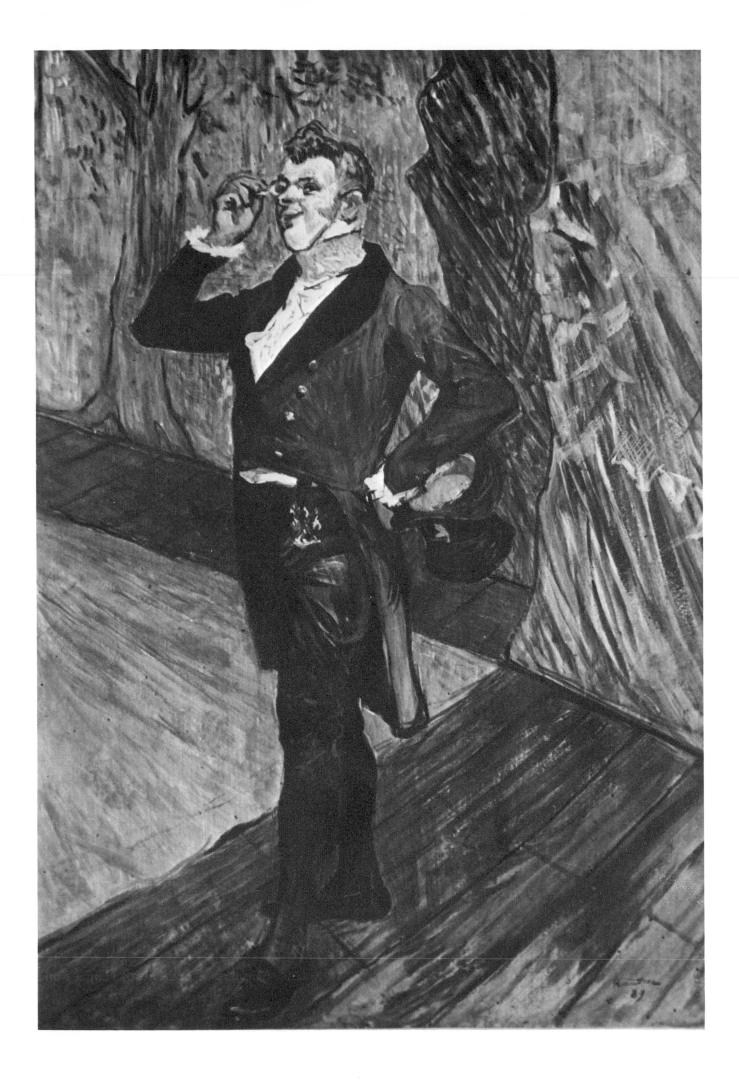

16. PORTRAIT OF HENRI SAMARY. 1889. Paris, Jacques Laroche

17. SELFPORTRAIT. Caricature Drawing, c. 1890. Rotterdam, Museum Boymans-van Beuningen

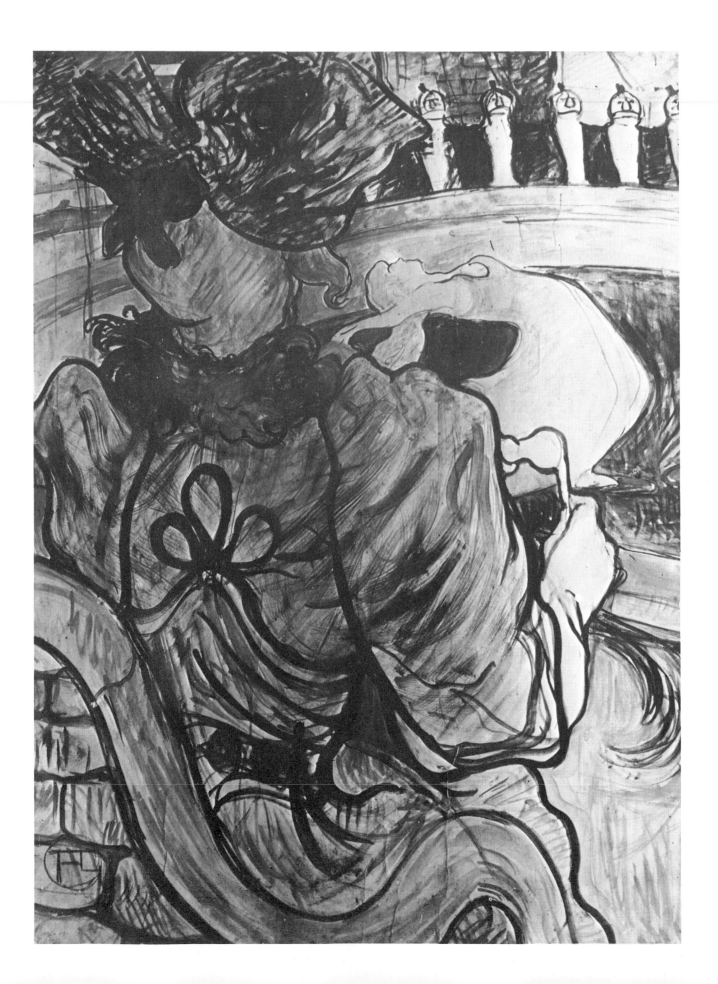

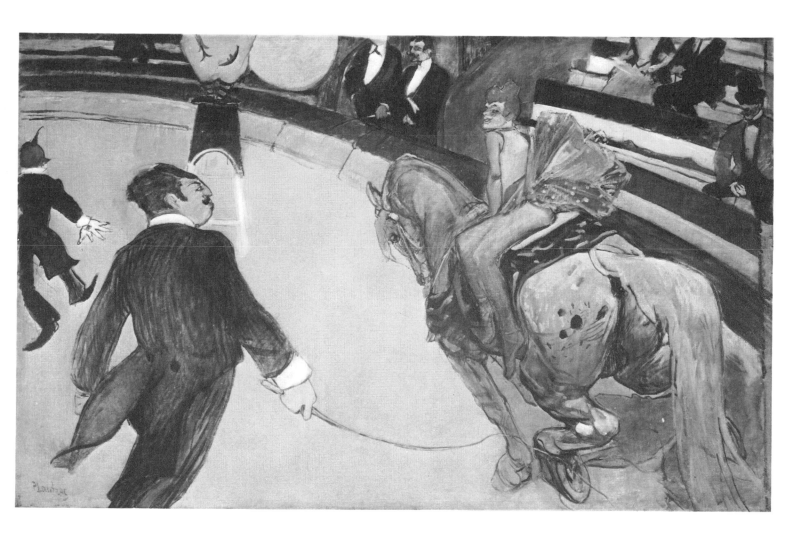

19. IN THE CIRCUS FERNANDO: THE RINGMASTER. 1888.
Chicago, Art Institute, Joseph Winterbotham Collection

18. AT THE NOUVEAU CIRQUE: FIVE STUFFED SHIRTS. 1891. Philadelphia, Museum of Art

20. DÉSIRÉ DIHAU READING IN THE GARDEN. 1891. Albi, Musée Toulouse-Lautrec

22 STUDY FOR THE POSTER 'MOULIN ROUGE'. Drawing, 1891. Albi, Musée Toulouse-Lautrec

23. MOULIN ROUGE – LA GOULUE. Poster, 1891

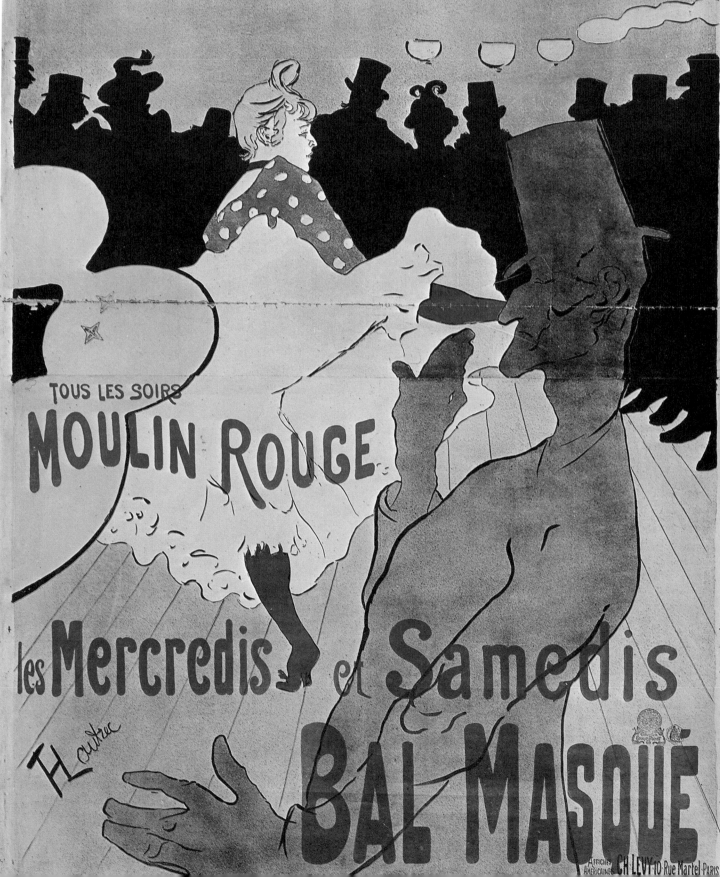

24. GIRL ARRANGING HER HAIR. 1891. Present whereabouts unknown

25. IN BED. 1892. Paris, Maurice Exsteens

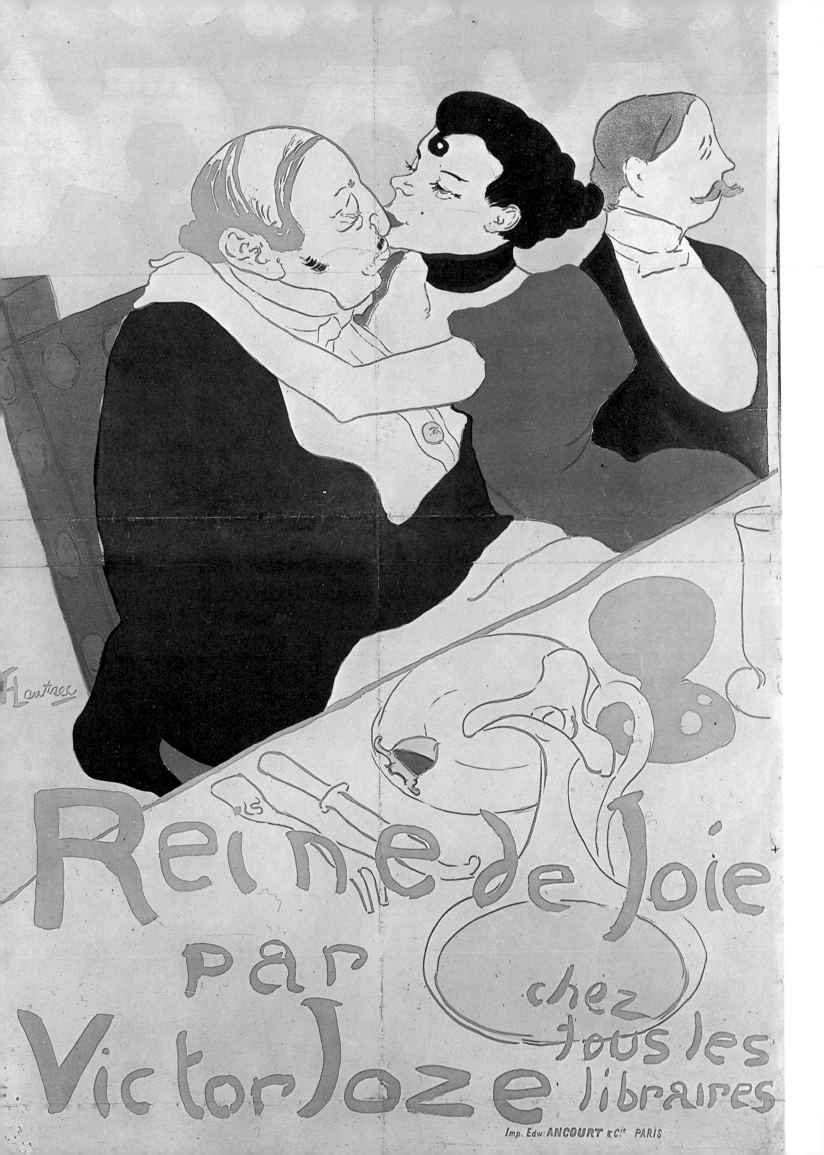

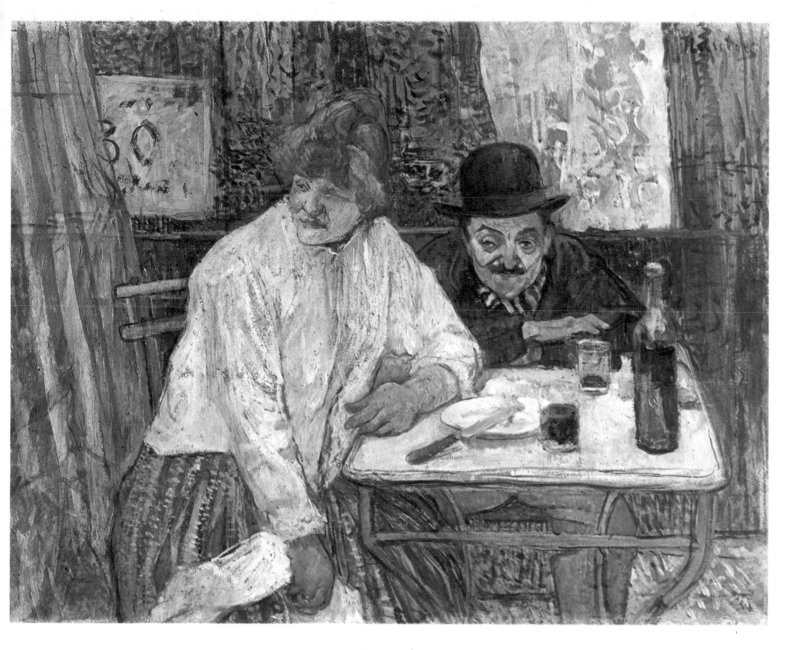

27. 'À LA MIE'. 1891. Boston, Museum of Fine Arts

26. 'REINE DE JOIE'. Poster, 1892

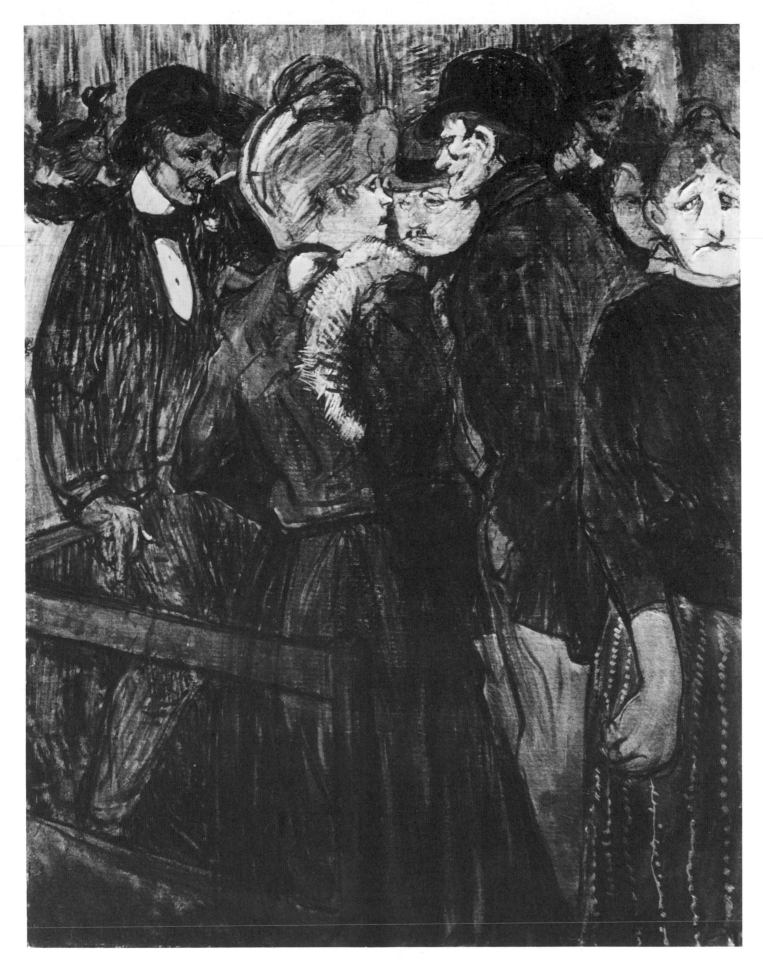

28. AT THE MOULIN DE LA GALETTE. 1891. Amsterdam, Stedelijk Museum

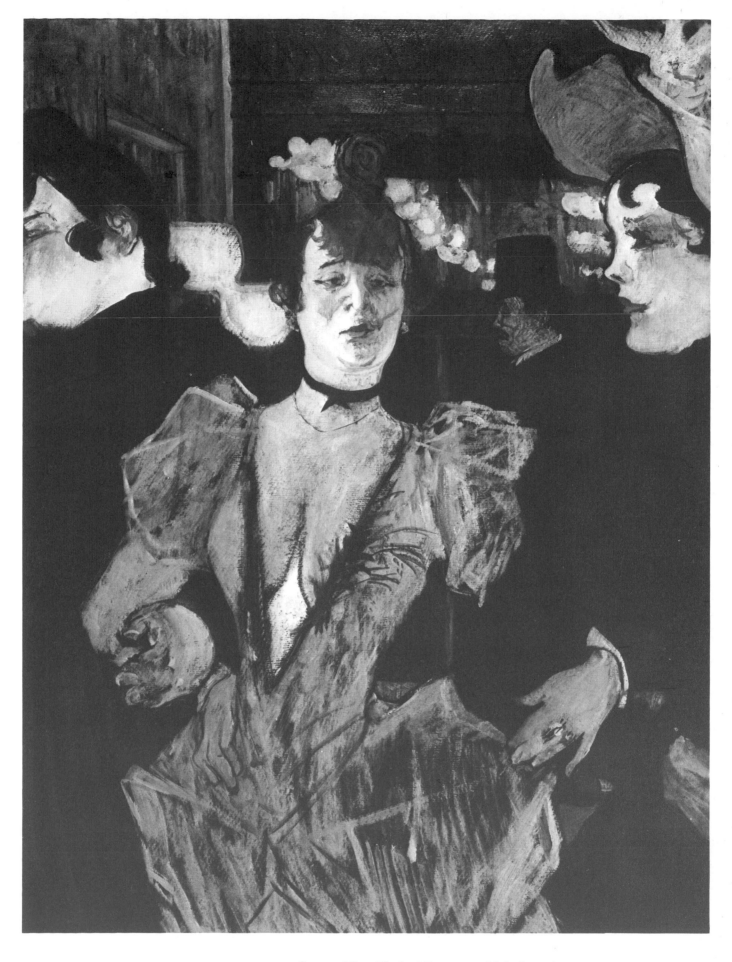

29. LA GOULUE AT THE MOULIN ROUGE. 1891–2. New York, Museum of Modern Art

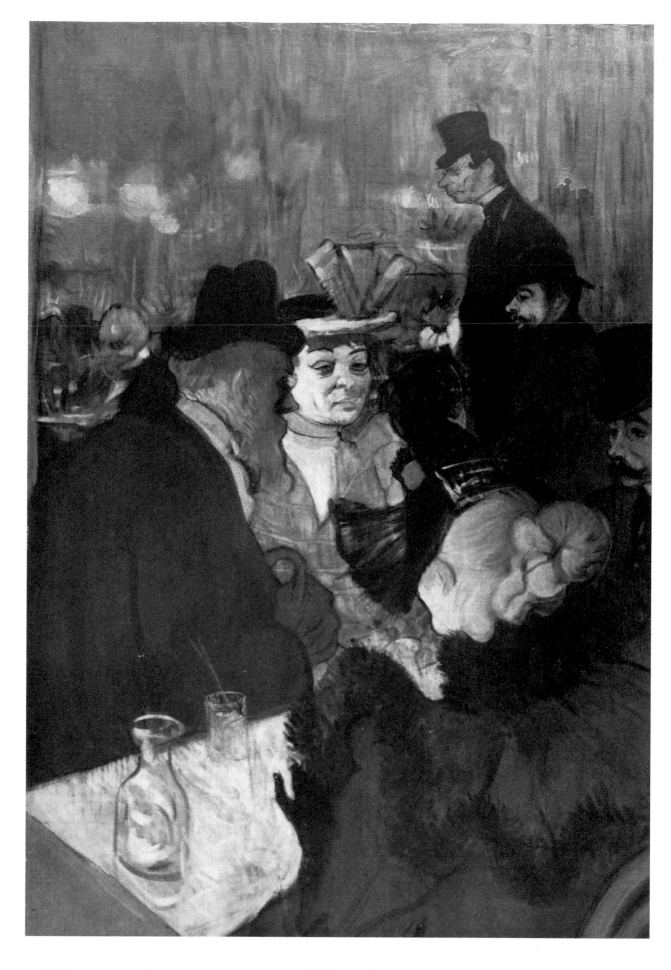

31. DETAIL FROM 'AT THE MOULIN ROUGE' (Plate 32)

30. 'DIVAN JAPONAIS'. Poster, 1893

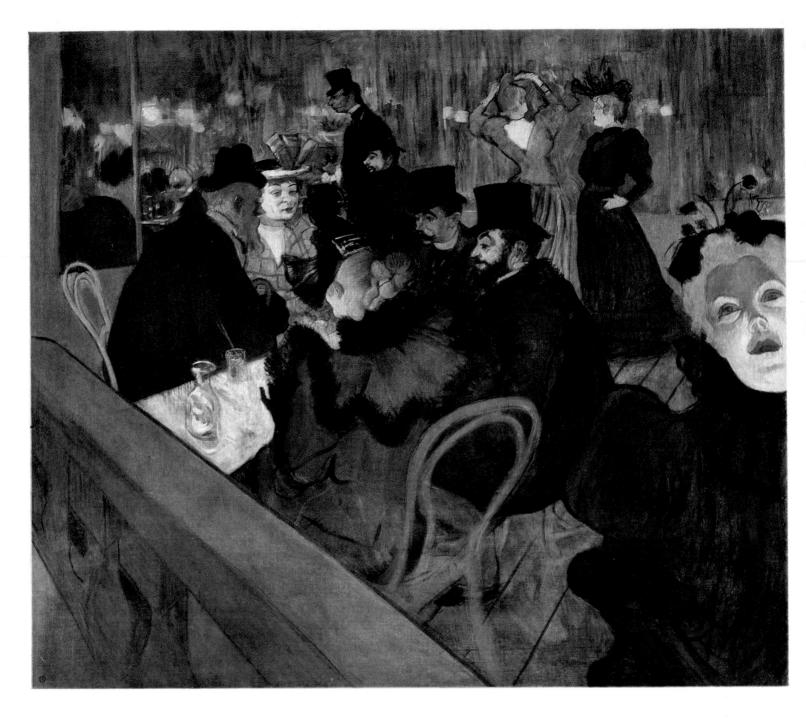

32. AT THE MOULIN ROUGE. 1892. Chicago, Art Institute, Helen Birch Bartlett Memorial Collection

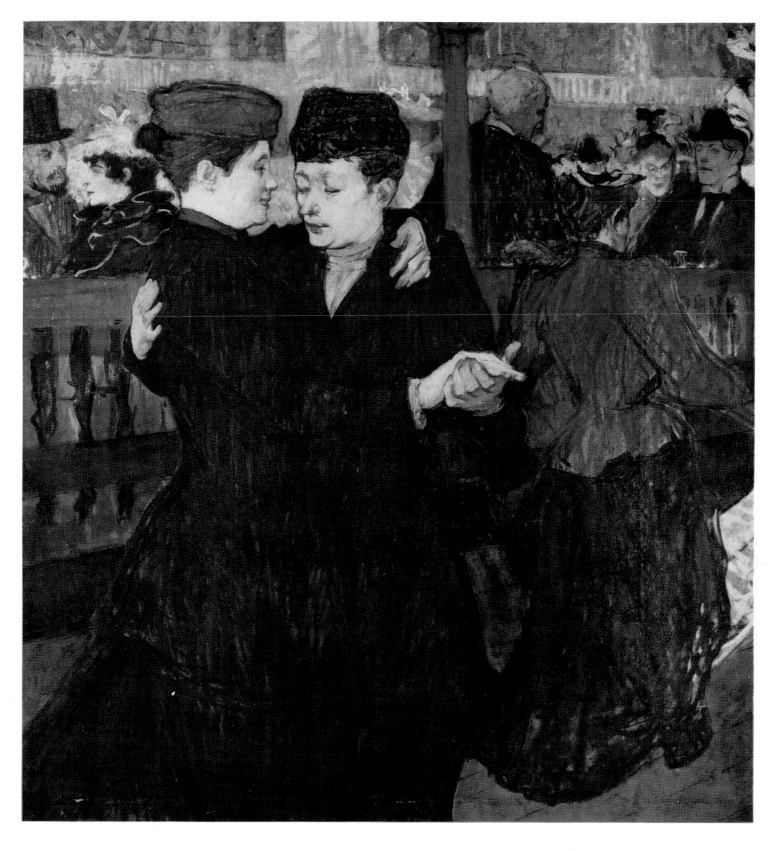

33. DANCE AT THE MOULIN ROUGE. 1892. Prague, National Gallery

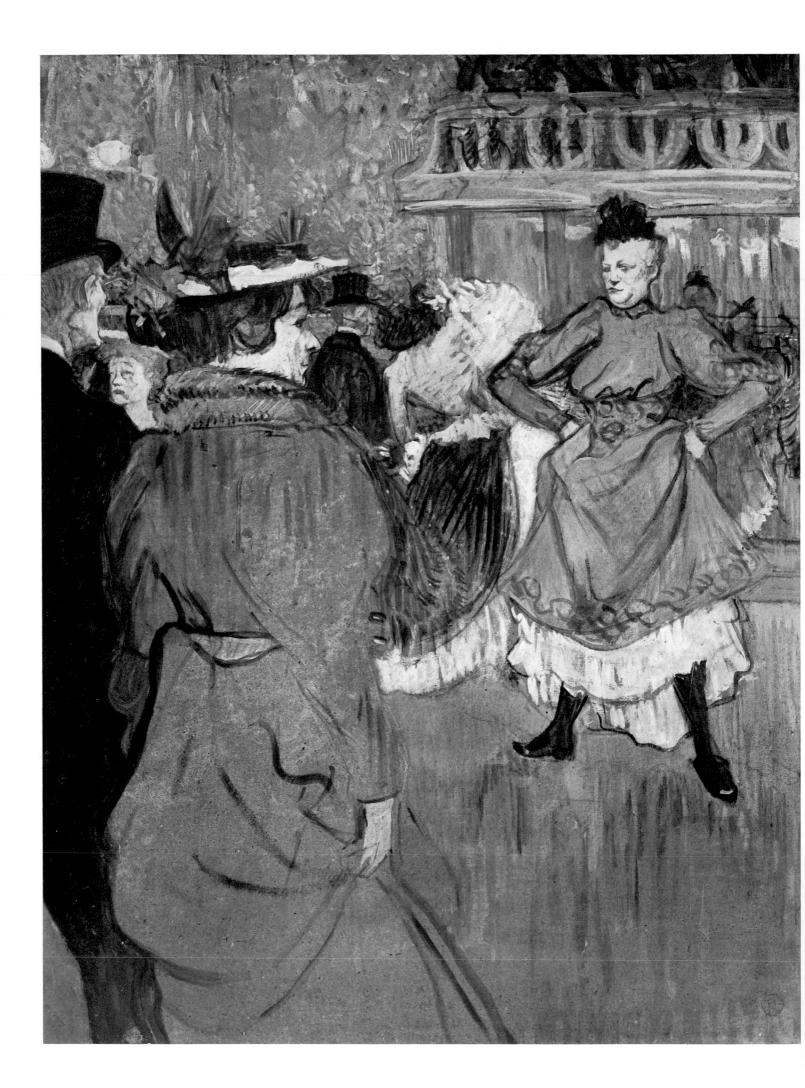

35. LA GOULUE AND HER SISTER. Lithograph, 1892

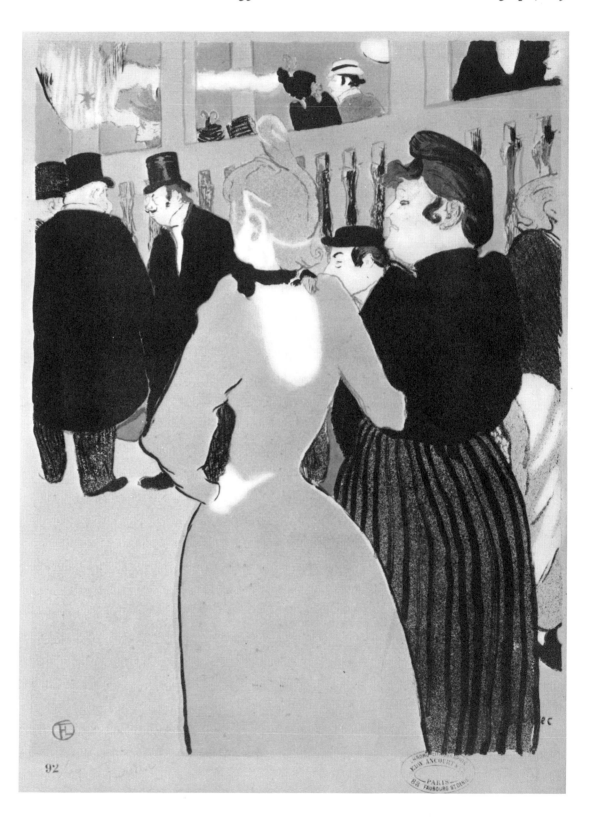

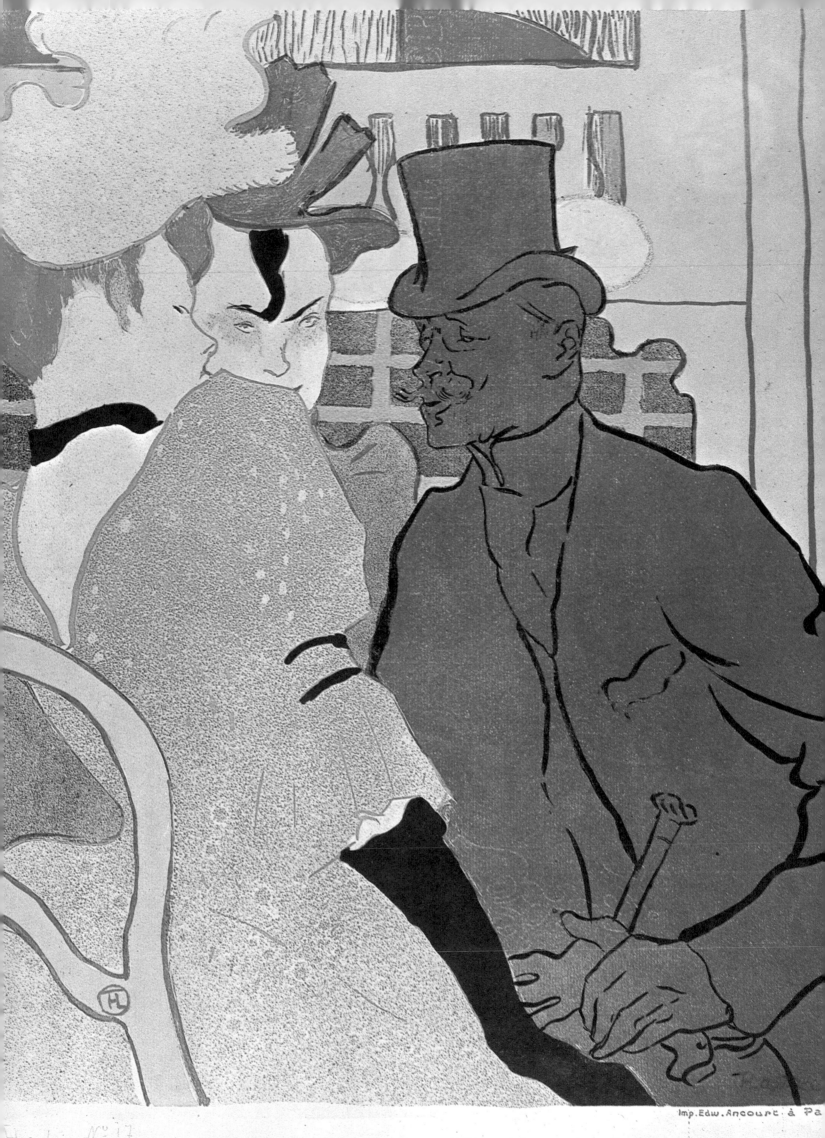

37. HEAD OF THE ENGLISHMAN AT THE MOULIN ROUGE. 1892. Albi, Musée Toulouse-Lautrec

36. THE ENGLISHMAN AT THE MOULIN ROUGE. Lithograph, 1892

38. PORTRAIT OF PAUL SESCAU. 1891.
New York, Brooklyn Museum

JANE AVRIL, DANCING. C. 1892.
Paris, Louvre

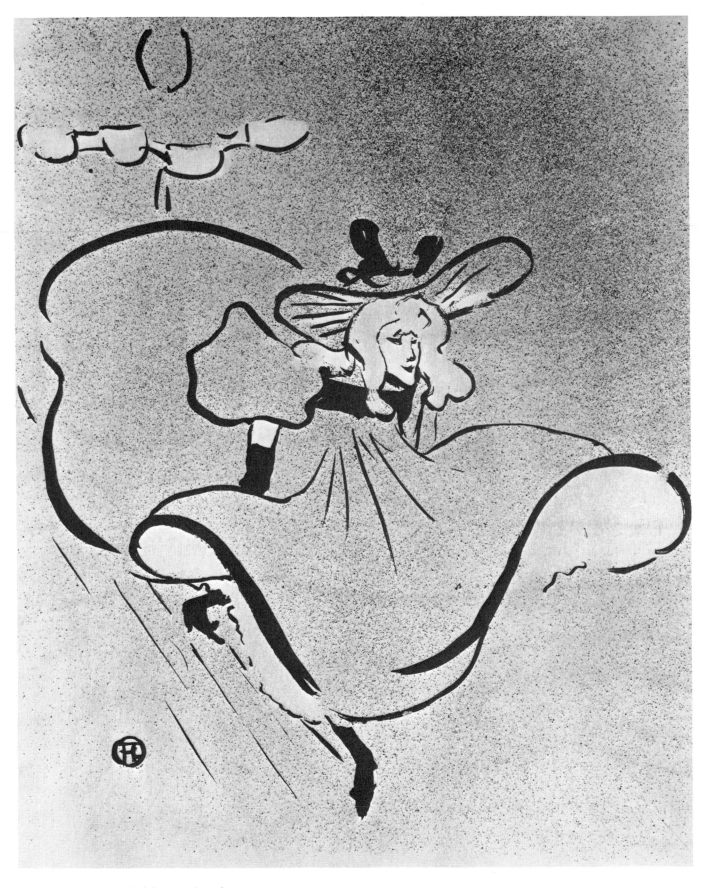

40. JANE AVRIL. Lithograph, 1893

41. LOÏE FULLER. Lithograph, 1893

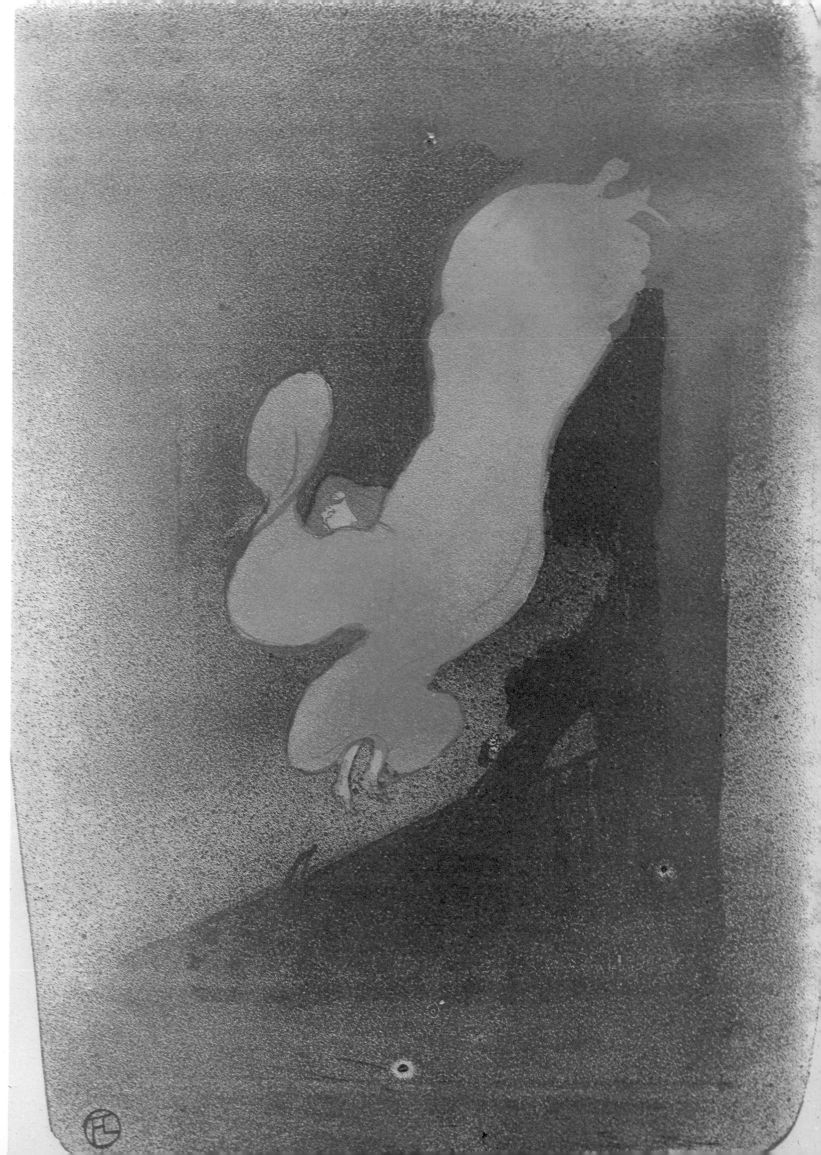

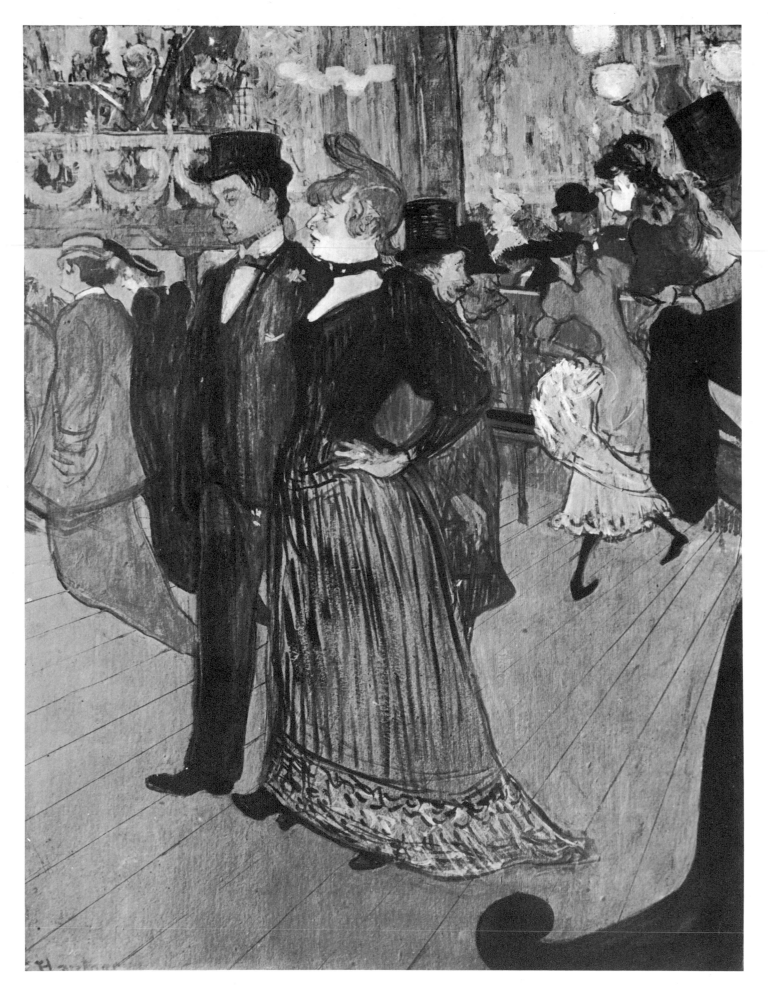

42. PROMENADE IN THE MOULIN ROUGE. 1891. Present whereabouts unknown

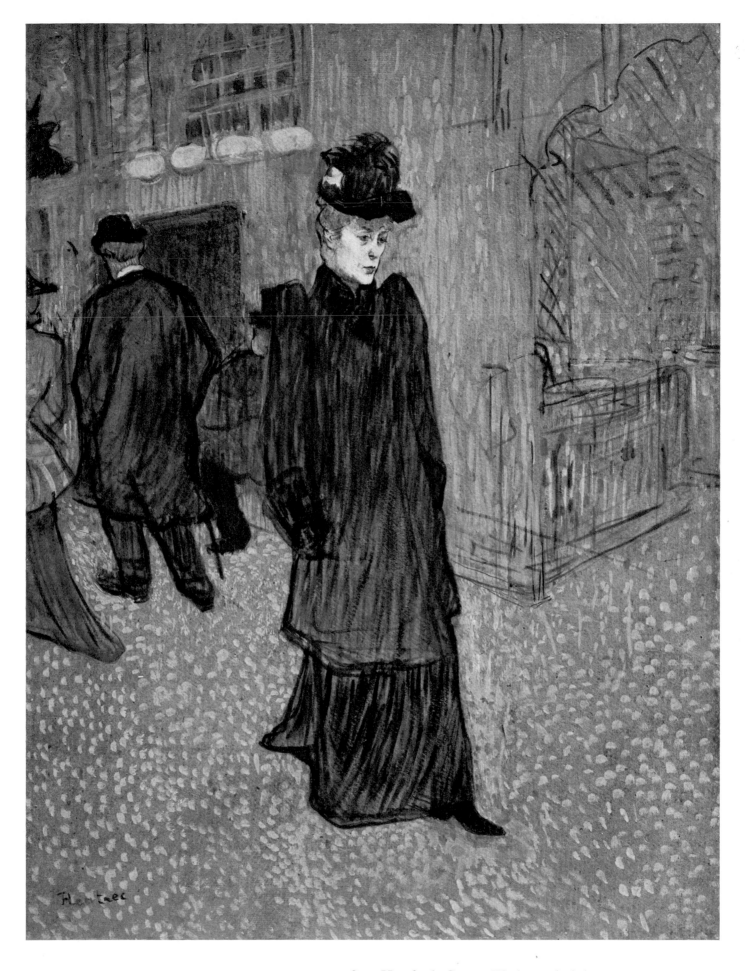

43. JANE AVRIL LEAVING THE MOULIN ROUGE. 1892. Hartford, Conn., Wadsworth Atheneum

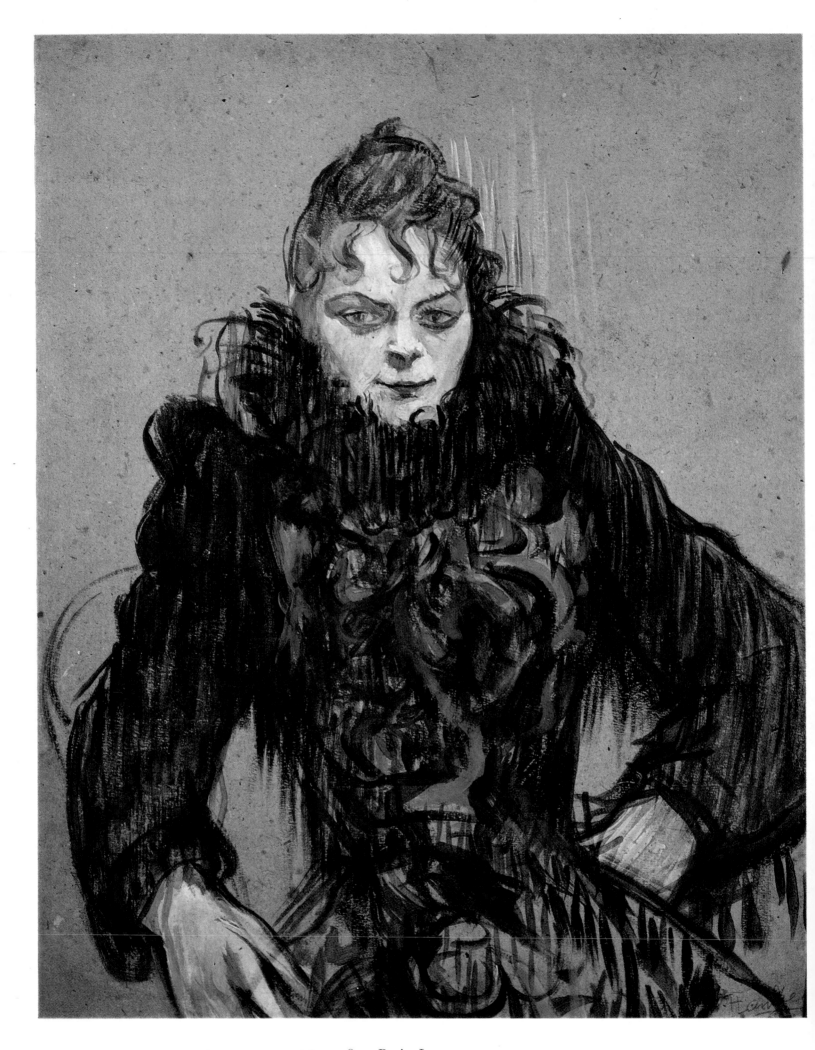

44. WOMAN WITH A BLACK FEATHER BOA. c. 1892. Paris, Louvre

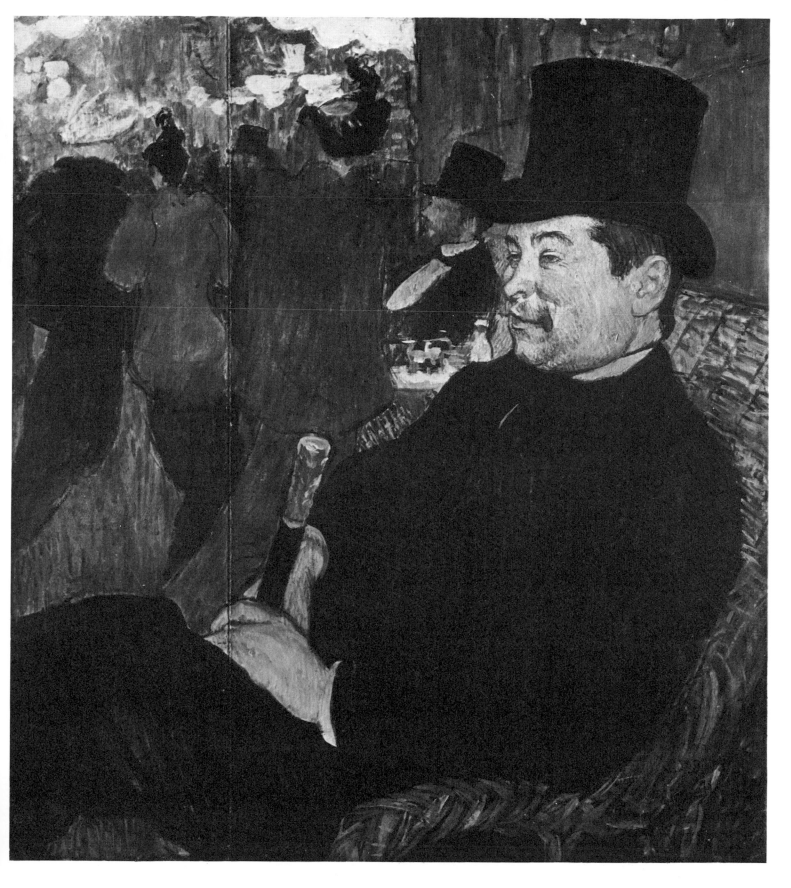

45. PORTRAIT OF M. DELAPORTE. 1893. Copenhagen, Ny Carlsberg Glyptotek

46. THE LAST JOURNEY ('ULTIME BALLADE'). Lithograph, 1893

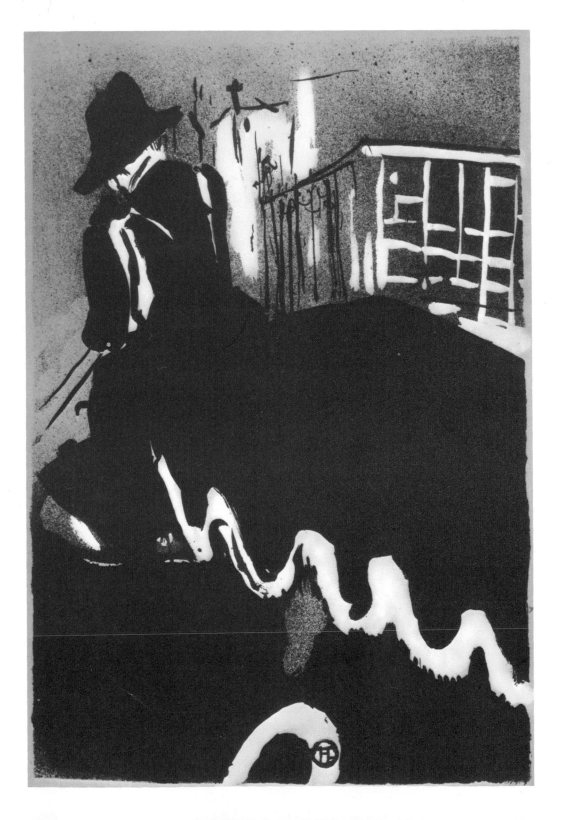

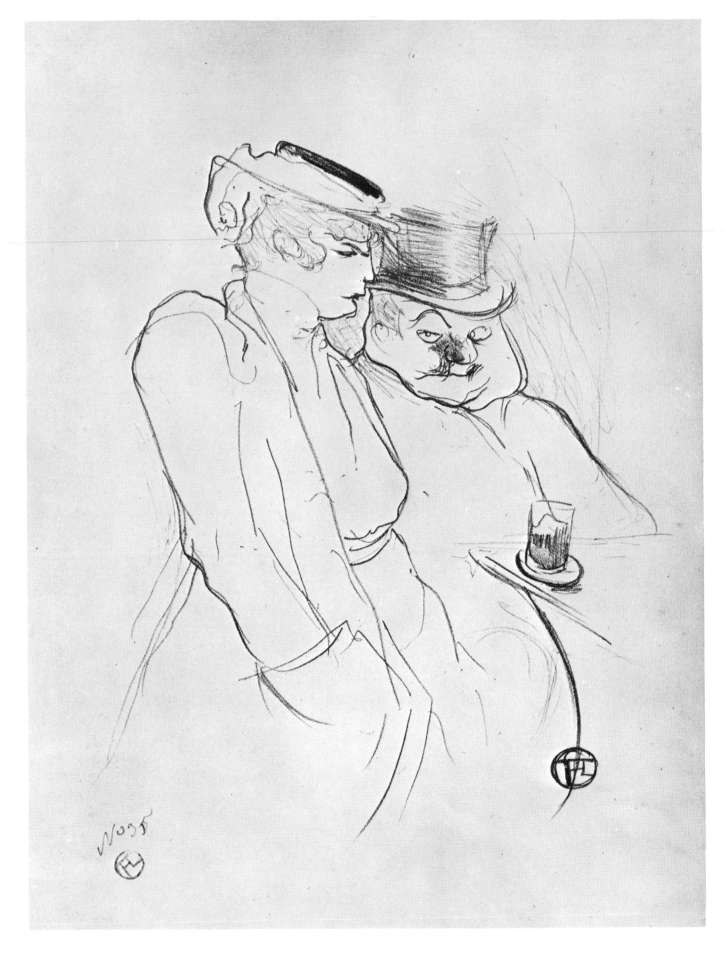

48. 'EN QUARANTE!' Lithograph, 1893.

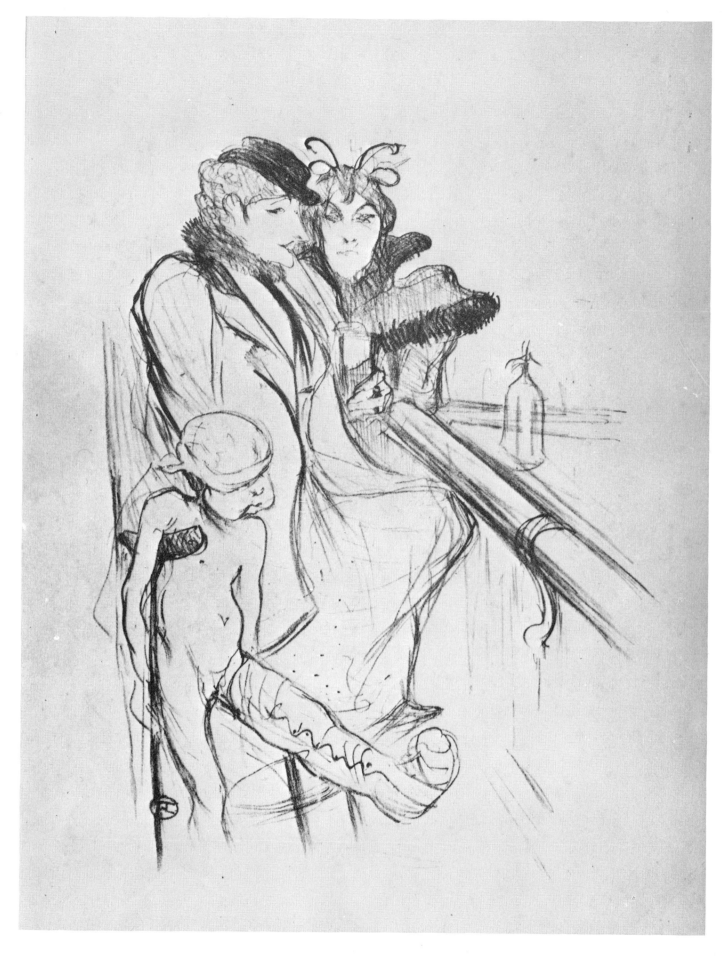

49. 'EROS VANNÉ'. Lithograph, 1894

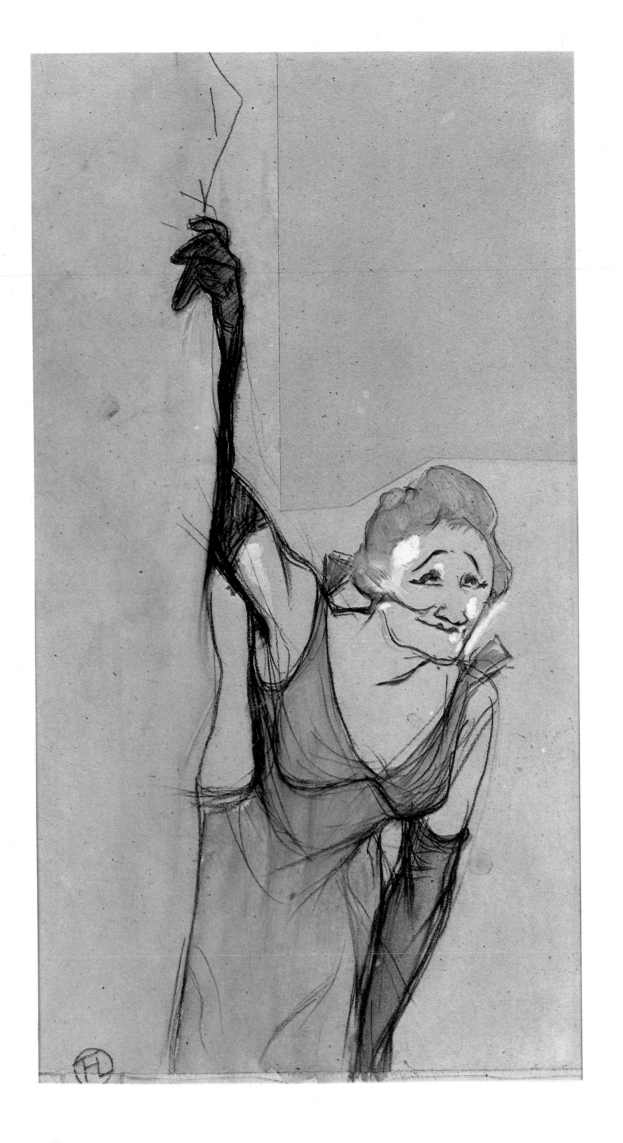

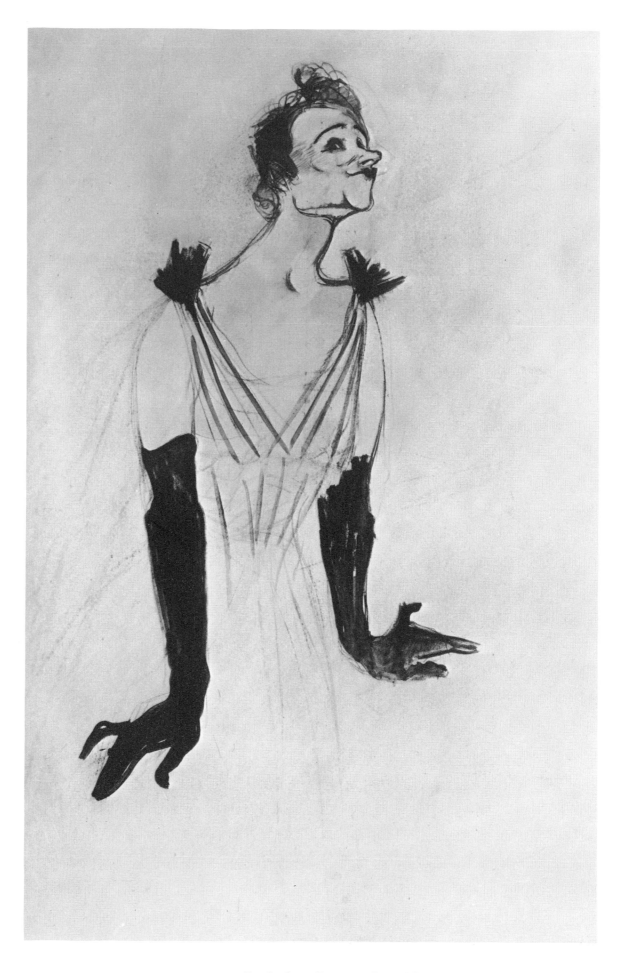

51. YVETTE GUILBERT. Study for a Poster, 1894. Albi, Musée Toulouse-Lautrec

50. YVETTE GUILBERT TAKING A CURTAIN CALL. Water-colour, 1893.
Providence, R.I., Museum of Art, Rhode Island School of Design

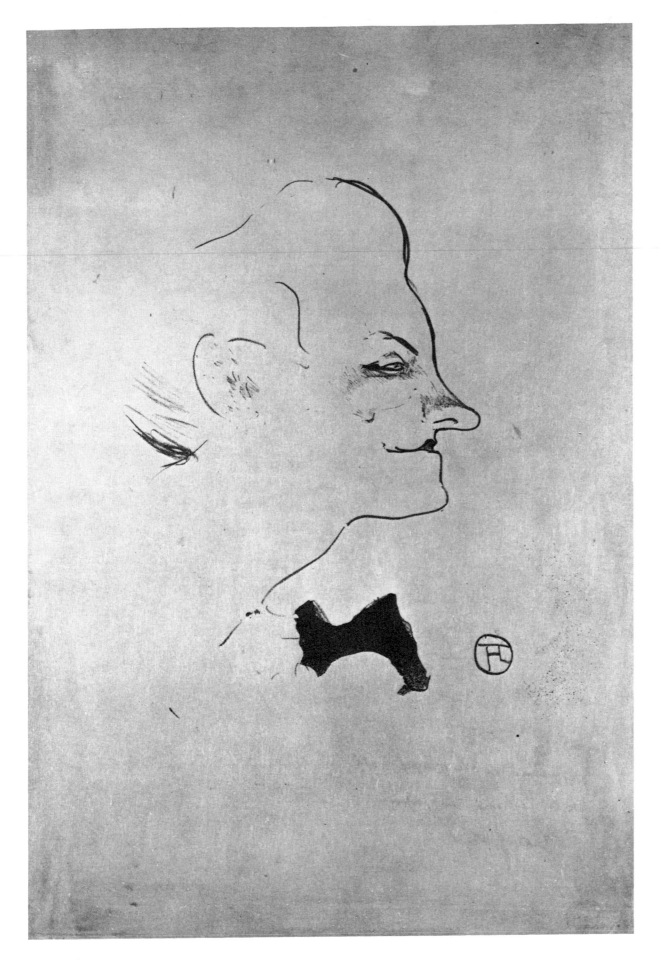

52. YVETTE GUILBERT, PROFILE. Lithograph, 1893

53. YVETTE GUILBERT'S GLOVES. 1894. Albi, Musée Toulouse-Lautrec

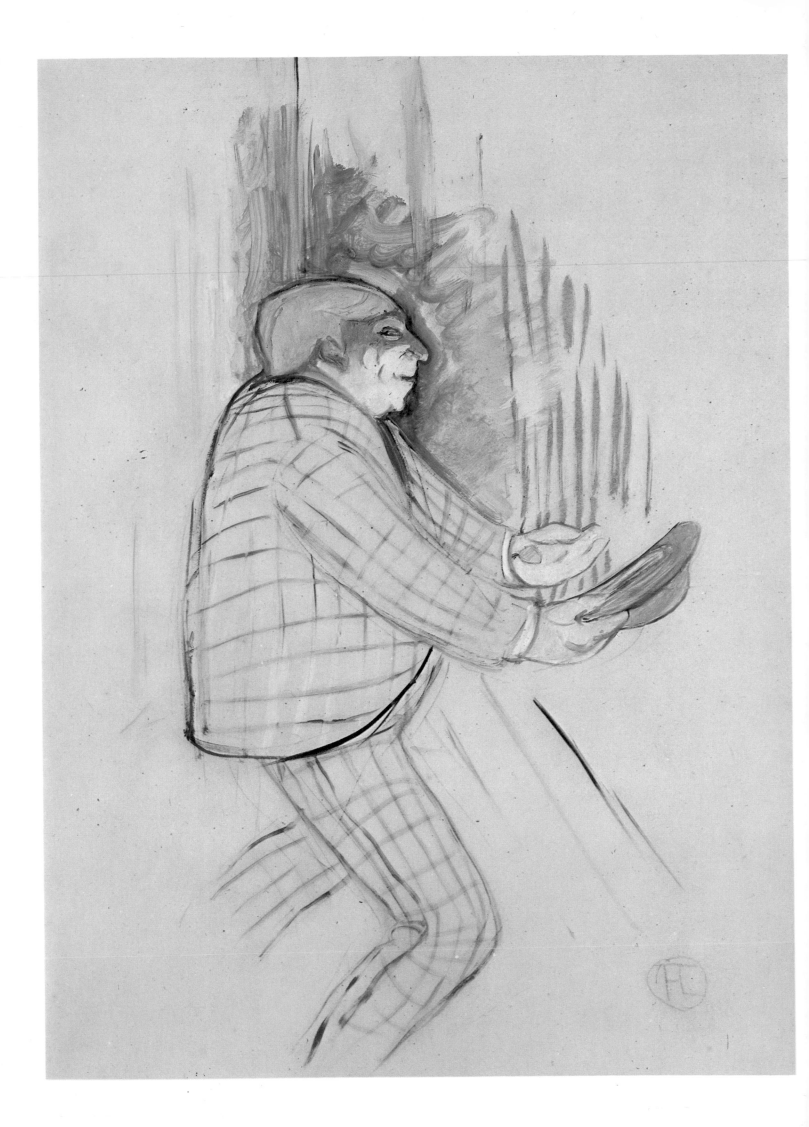

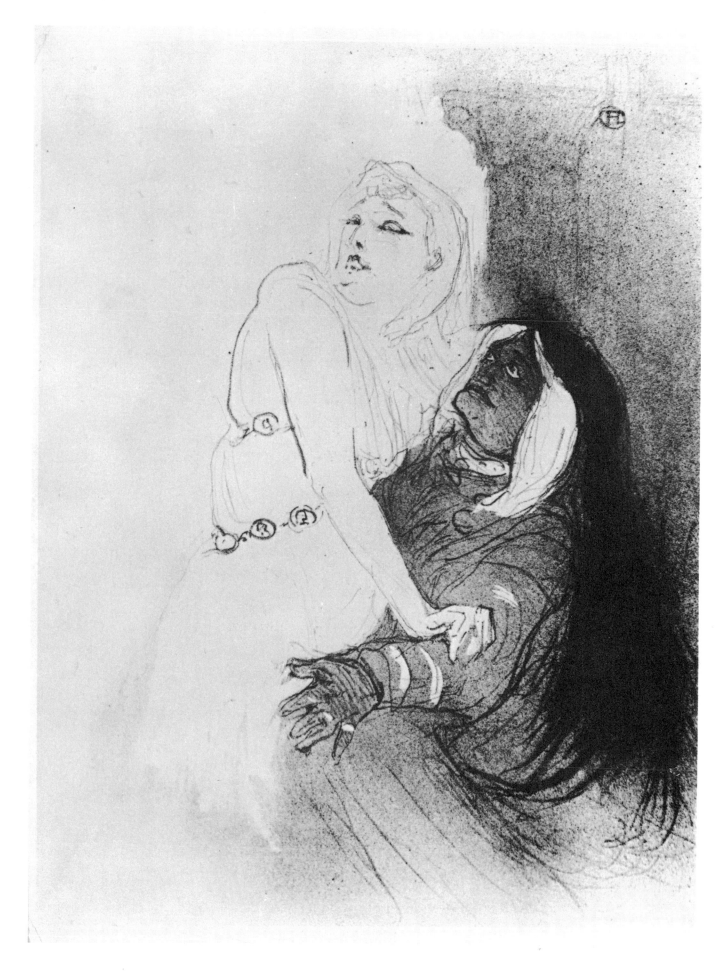

55. SARAH BERNHARDT IN 'PHÈDRE'. Lithograph, 1893

54. M. PRAINCE. Water-colour, 1893. New York, André and Clara Mertens

56. RÉJANE AND GALIPAUX IN 'MADAME SANS-GÊNE'. Lithograph, 1894

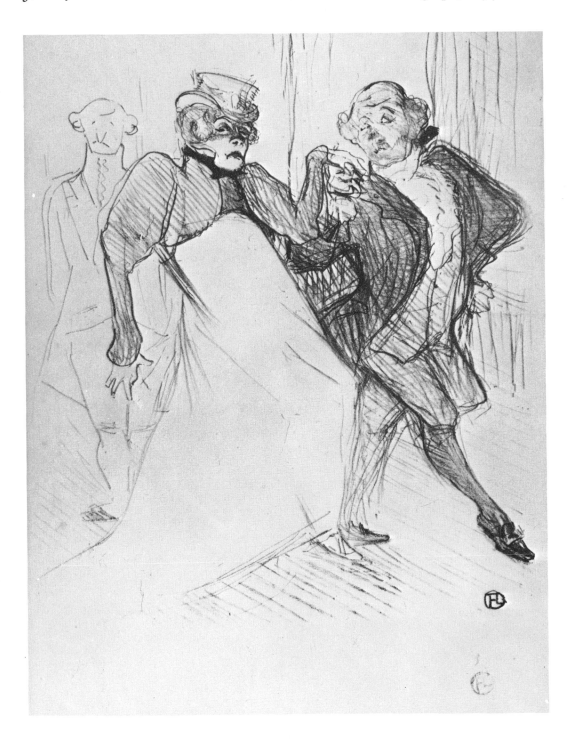

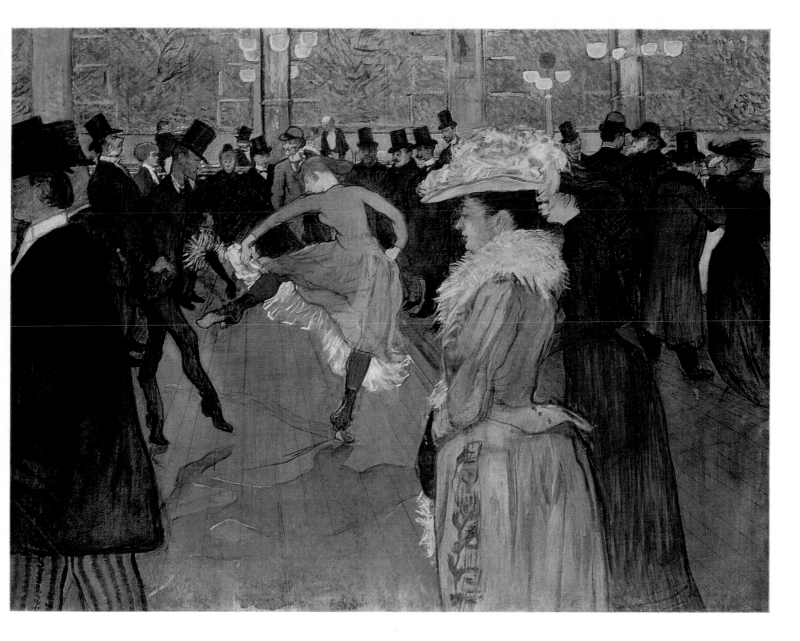

57. DANCE AT THE MOULIN ROUGE. 1894. Philadelphia, Henry P. McIlhenny

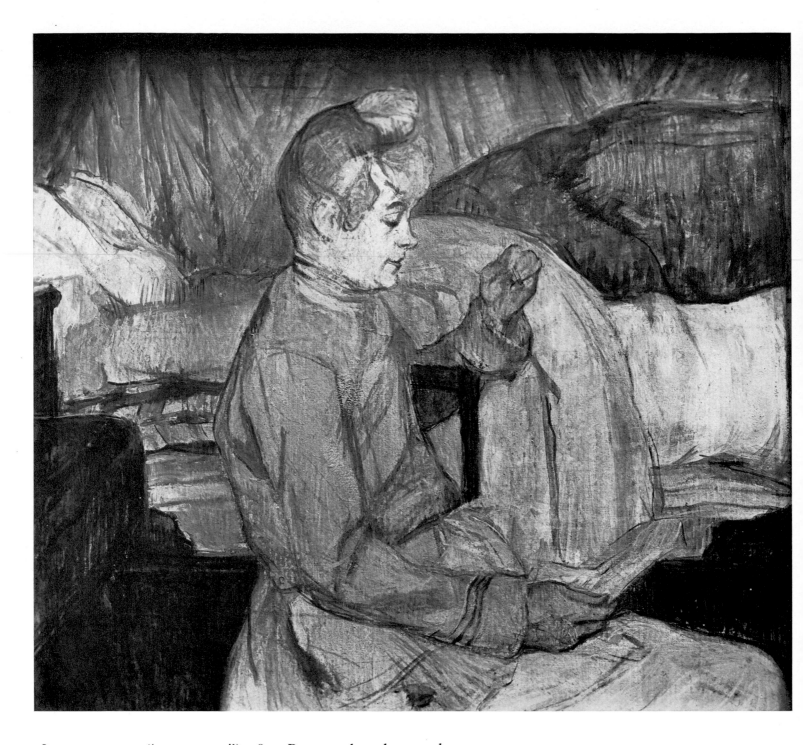

58. THE LETTER ('EN MEUBLÉ'). 1890. Present whereabouts unknown

59. THE CARDPLAYERS. c. 1893. Bern, Professor Hans R. Hahnloser

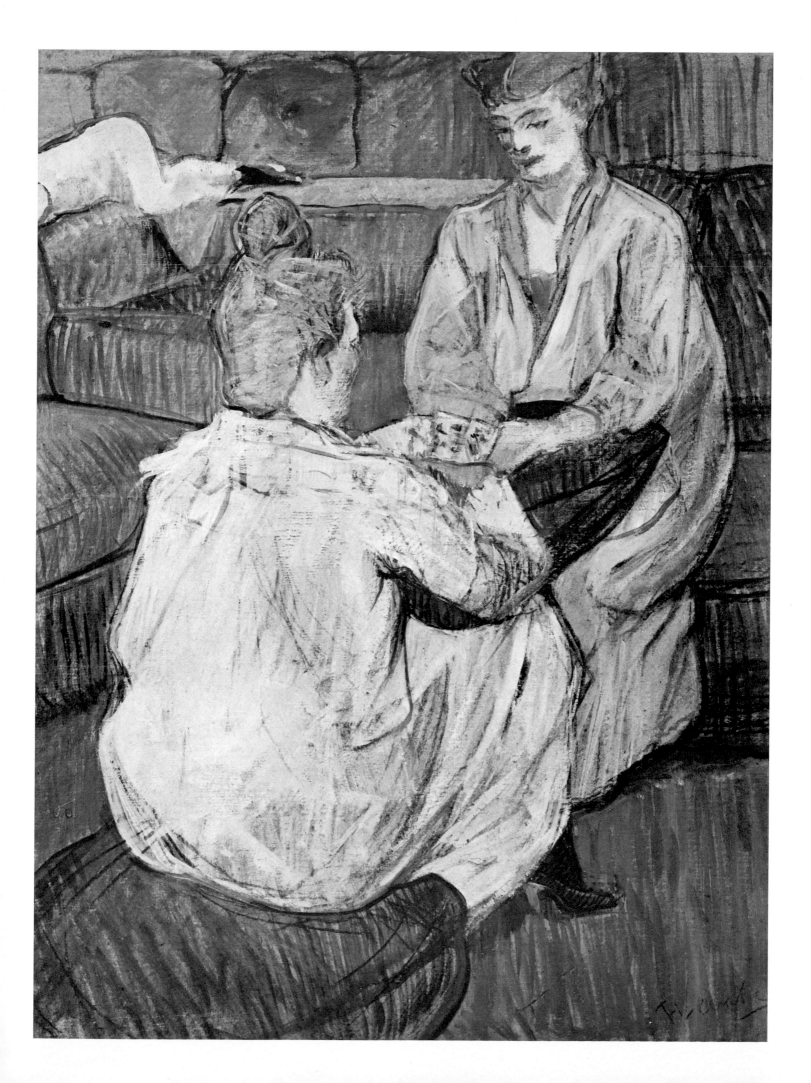

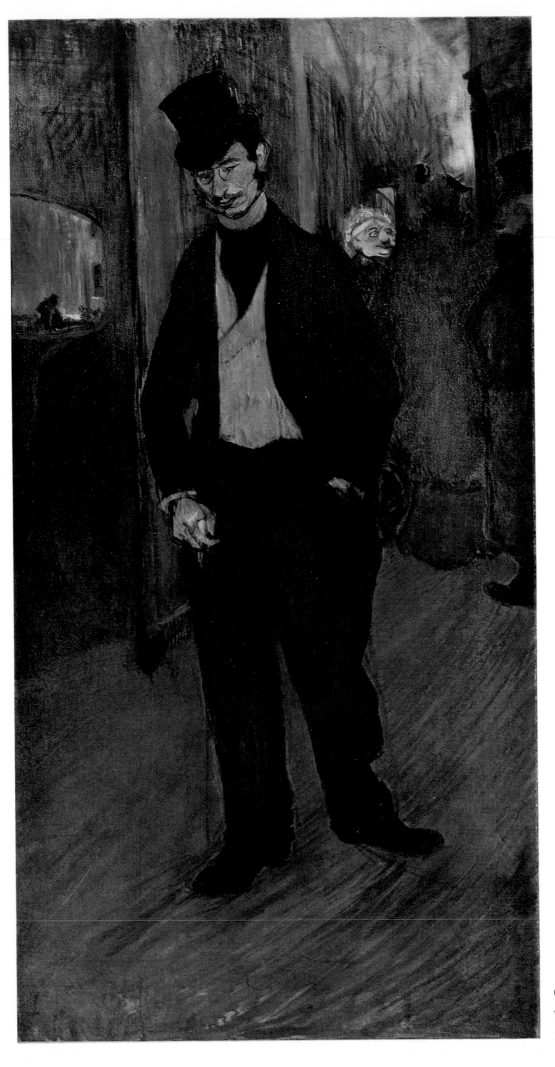

60. PORTRAIT OF GABRIEL
TAPIÉ DE CÉLEYRAN. 1894.
Albi, Musée Toulouse-Lautrec

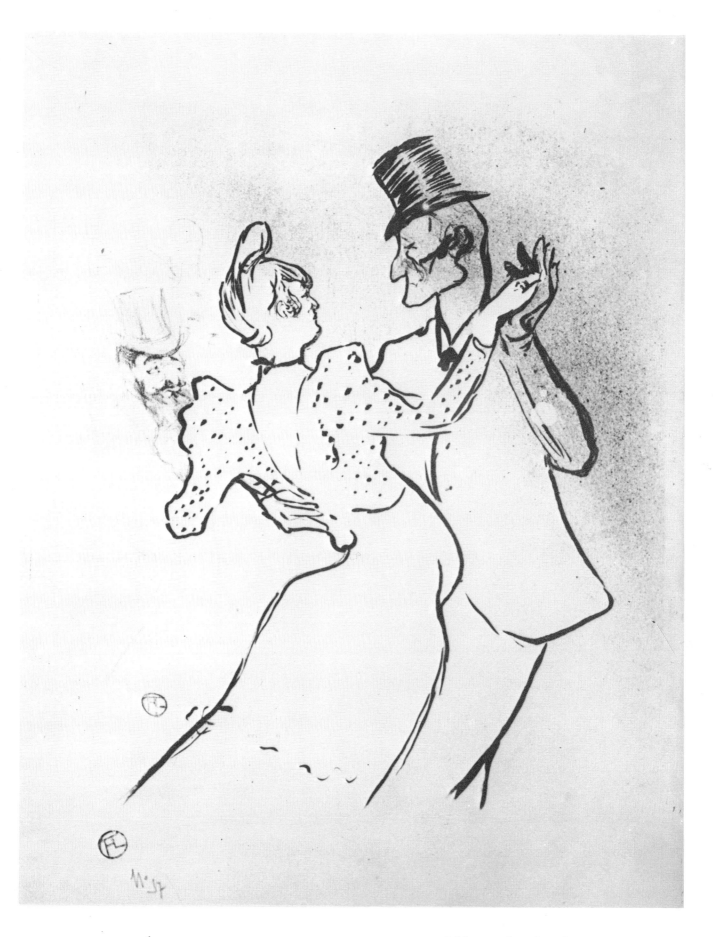

61. LA GOULUE AND VALENTIN, WALTZING. Lithograph, 1894

62. THE MILLINER (RENÉE VERT). Lithograph, 1893

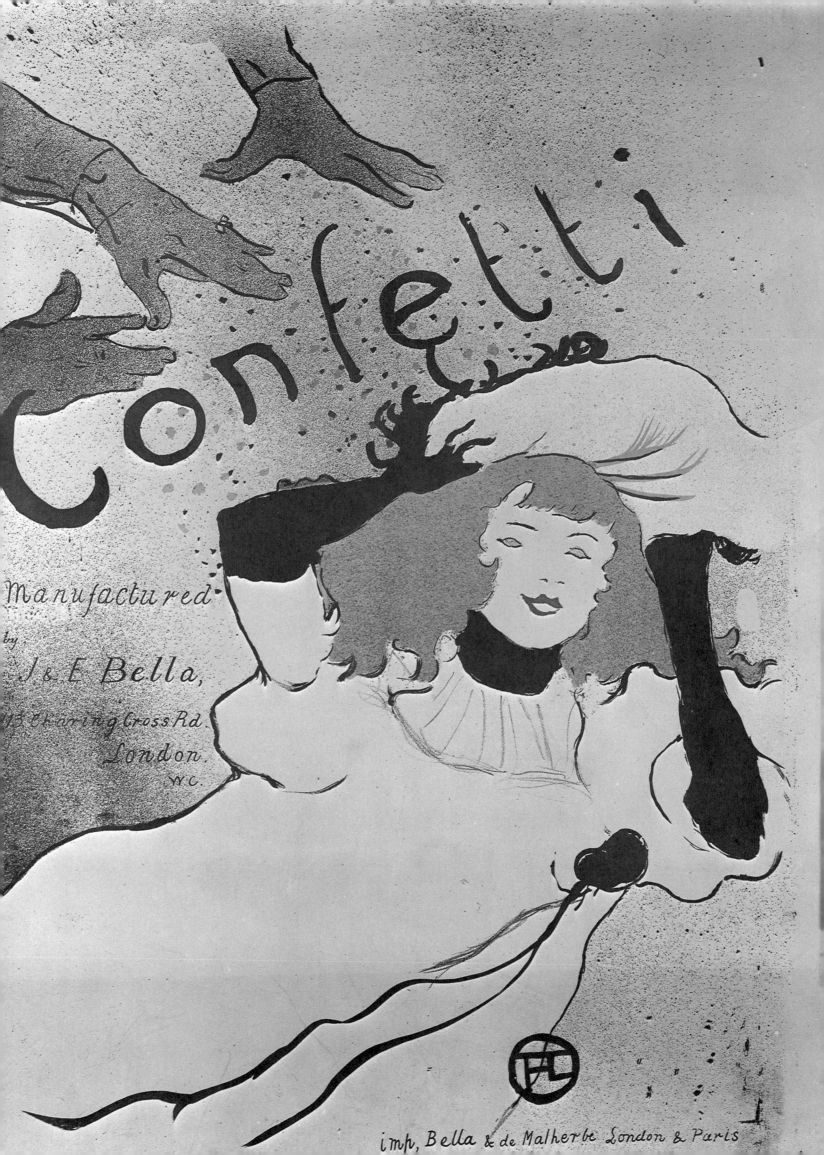

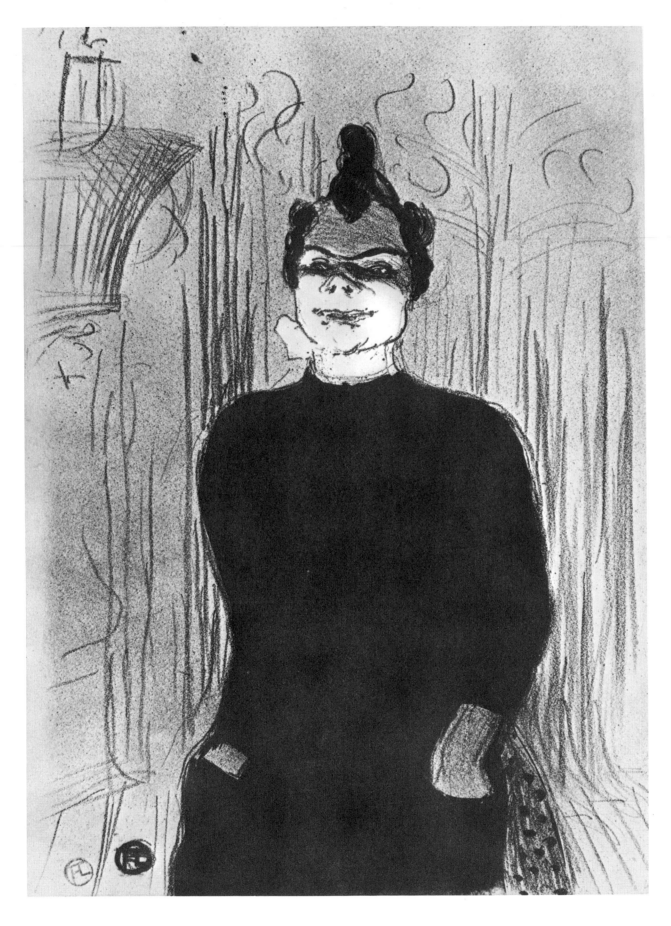

64. AT THE GAIETÉ-ROCHECHOUART: NICOLLE AS A GIRL OF THE STREETS. Lithograph, 1893

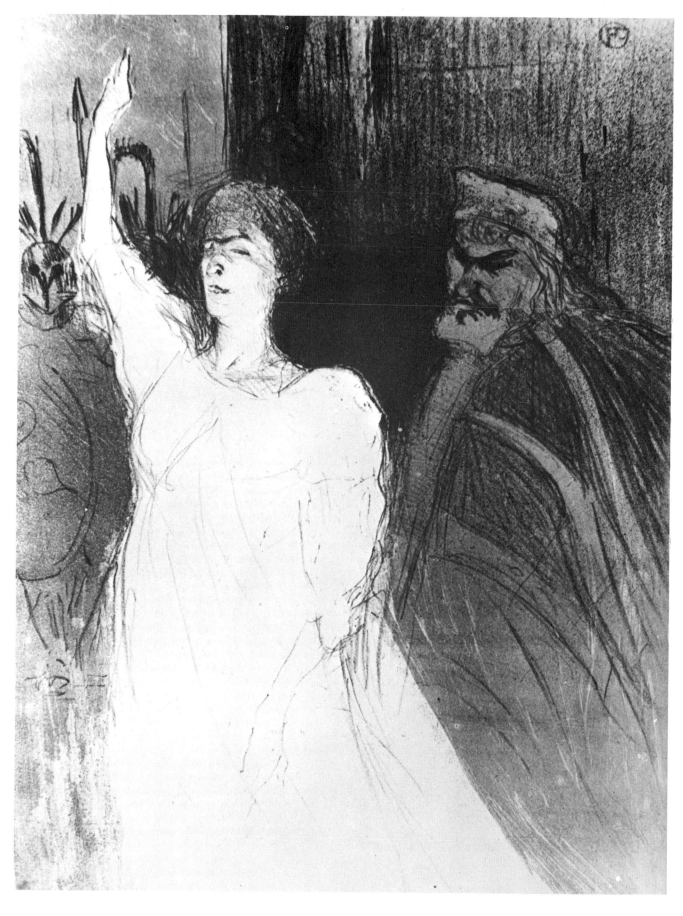

65. BARTET AND MOUNET-SULLY IN 'ANTIGONE'. Lithograph, 1893

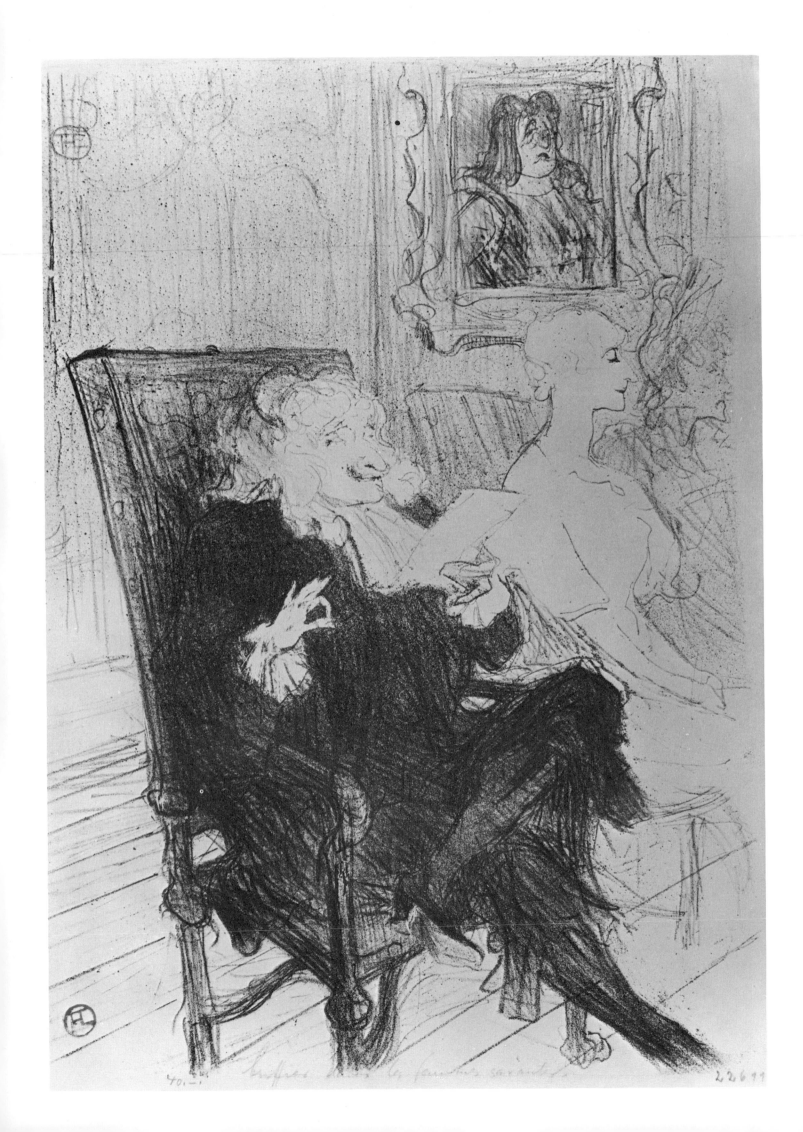

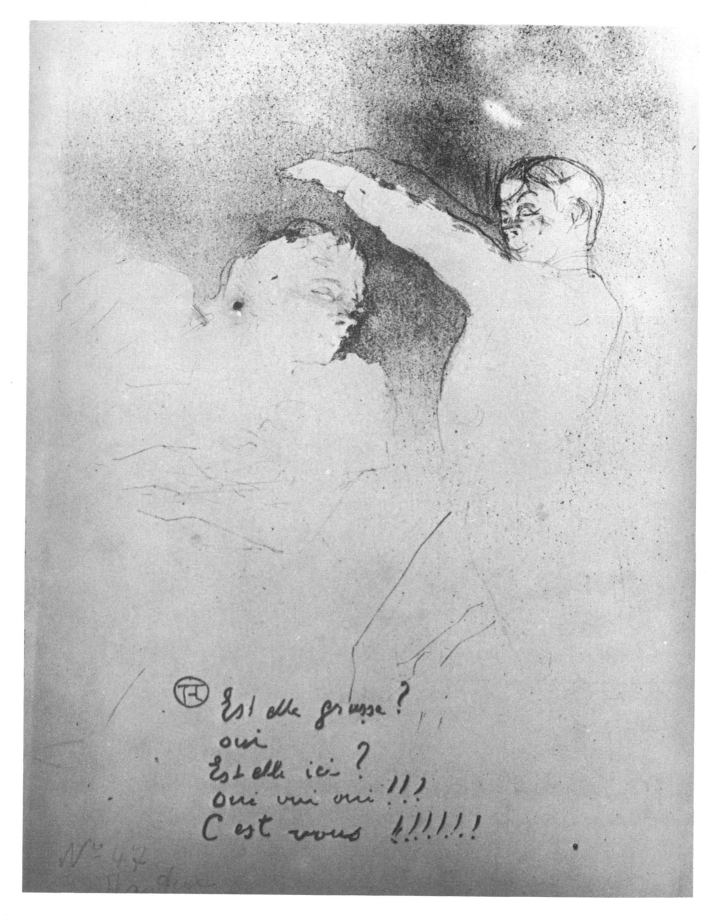

67. MLLE LENDER AND BRASSEUR. Lithograph, 1893

66. LELOIRE AND MORÉNO IN MOLIÈRE'S 'LES FEMMES SAVANTES'. Lithograph, 1893

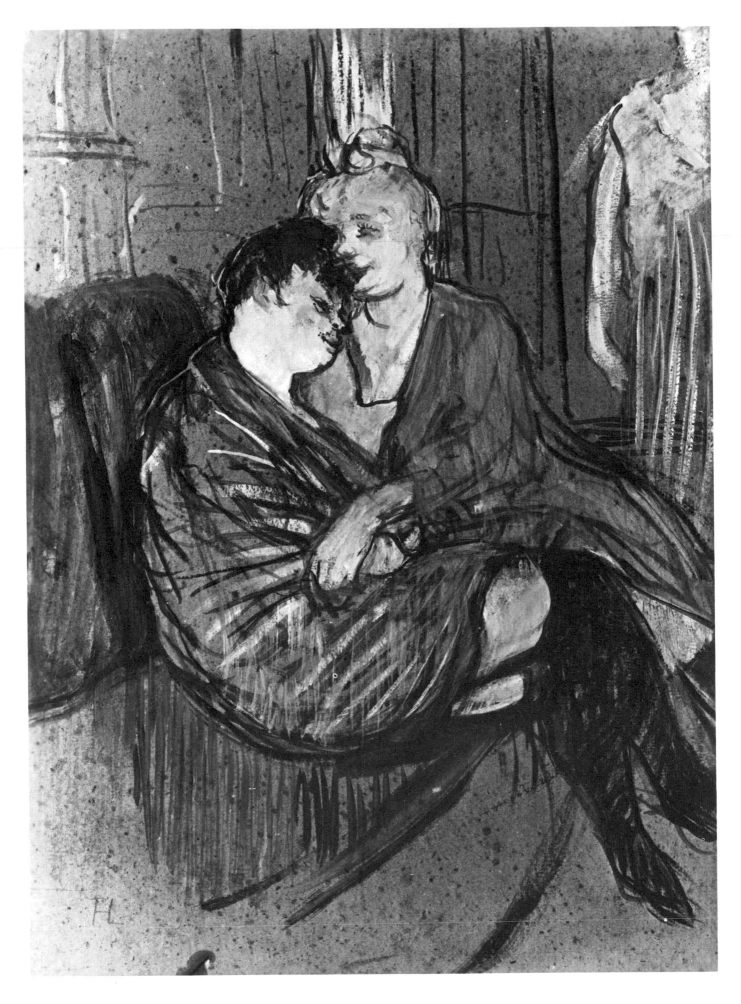

68. THE FRIENDS. 1894. Albi, Musée Toulouse-Lautrec

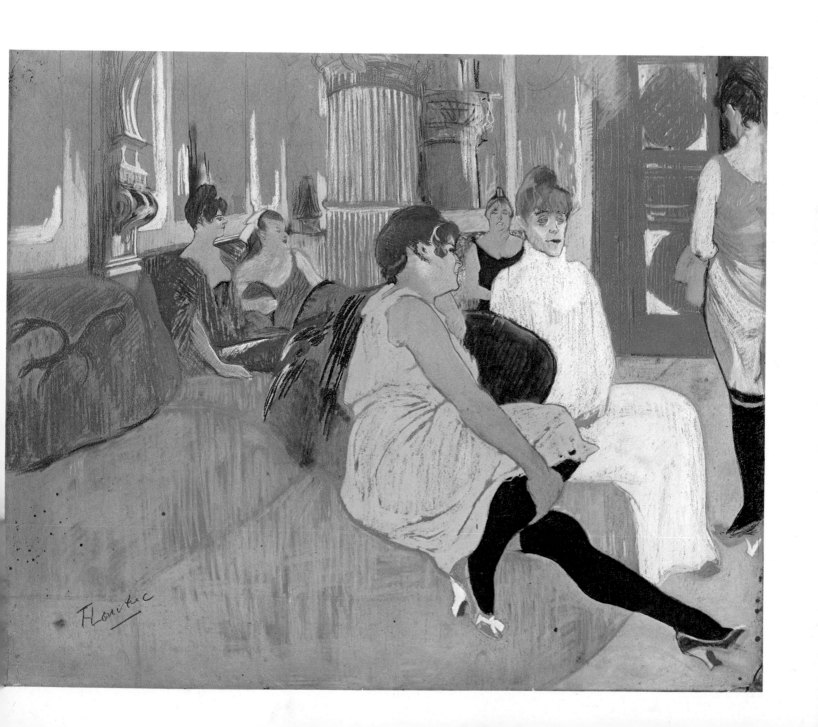

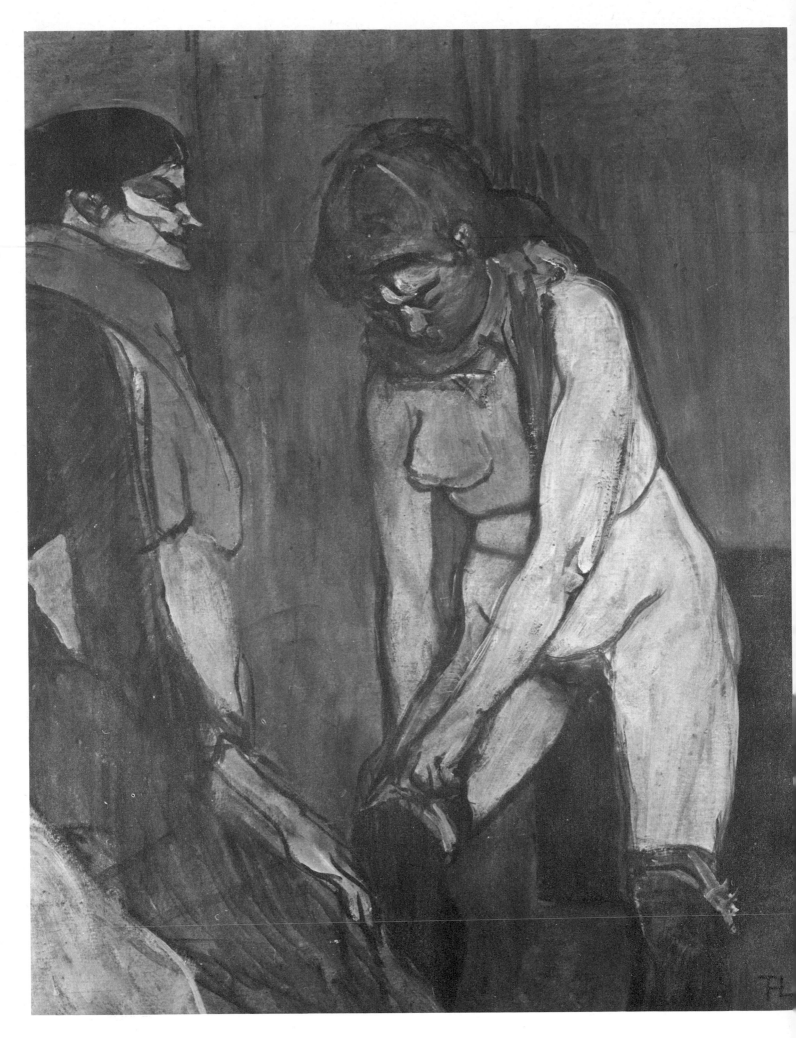

70. WOMAN PULLING UP HER STOCKING. c. 1894. Paris, Louvre

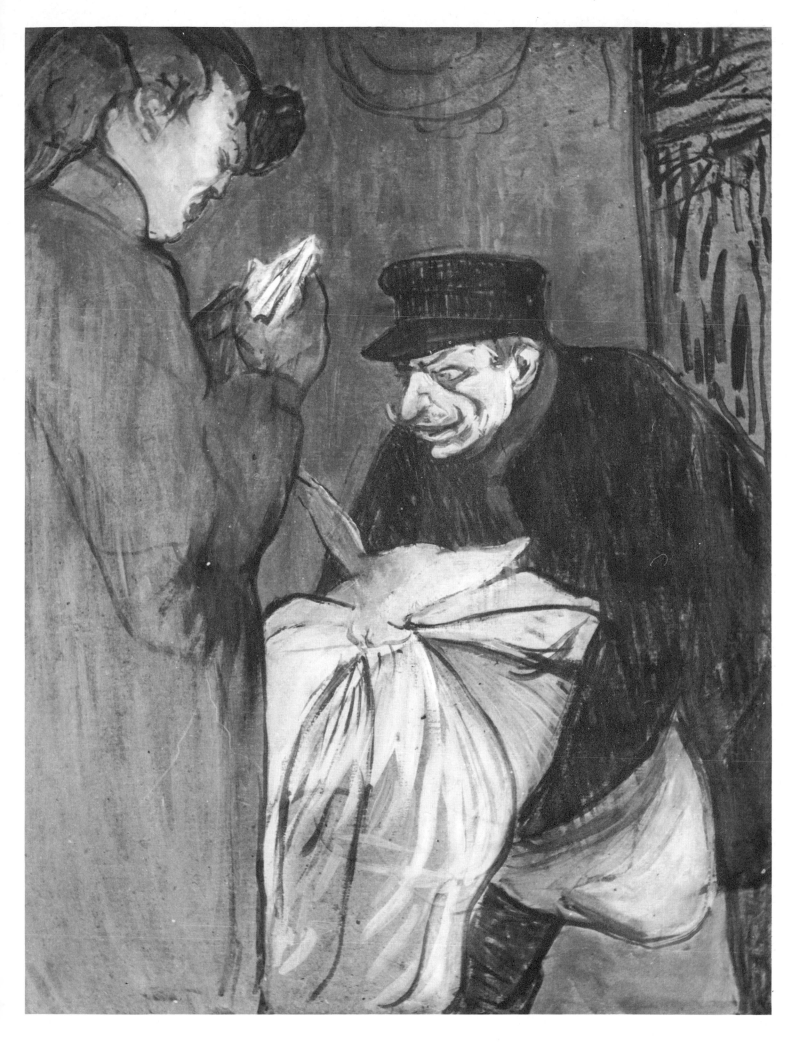

71. THE LAUNDRYMAN. 1894. Albi, Musée Toulouse-Lautrec

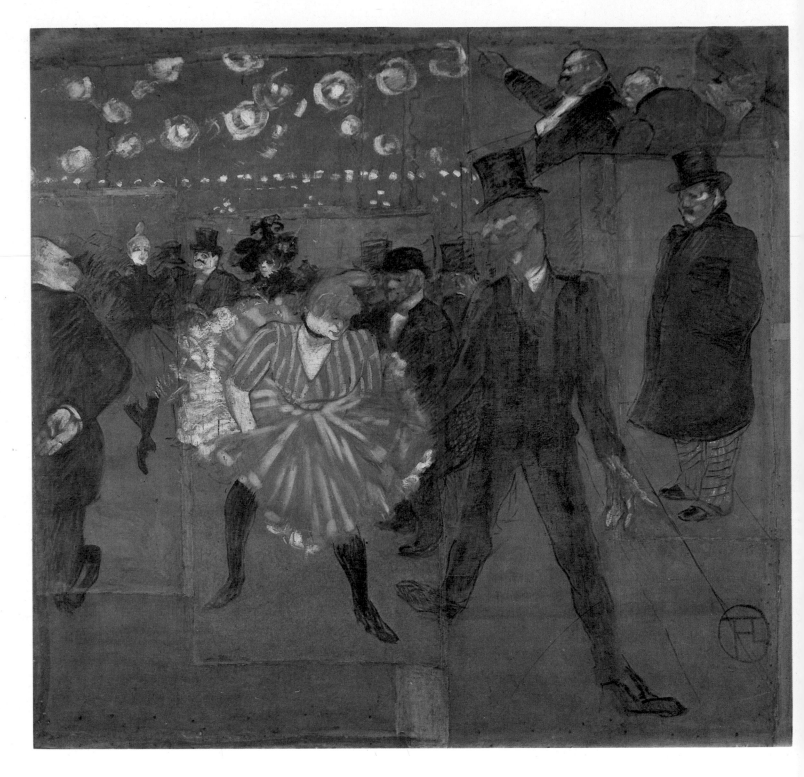

72. LA GOULUE, DANCING WITH VALENTIN LE DÉSOSSÉ. 1895. Paris, Louvre

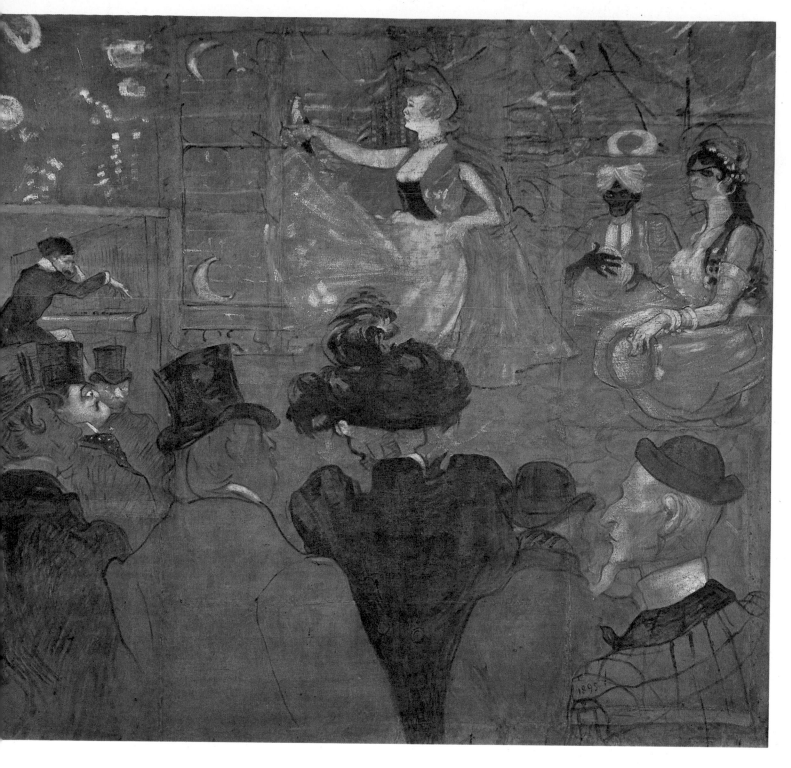

LA GOULUE, DANCING ('LA DANSE DE L'ALMÉE'). 1895. Paris, Louvre

74. PORTRAIT OF FÉNÉON. DETAIL FROM 'LA GOULUE, DANCING'. 1895. Paris, Louvre

PORTRAIT OF OSCAR WILDE. 1895. Vienna, Dr. and Mrs. Conrad H. Lester

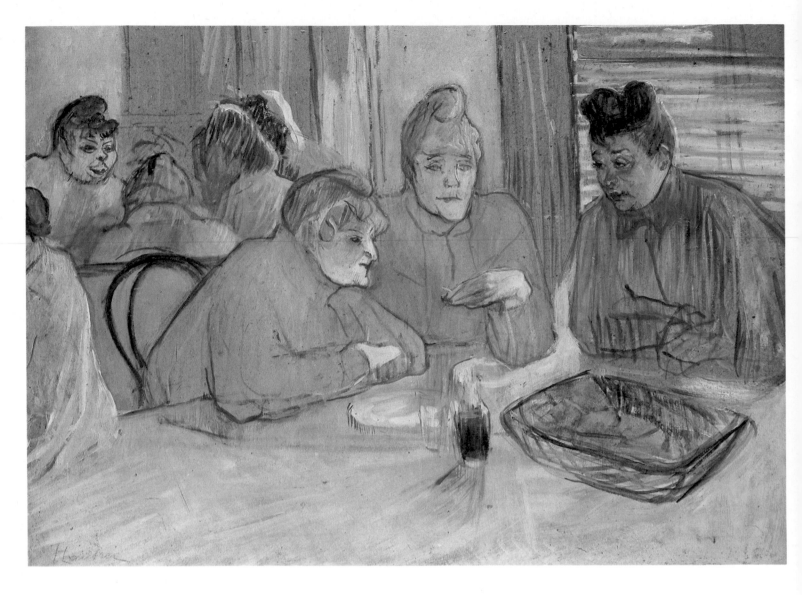

76. WOMEN IN A BROTHEL. 1895. Budapest, Museum of Fine Arts

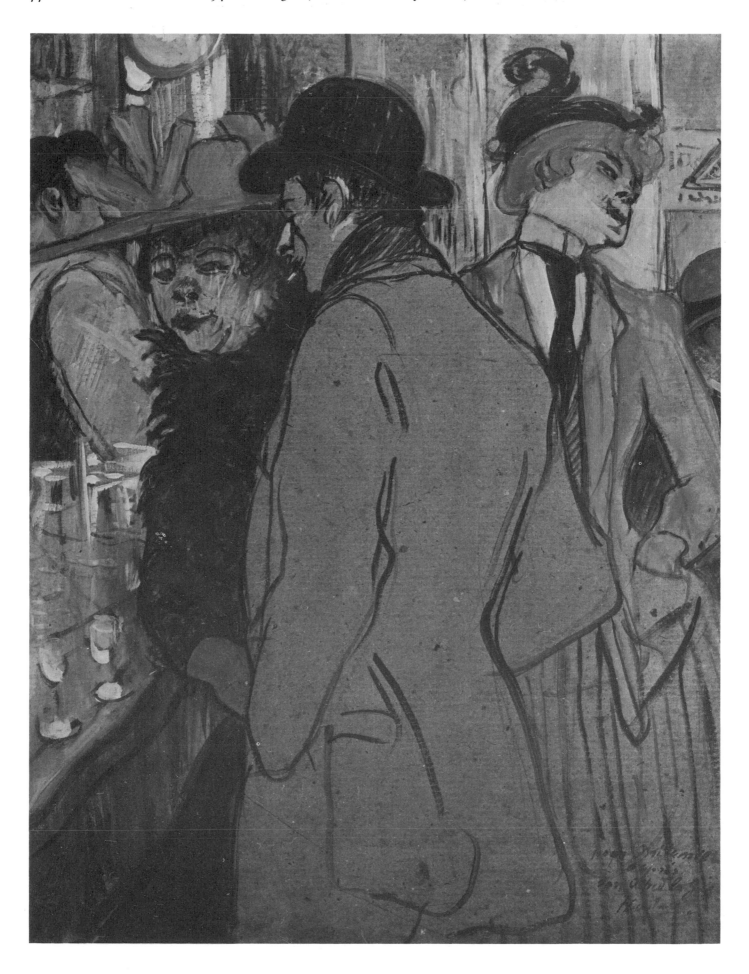

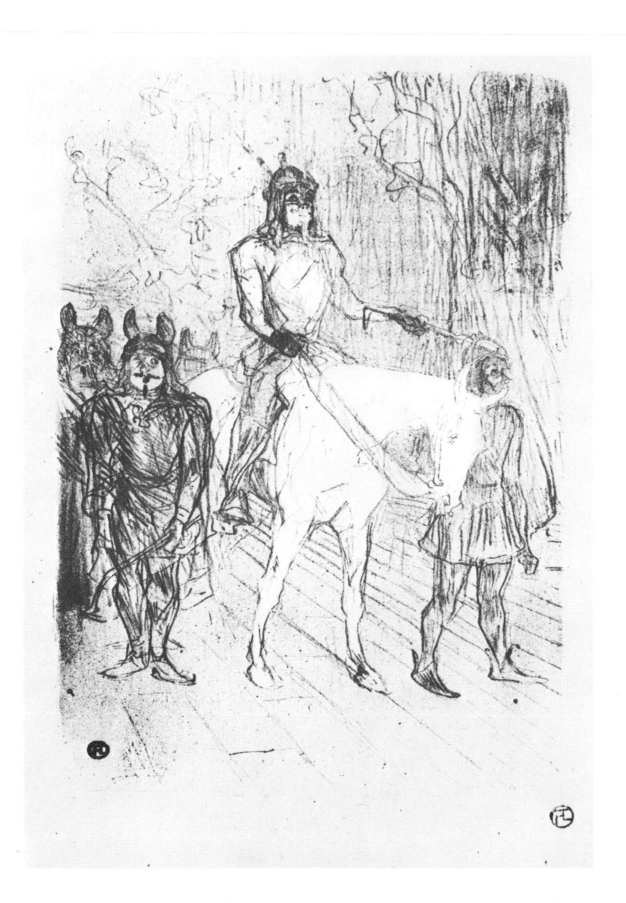

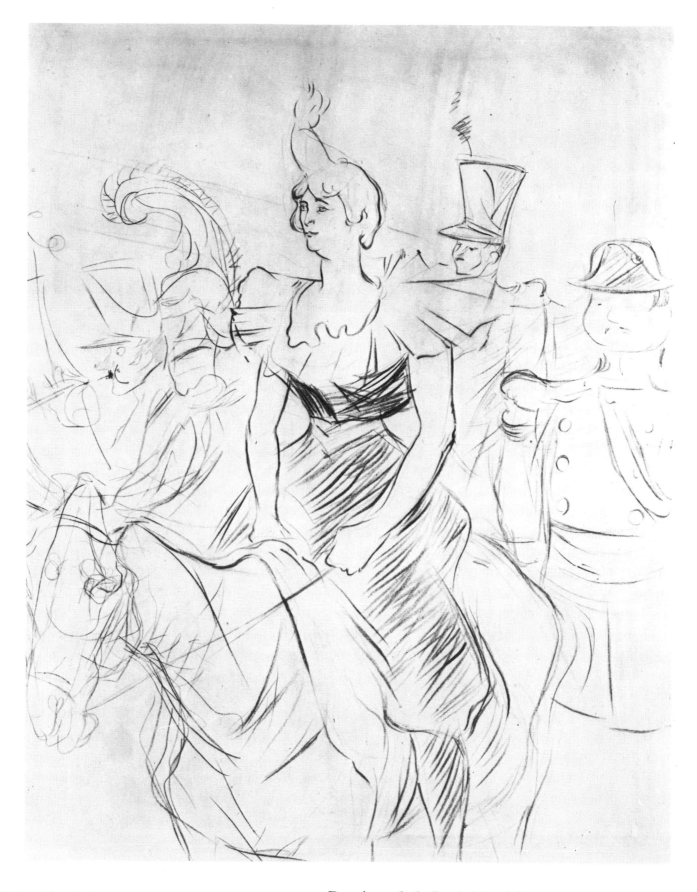

79. THE ENTRY OF CHA–U–KA–O AT THE MOULIN ROUGE. Drawing. 1896. Cambridge, Mass., Fogg Art Museum

80. THE CLOWNESS CHA-U-KA-O, SEATED. Lithograph, 1896

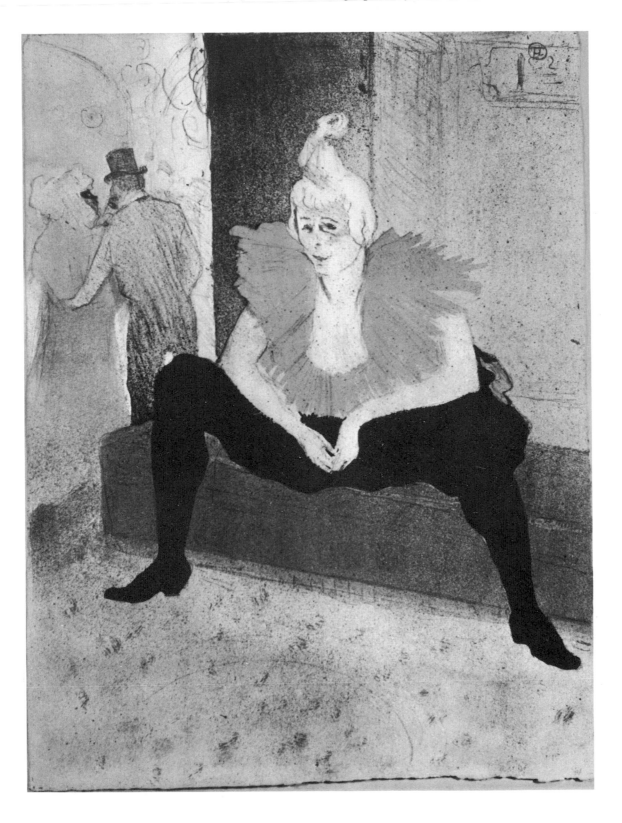

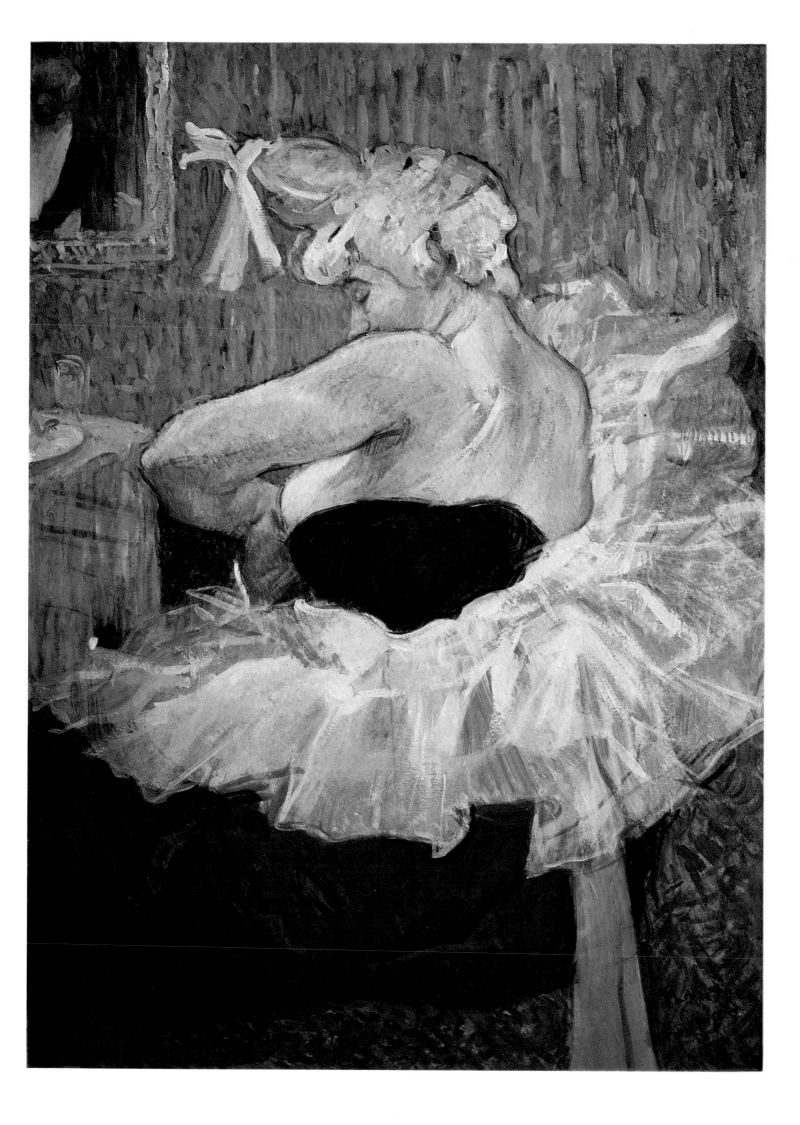

82. THE CLOWNESS CHA-U-KA-O. 1895. Cannes, Mrs. Frank J. Gould

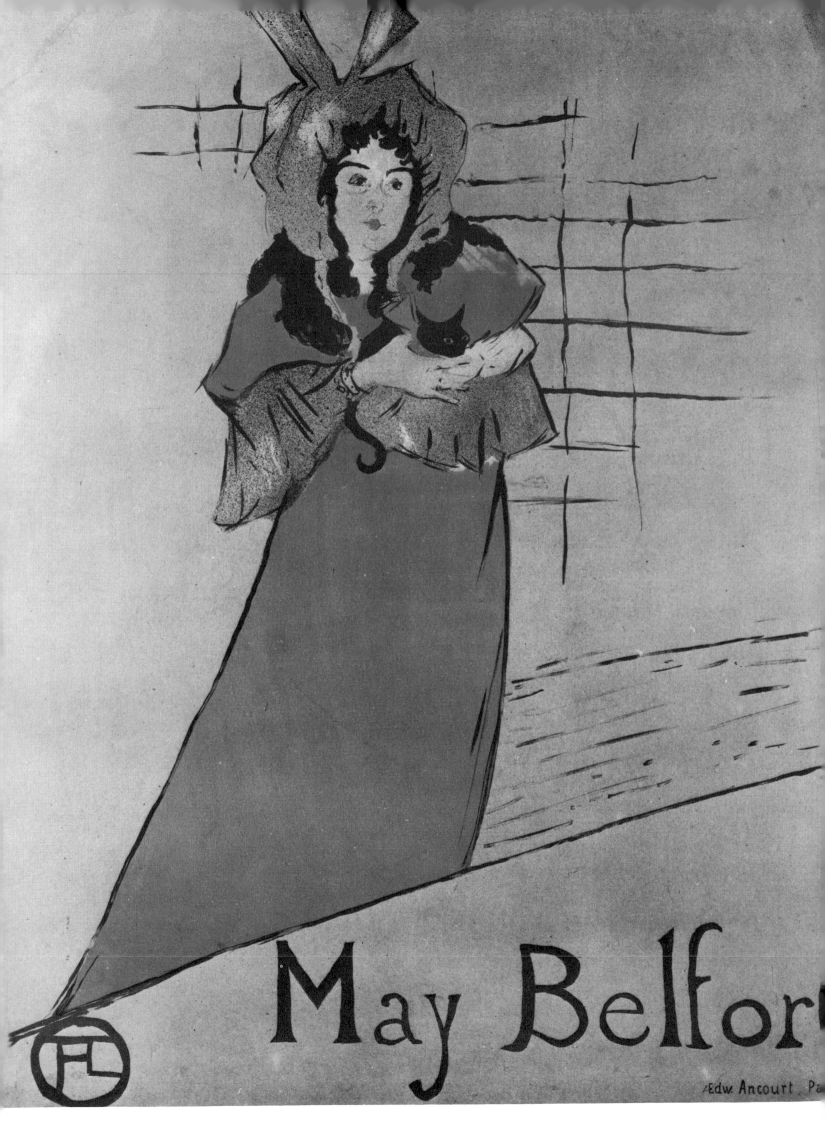

84. MAY BELFORT. Poster, 1895

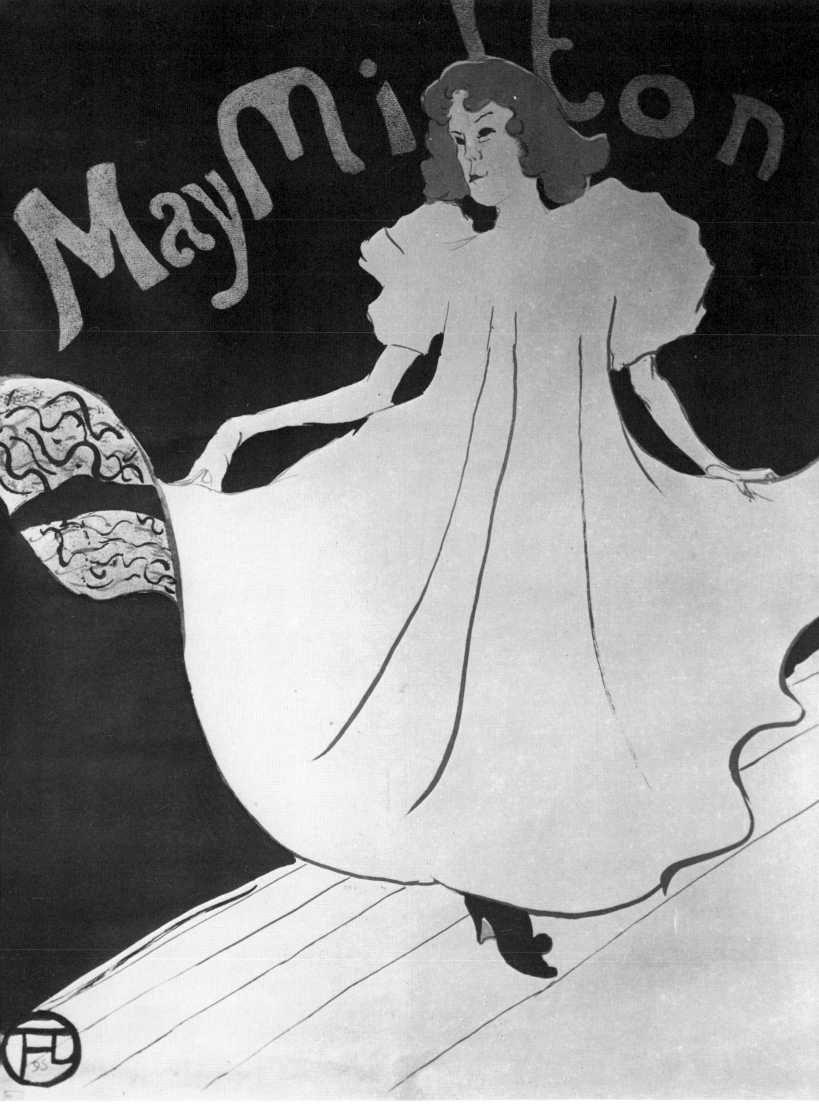

85. MAY MILTON. Poster, 1895

86. CÉCY LOFTUS. Lithograph, 1894

87. LUCIEN GUITRY AND JEANNE GRANIER. 1895. Albi, Musée Toulouse-Lautrec

88. MISIA NATANSON, SKATING. Sketch for a Poster, 1895.
Albi, Musée Toulouse-Lautrec

89. CHOCOLAT, DANCING. Drawing, 1896. Albi, Musée Toulouse-Lautrec

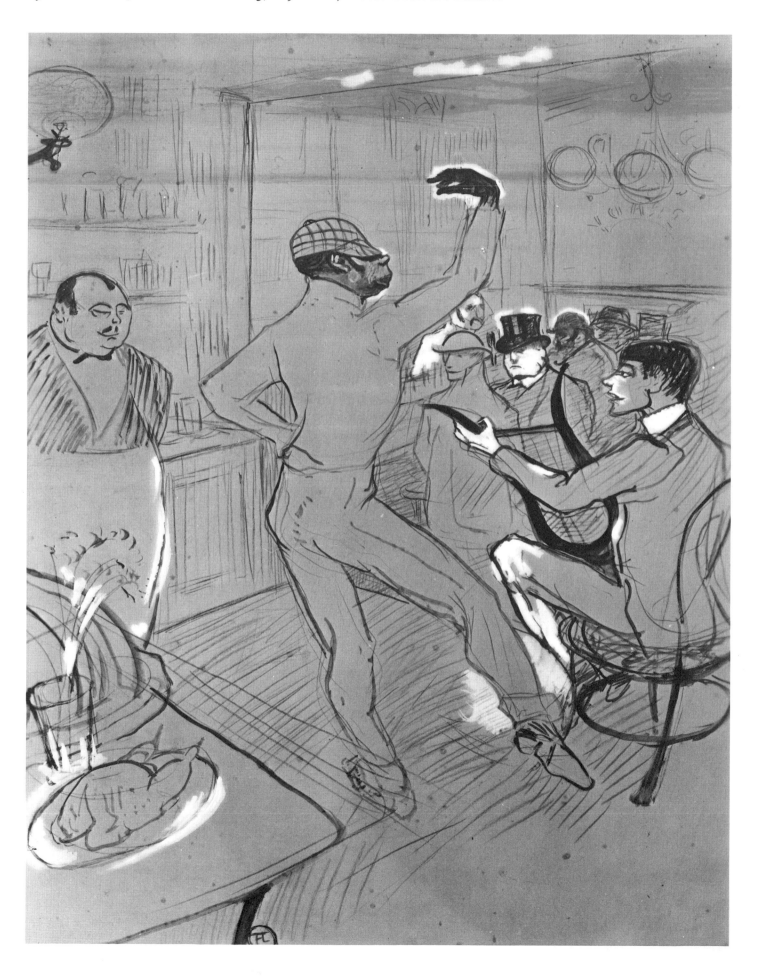

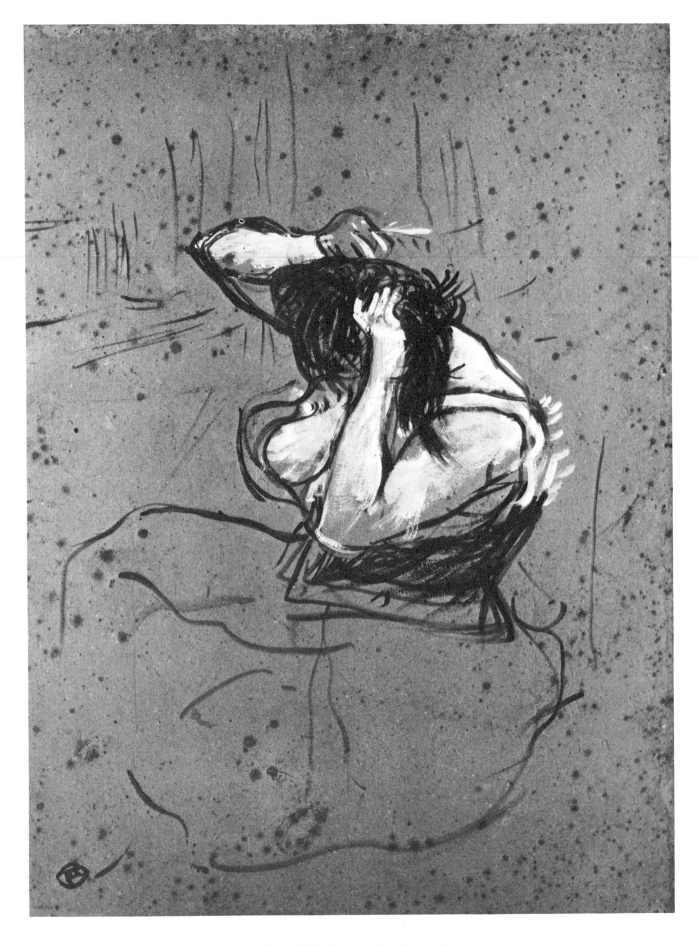

90. WOMAN COMBING HER HAIR. 1896. Albi, Musée Toulouse-Lautrec

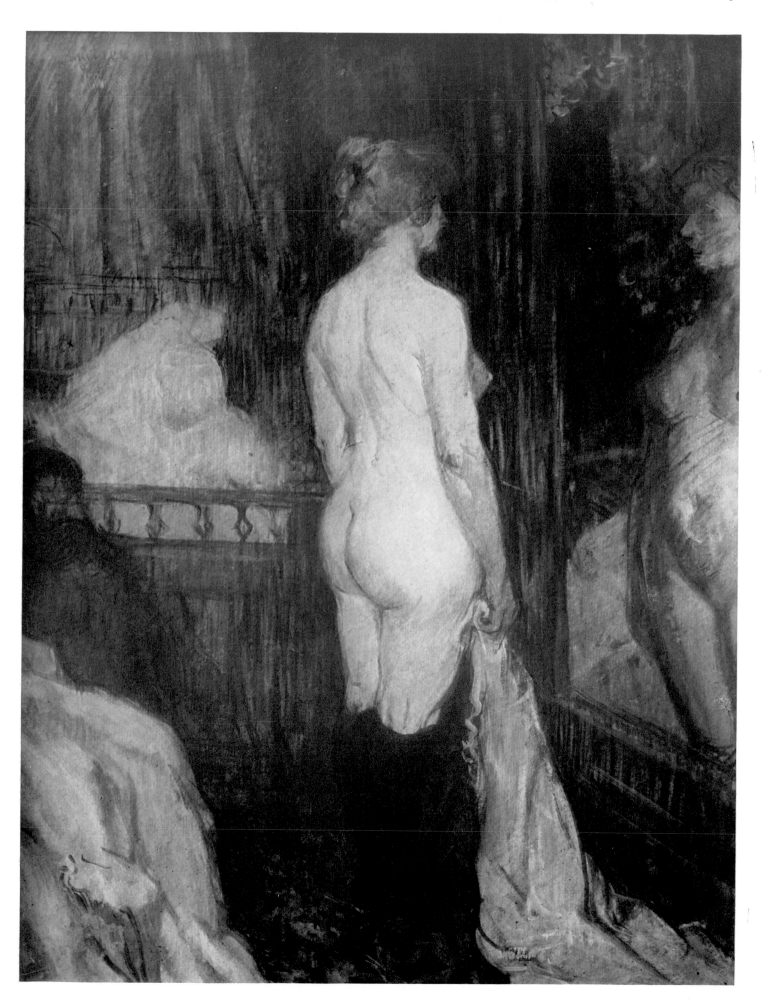

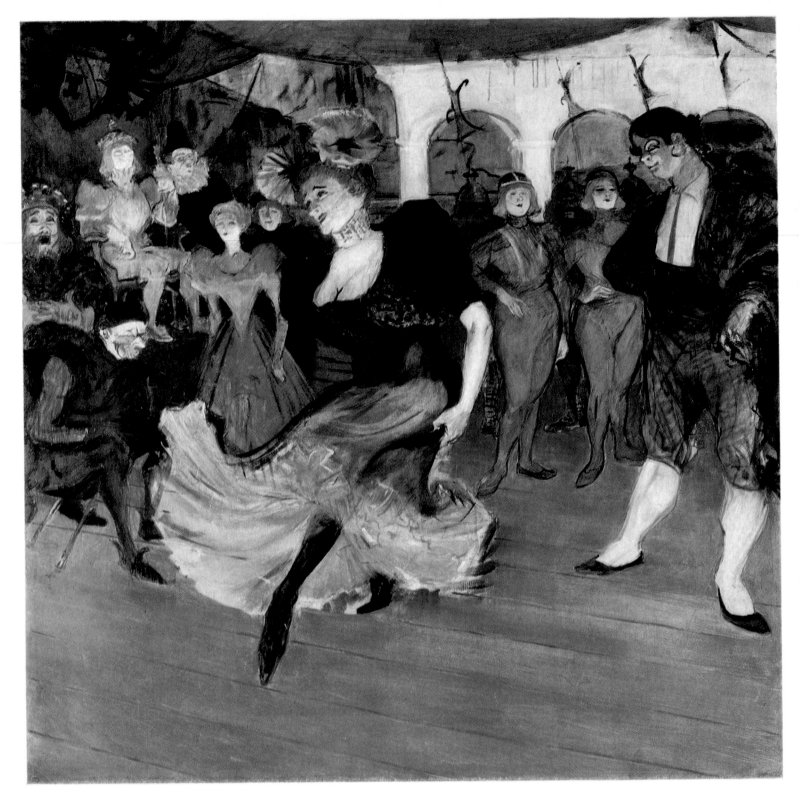

92. MARCELLE LENDER DANCING THE BOLERO IN 'CHILPÉRIC'. 1895. New York, Mr. John Hay Whitney

93. MARCELLE LENDER, STANDING. Lithograph, 1895

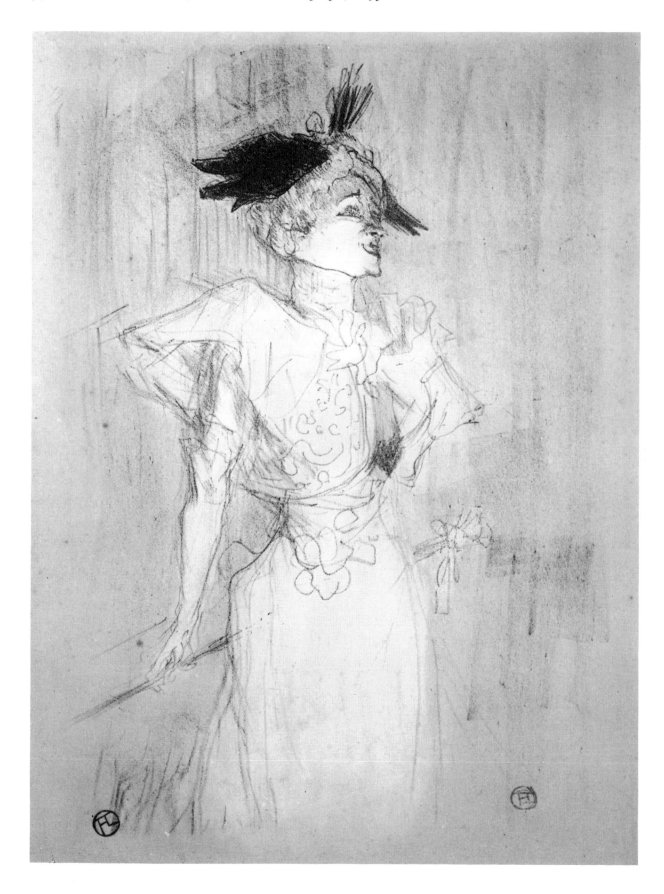

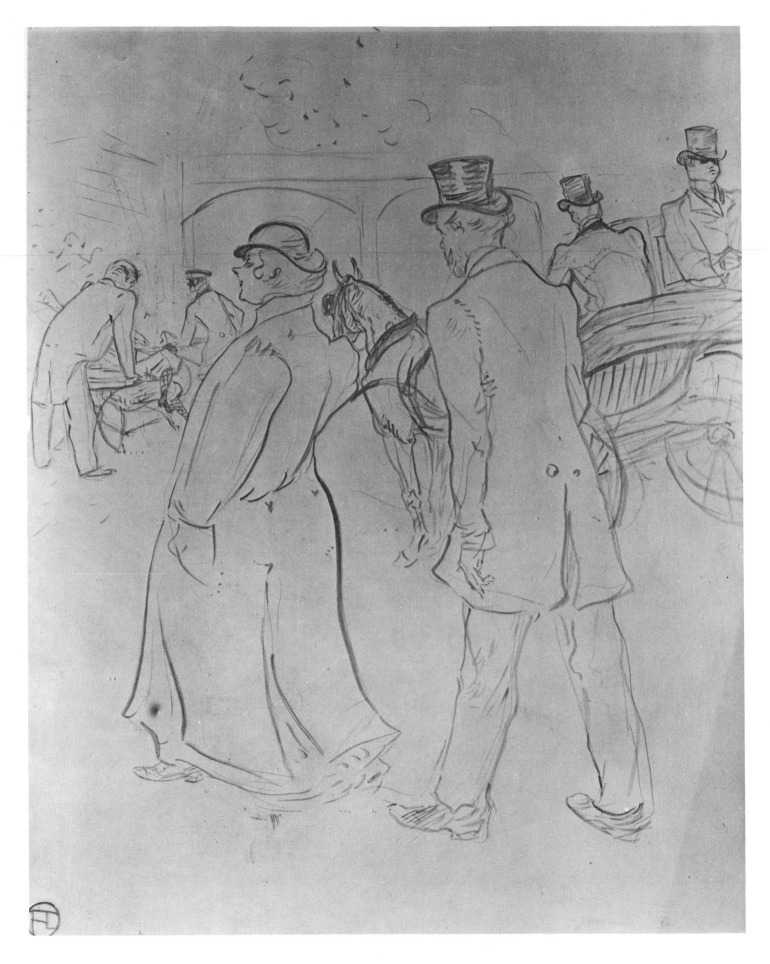

94. AT ARMÉNONVILLE. Drawing, 1896. Minneapolis, Institute of Arts

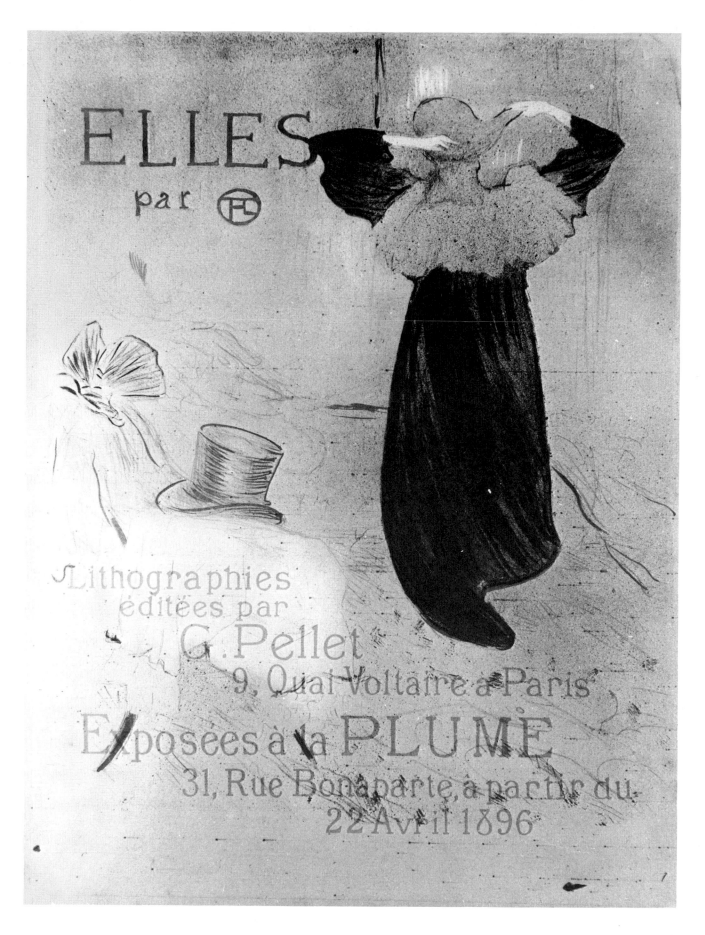

95. TITLE-PAGE FOR 'ELLES'. Lithograph, 1896

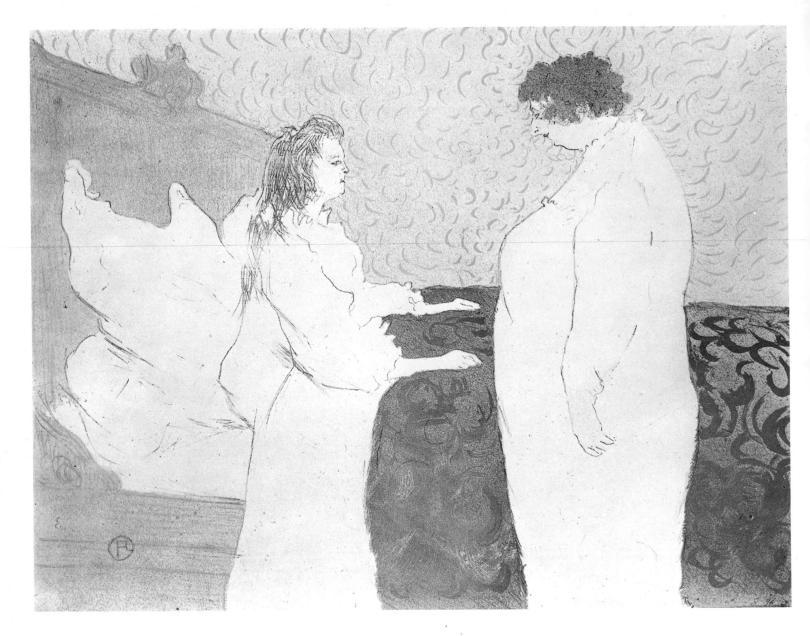

96. 'AU PETIT LEVER'. Lithograph, 1896

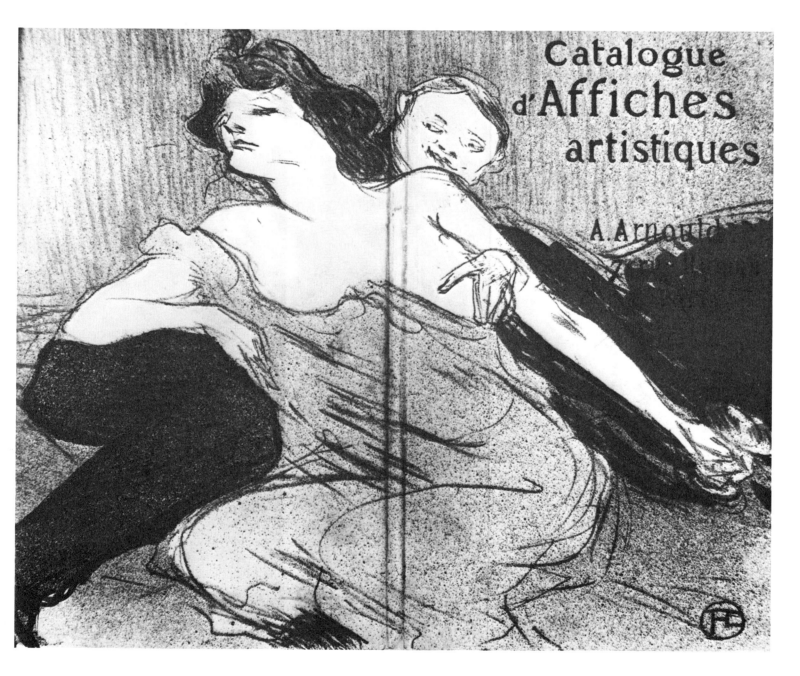

97. 'DEBAUCHE'. Cover for a poster catalogue, 1896

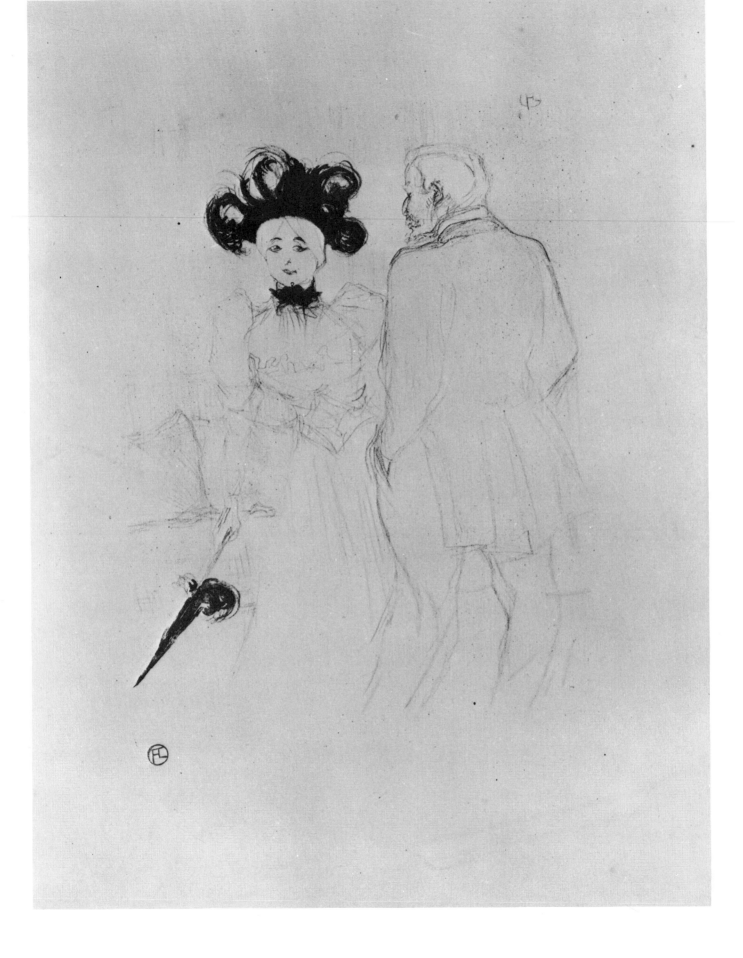

98. YAHNE AND ANTOINE IN 'L'ÂGE DIFFICILE'. Lithograph, 1895

99. WOMAN LYING ON HER BACK ('LASSITUDE'). Lithograph, 1896

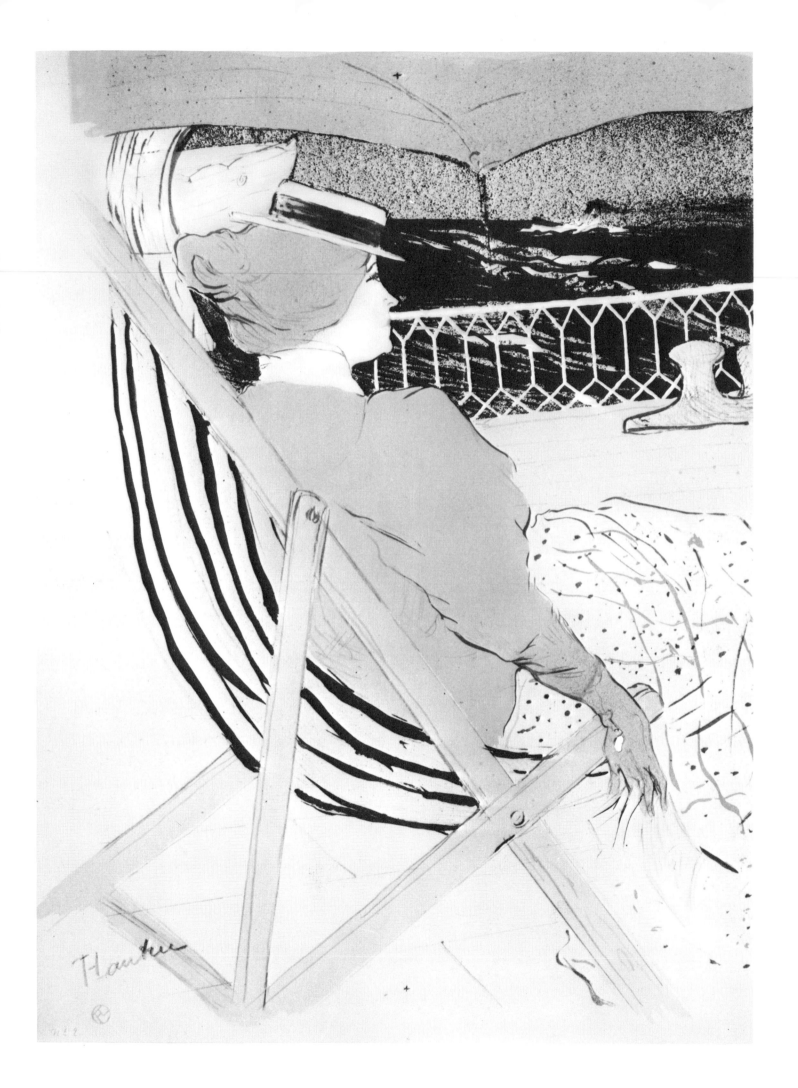

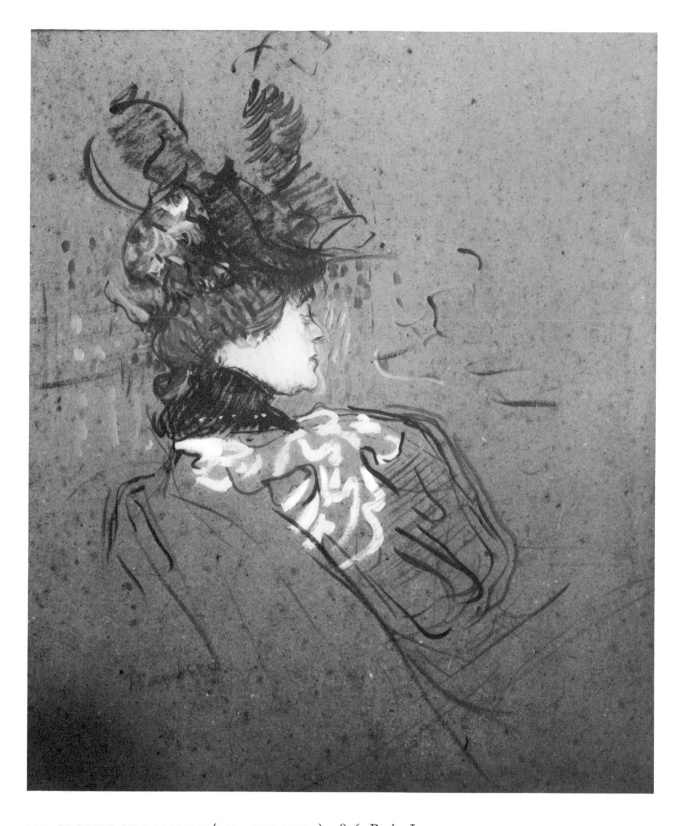

101. PROFILE OF A WOMAN (MADAME LUCY). 1896. Paris, Louvre

100. THE PASSENGER ON A YACHT. Lithograph, 1896

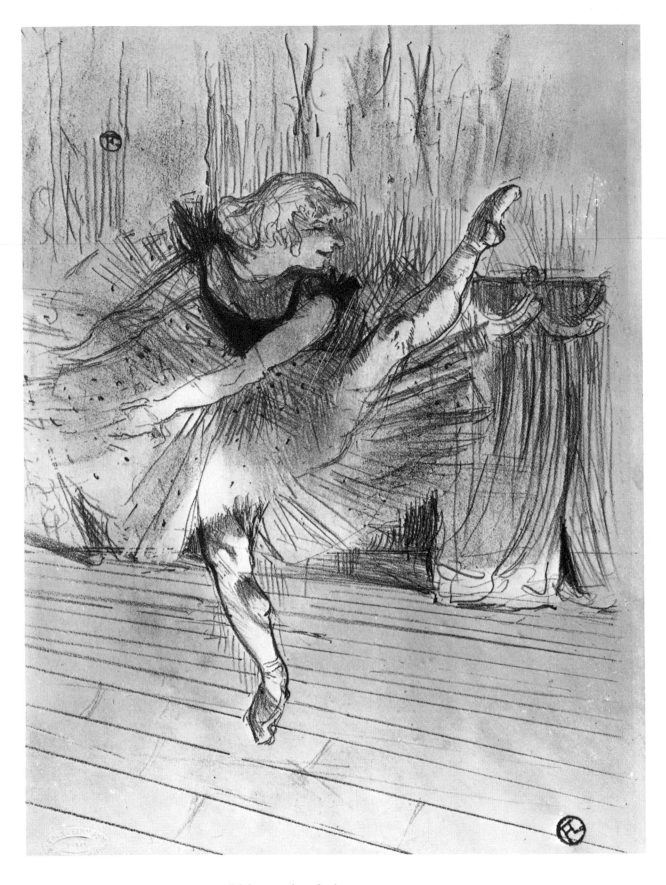

102. THE DANCER IDA HEATH. Lithograph, 1896

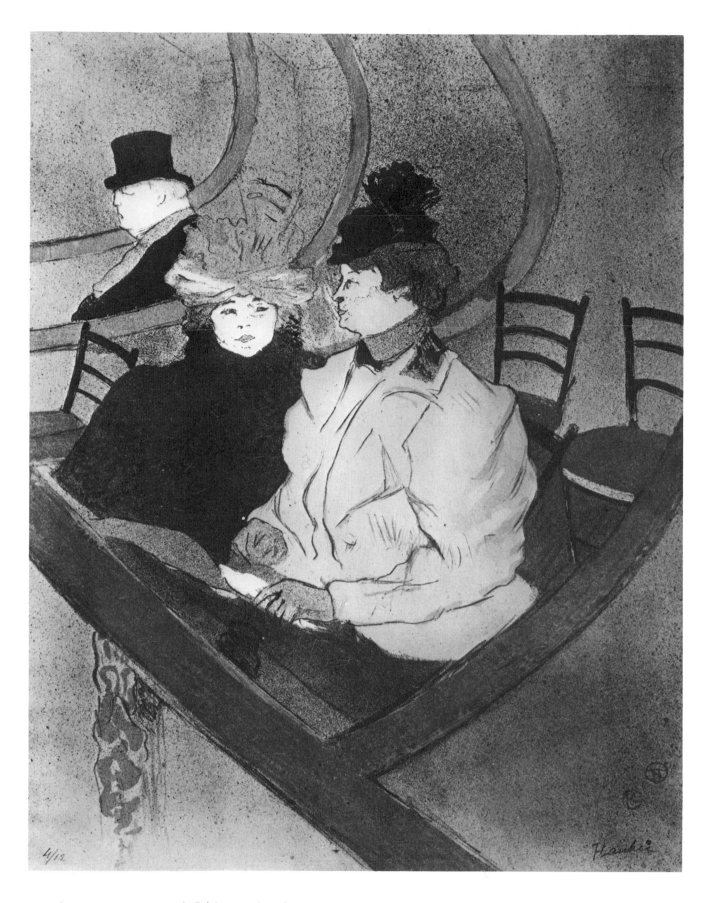

4/12

103. 'LA GRANDE LOGE'. Lithograph, 1897

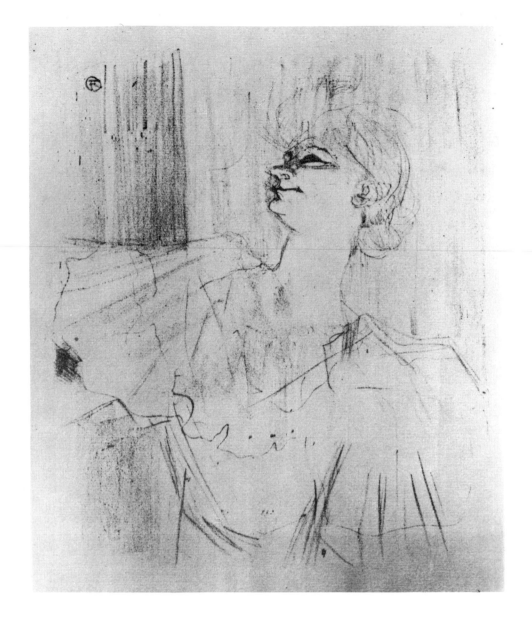

104. YVETTE GUILBERT: 'À MENILMONTANT'. Lithograph, 1898

105. ELSA, CALLED 'LA VIENNOISE'. Lithograph, 1897

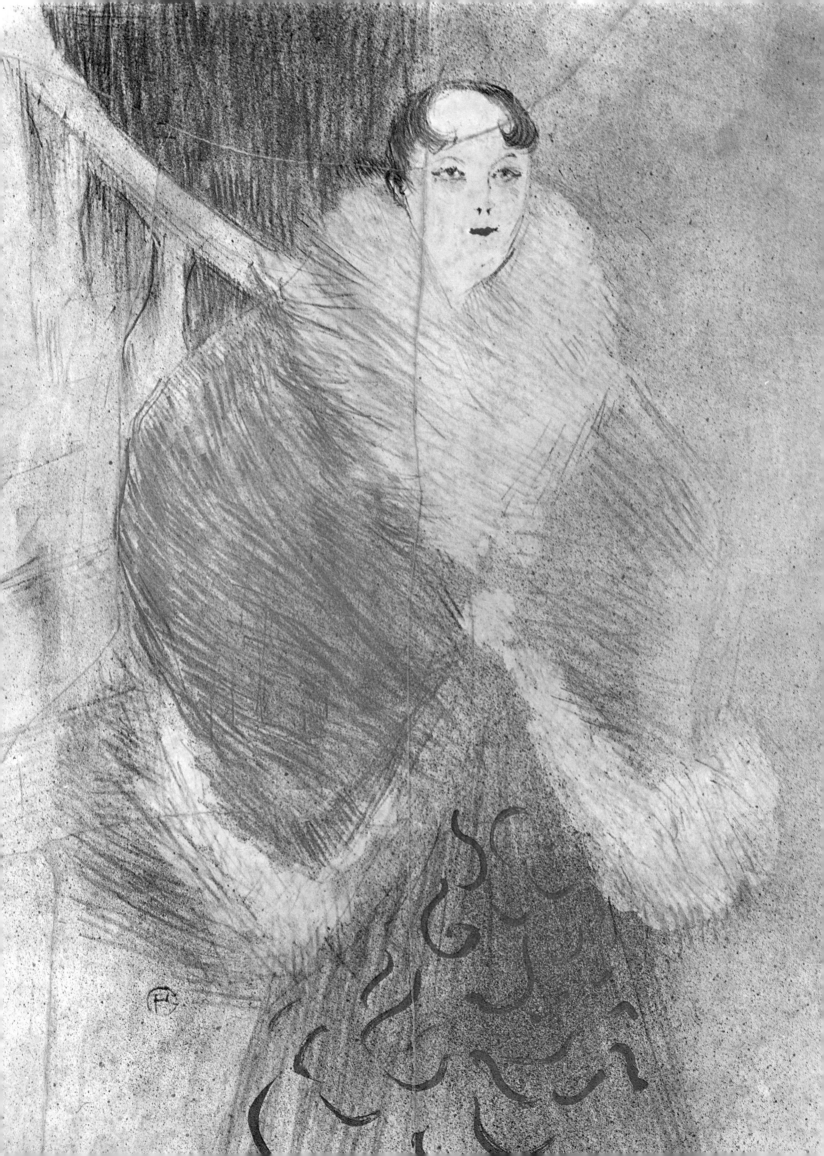

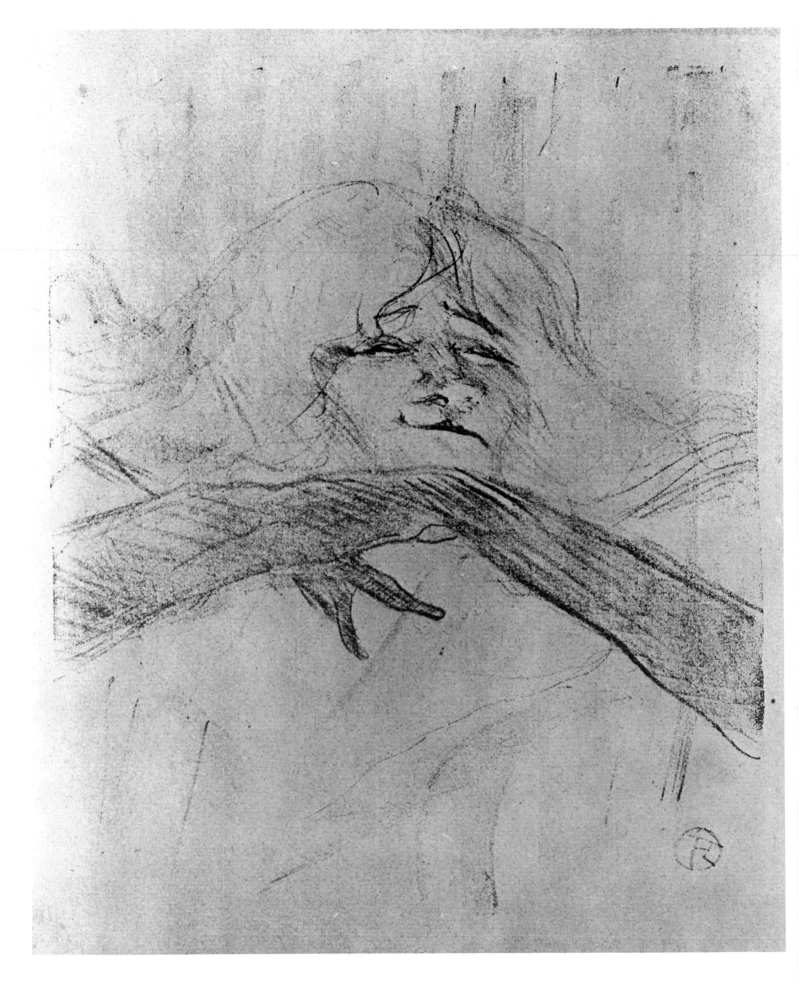

106. YVETTE GUILBERT: 'LINGER LONGER LOO'. Lithograph, 1898

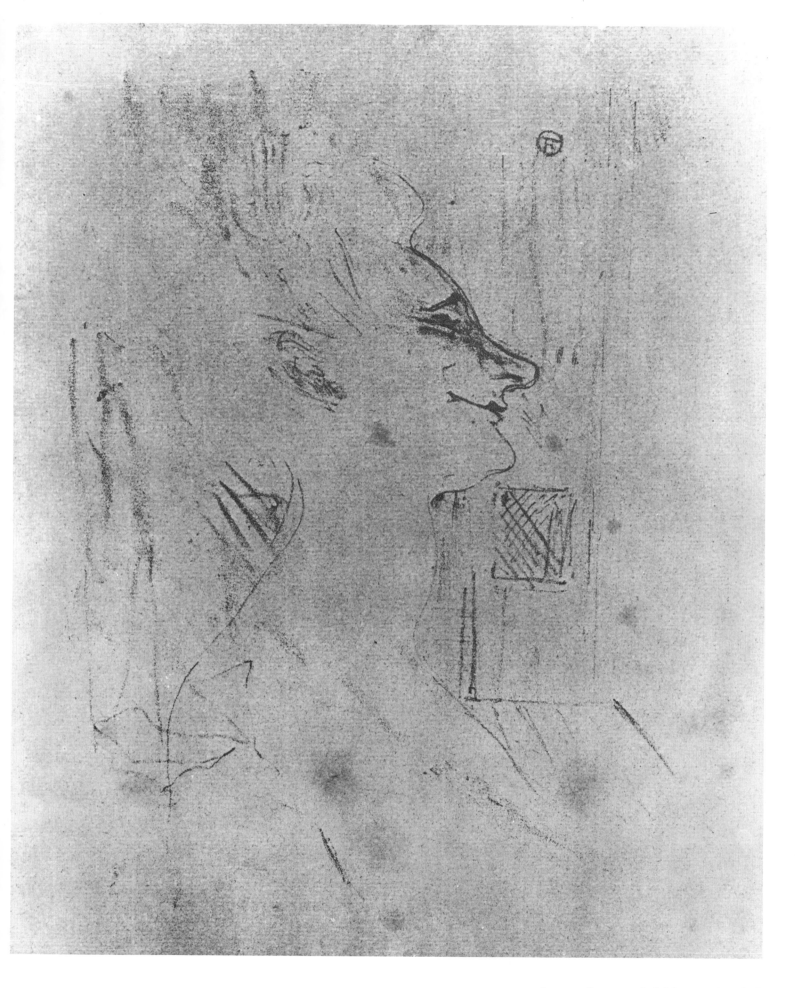

107. YVETTE GUILBERT: 'LA SOÛLARDE'. Lithograph, 1898

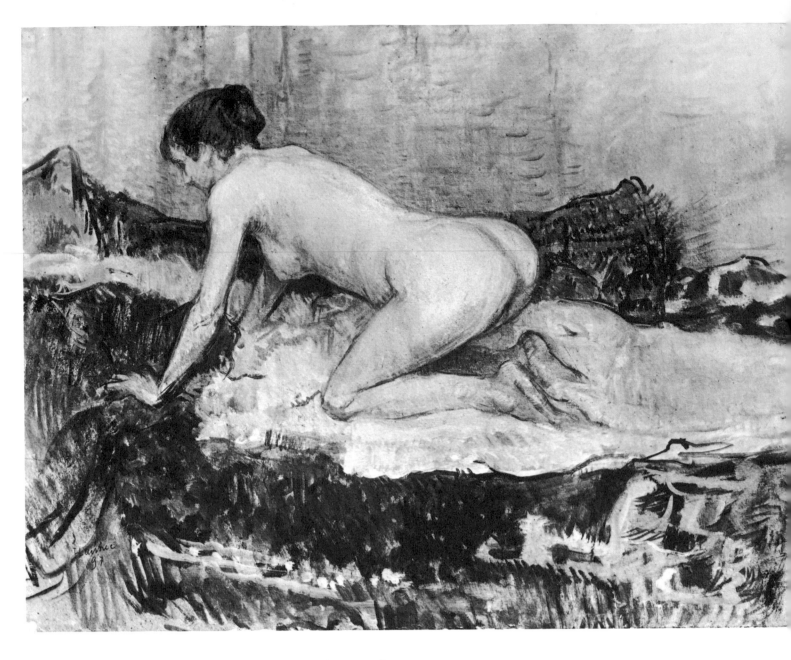

108. WOMAN KNEELING ON A SOFA. 1897. Paris, Maurice Exsteens

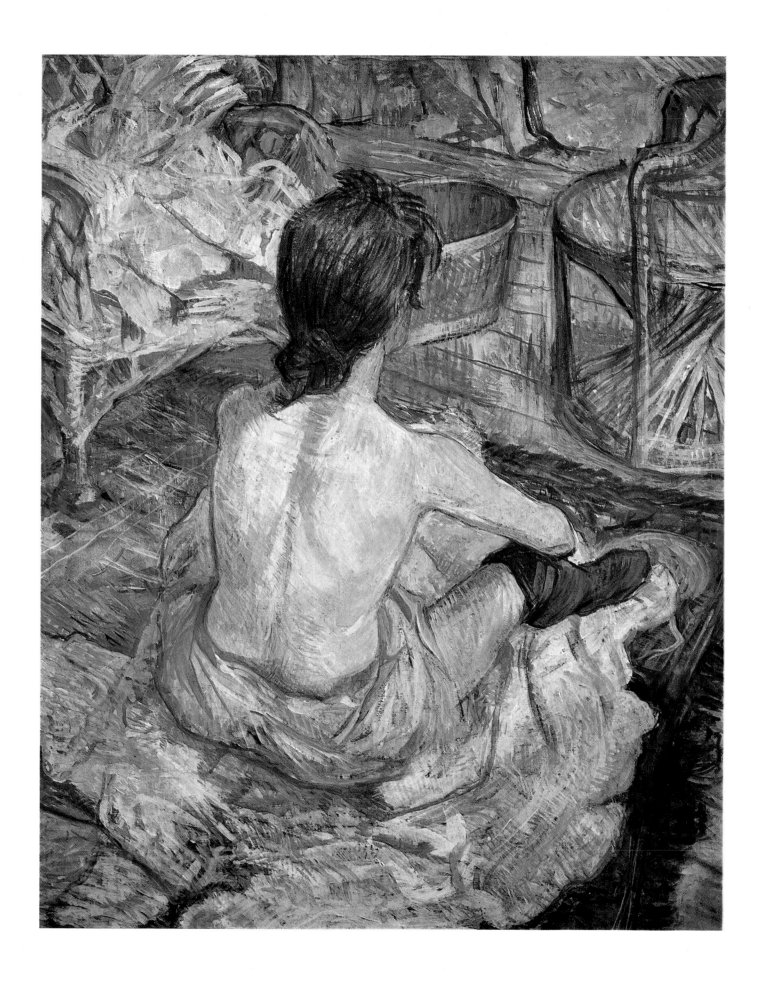

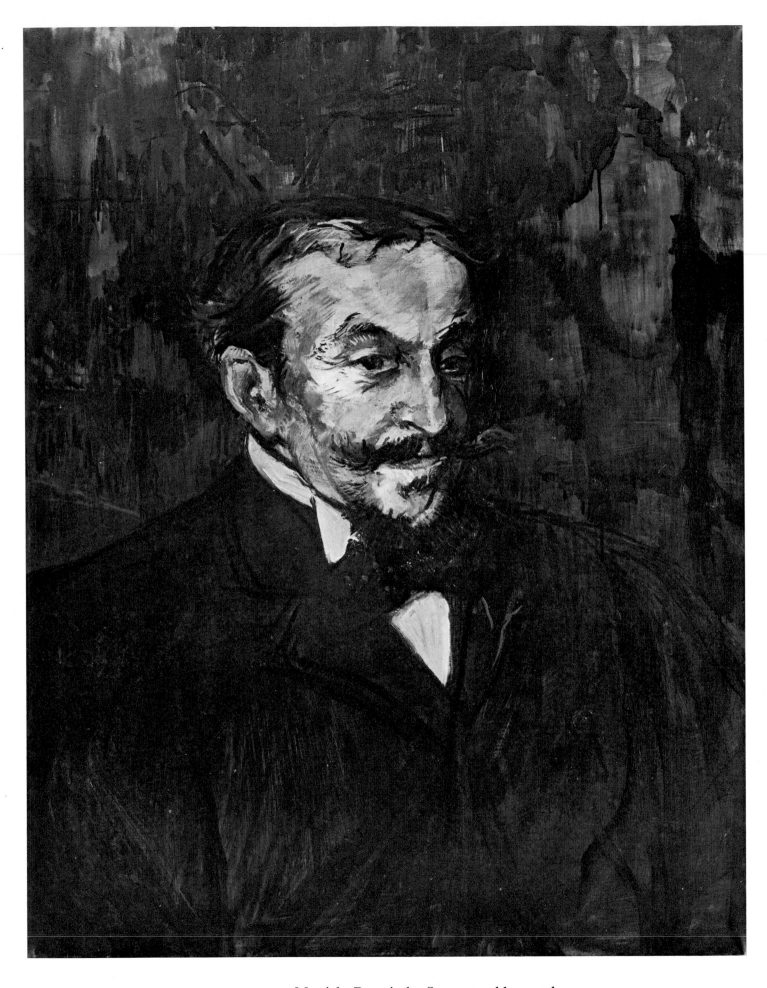

110. PORTRAIT OF A GENTLEMAN. 1900. Munich, Bayerische Staatsgemäldesammlungen

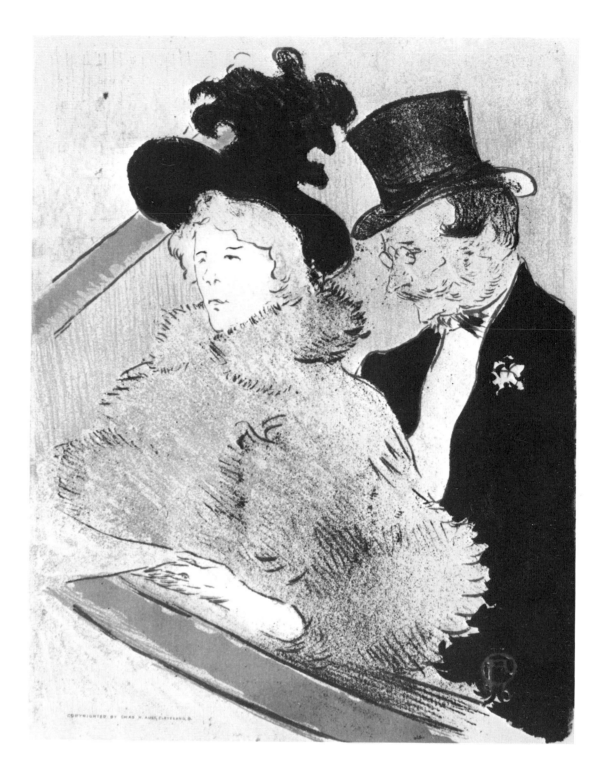

III. AT THE CONCERT. Lithograph, 1896

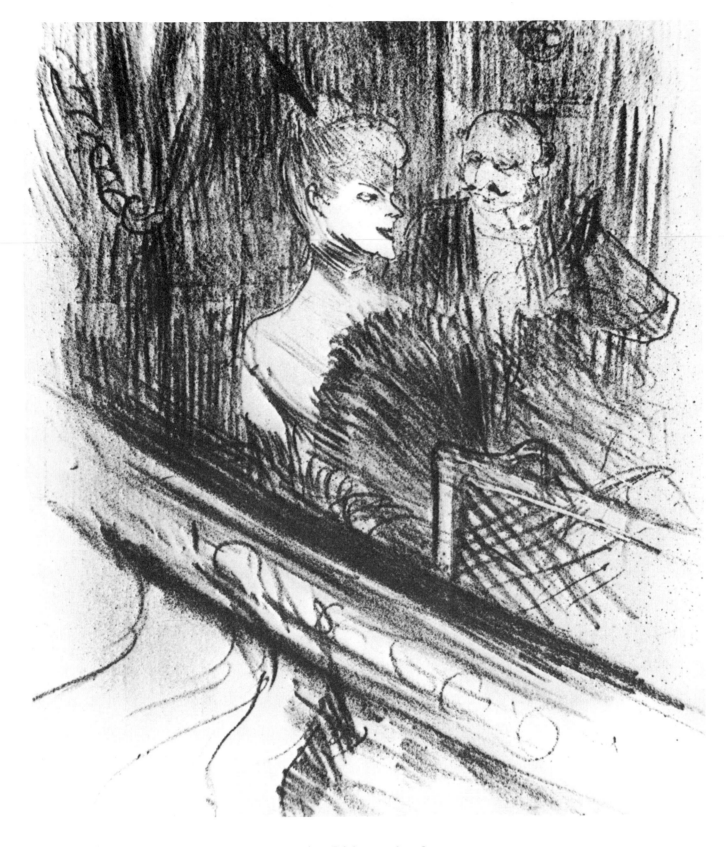

112. 'AT THE FOOT OF SINAÏ': BARON MOÏSE. Lithograph, 1897

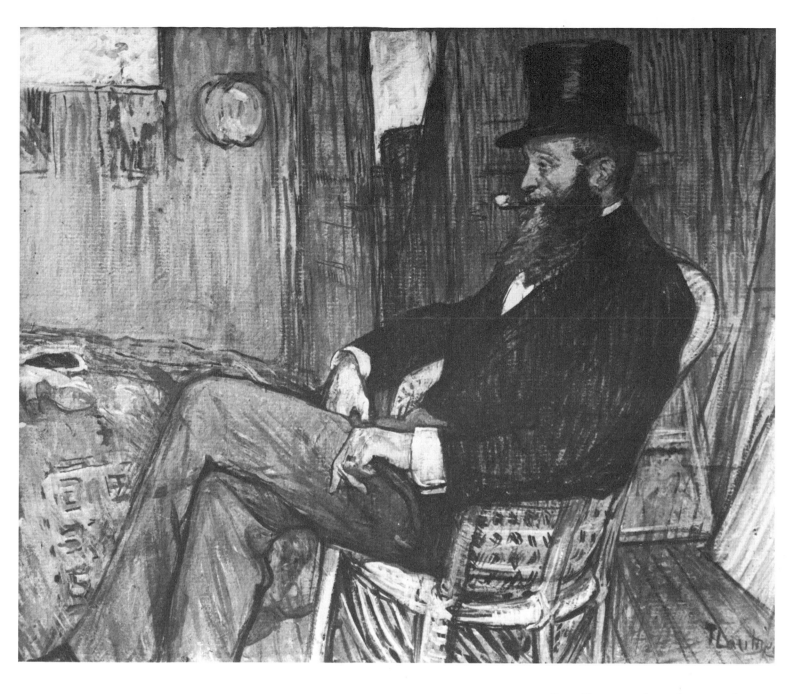

113. PORTRAIT OF M. LAURADOUR. 1897. Present whereabouts unknown

114. AT THE CIRCUS: PONY AND BABOON. Drawing, 1899.
Chicago, Art Institute, Gift of Tiffany and Margaret Black

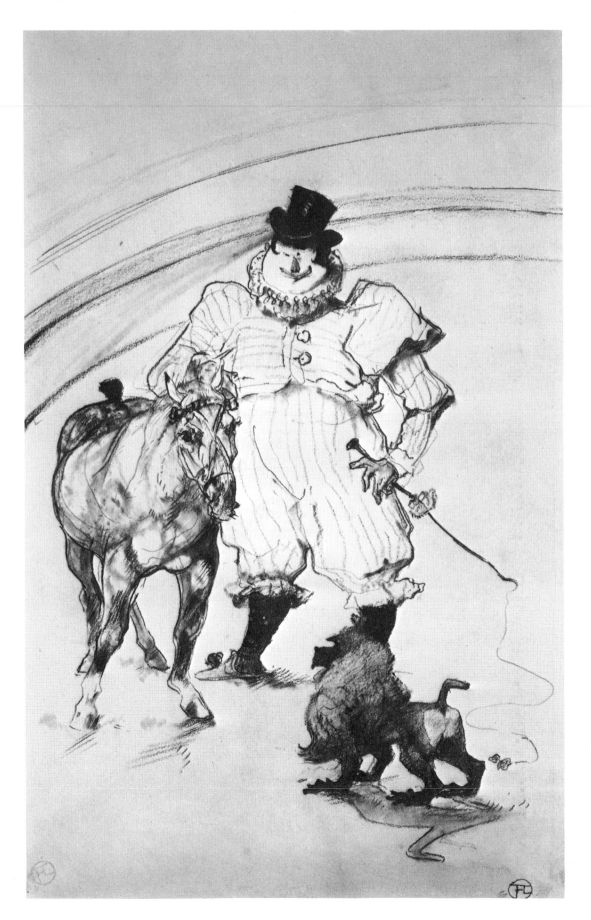

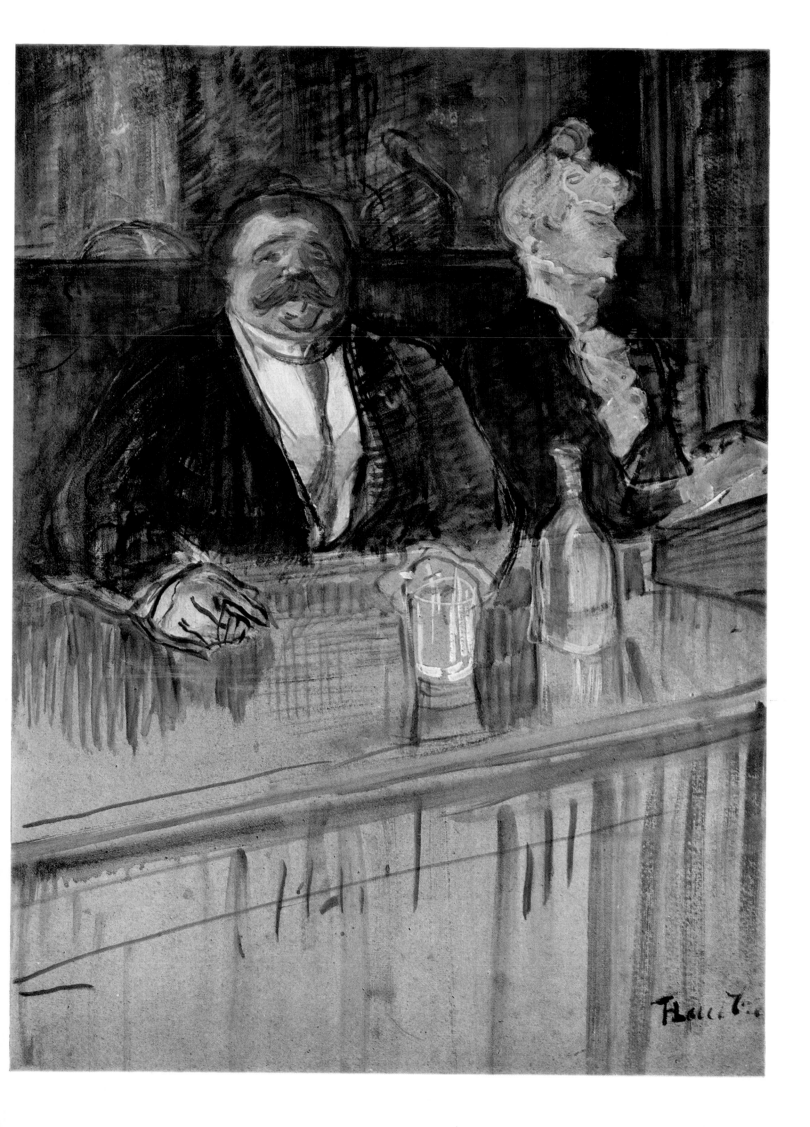

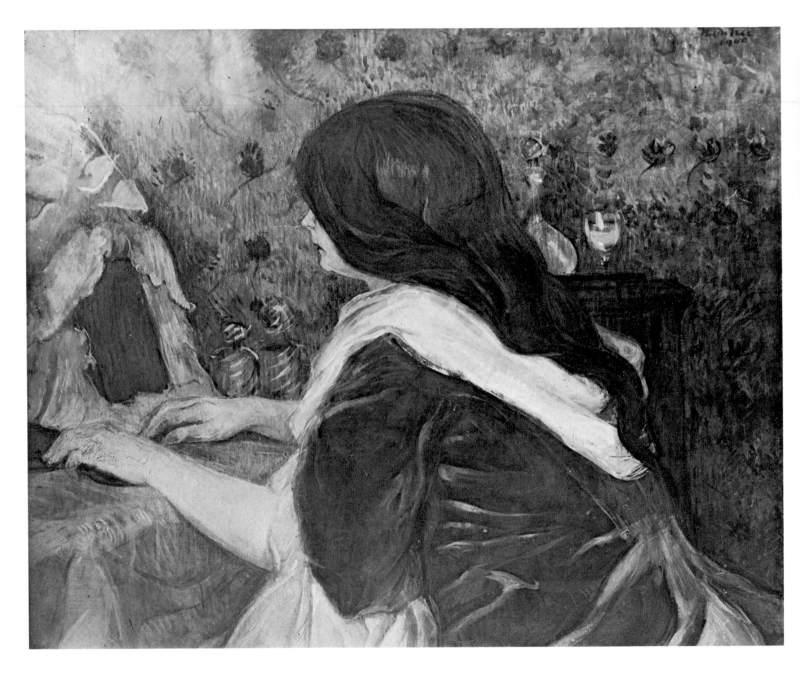

116. MADAME POUPOULE. 1900. Private Collection

117. THE SPHINX. 1898. Zurich, Alfred Hausammann

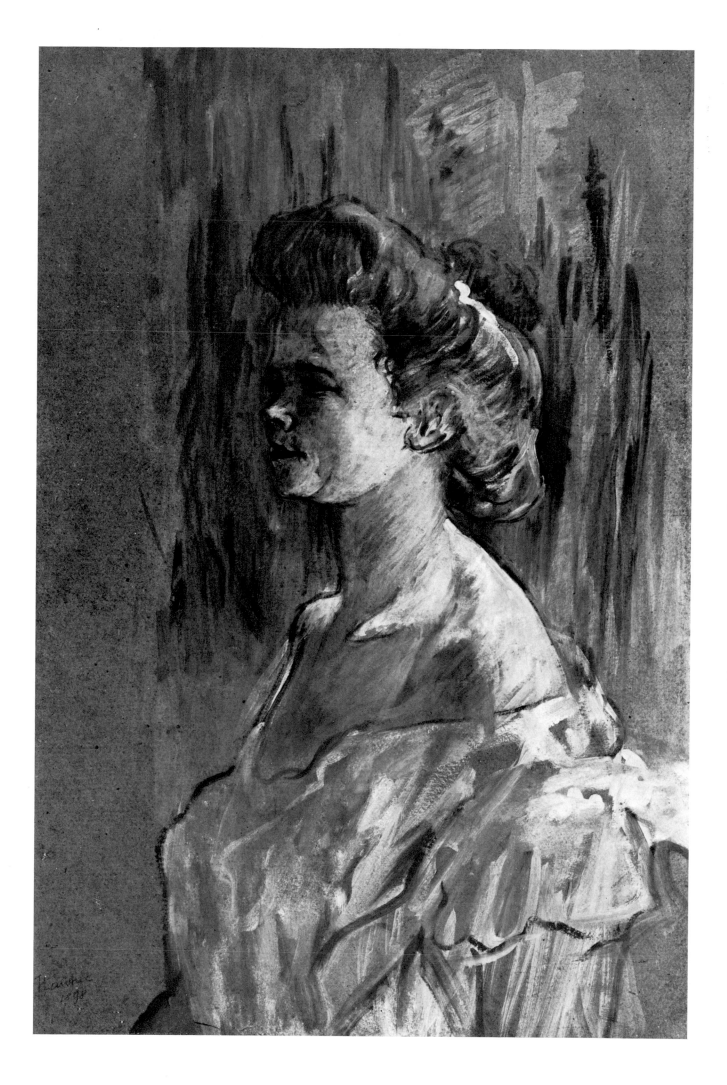

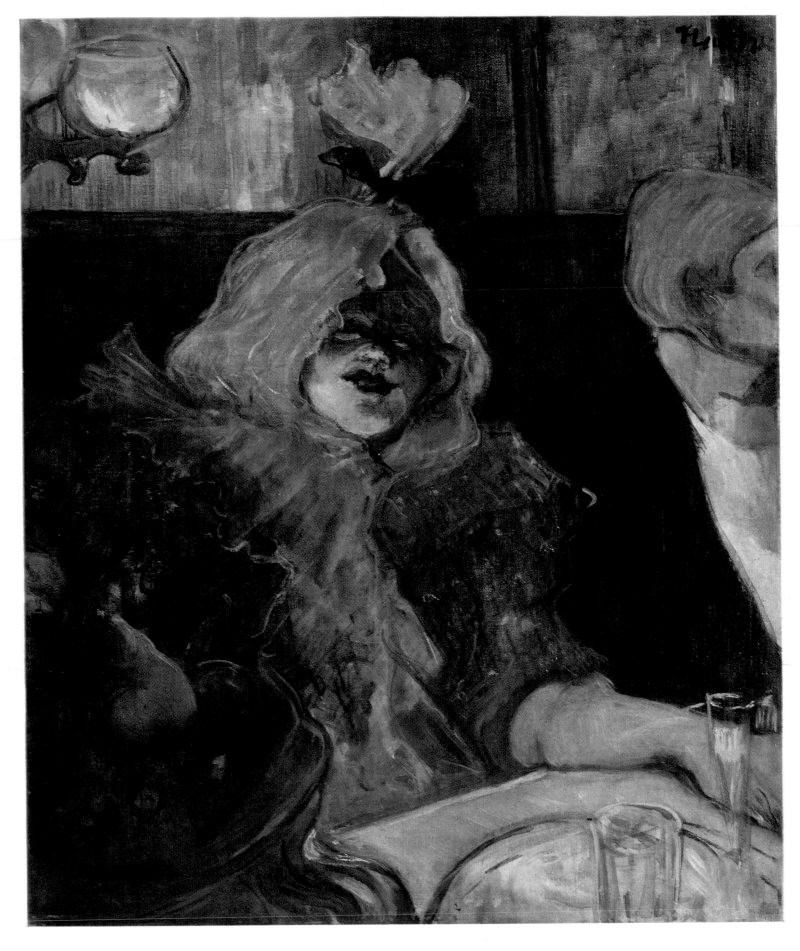

118. TÊTE-À-TÊTE SUPPER. 1899. London, Courtauld Institute Galleries

119. MLLE COCYTE AS 'BELLE HÉLÈNE'. Drawing, 1900. Present whereabouts unknown

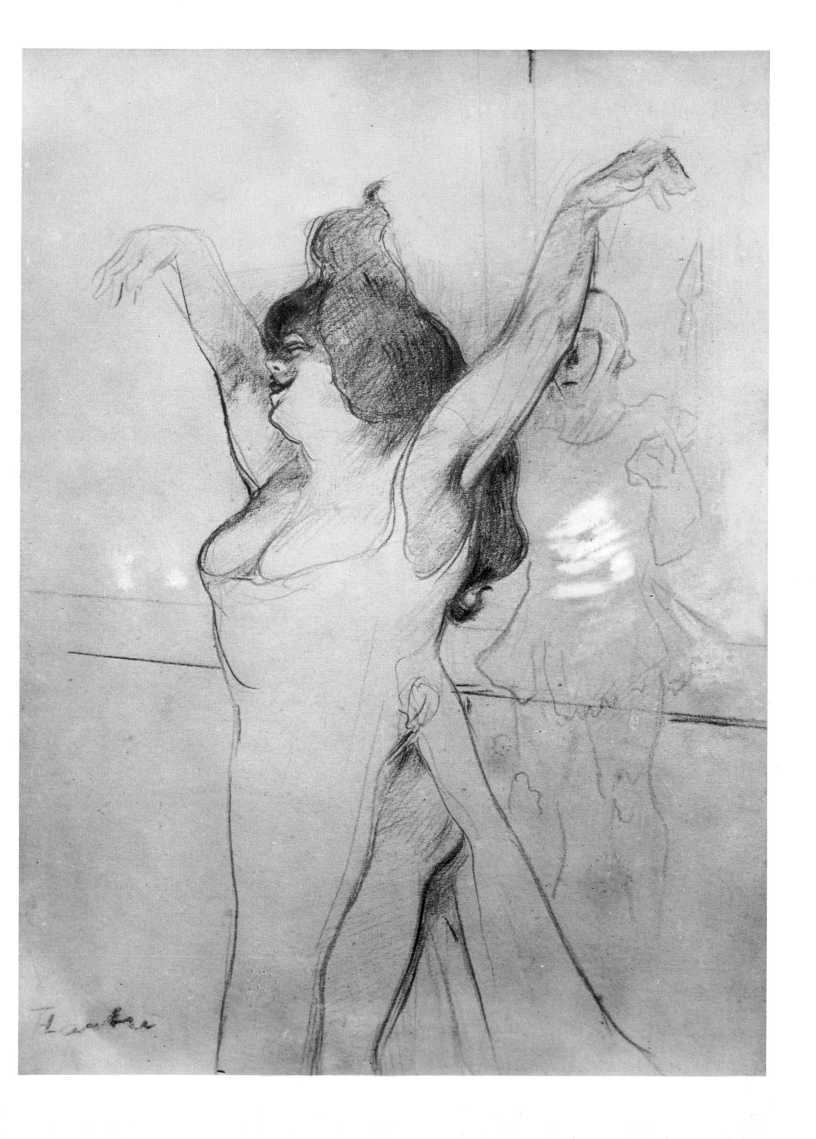

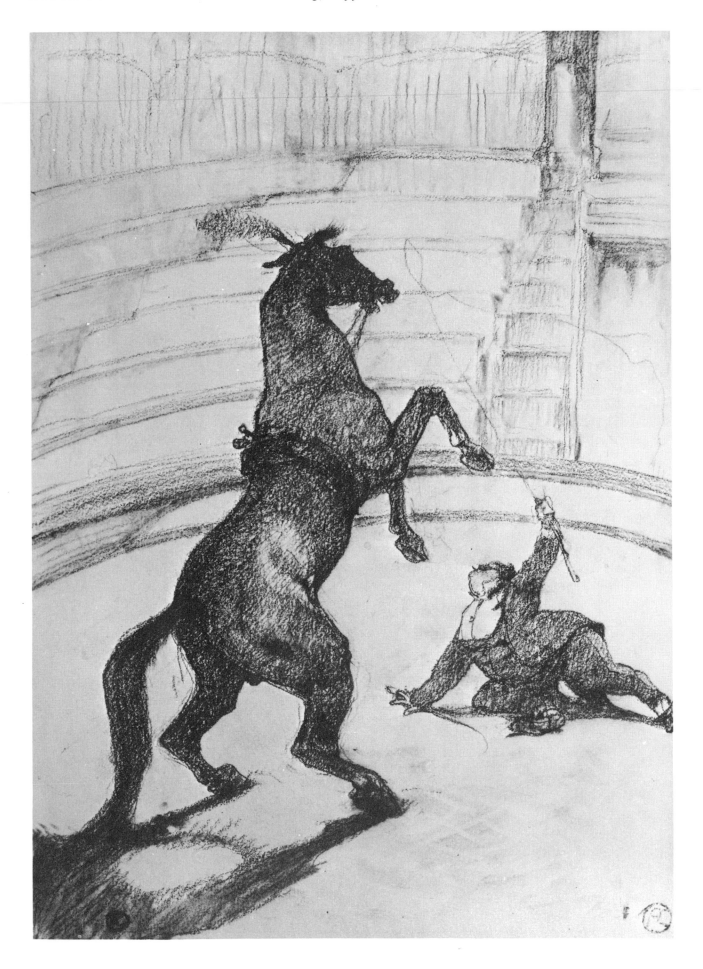

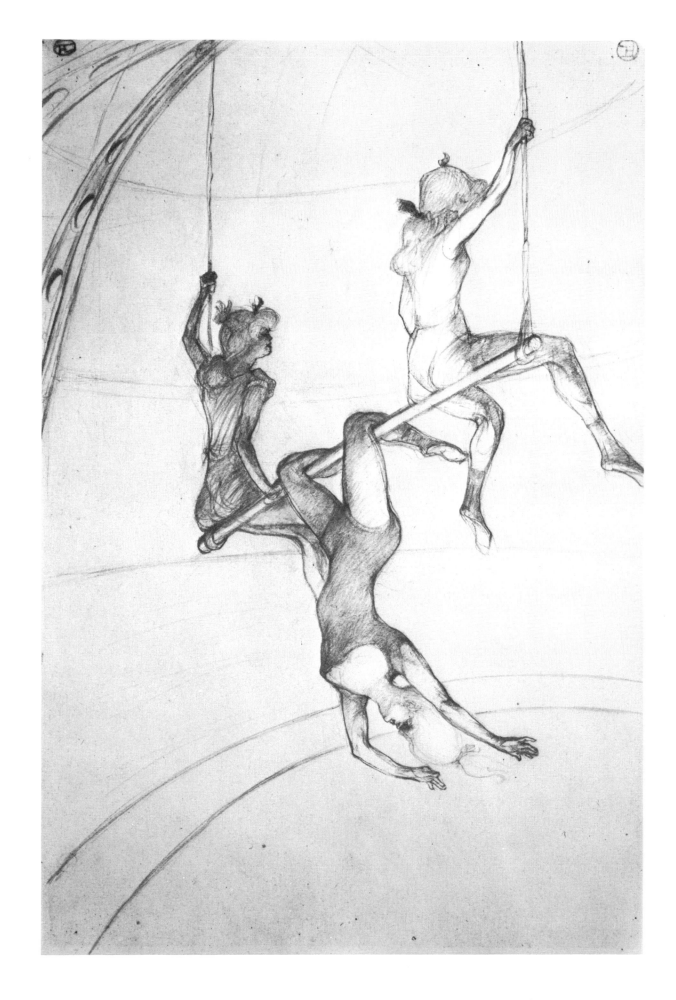

121. FLYING TRAPEZE ACT. Drawing, 1899.
Cambridge, Mass., Fogg Art Museum, Bequest of Grenville L. Winthrop

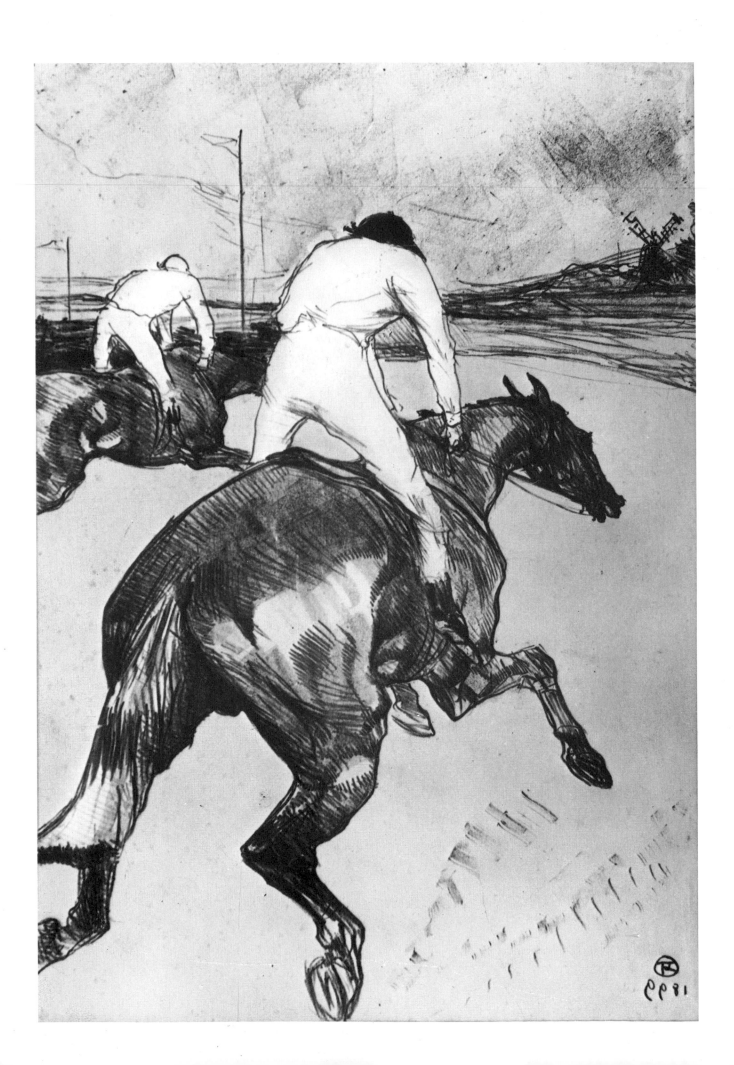

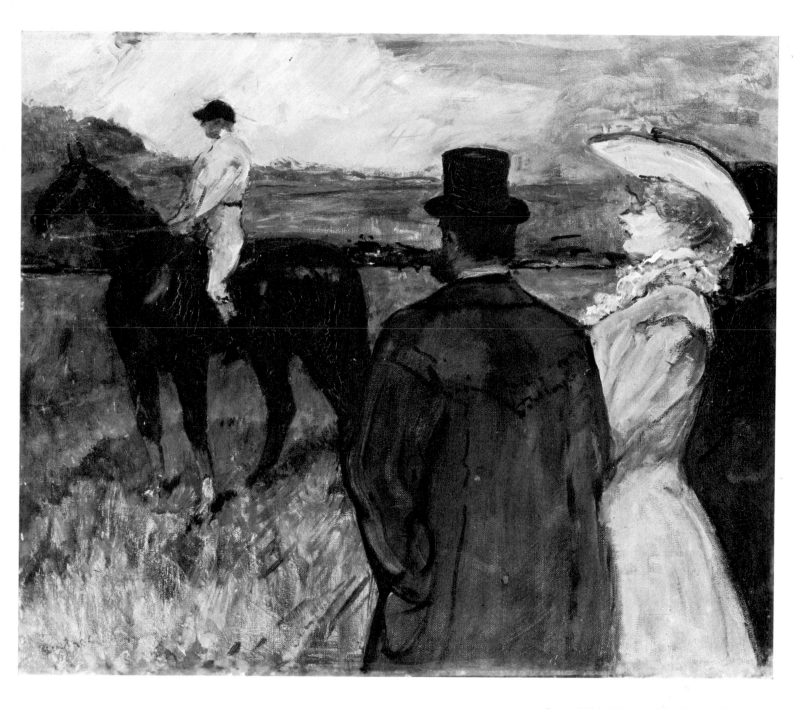

123. AT THE RACES. 1899. Albi, Musée Toulouse-Lautrec

122. THE JOCKEY. Lithograph, 1899

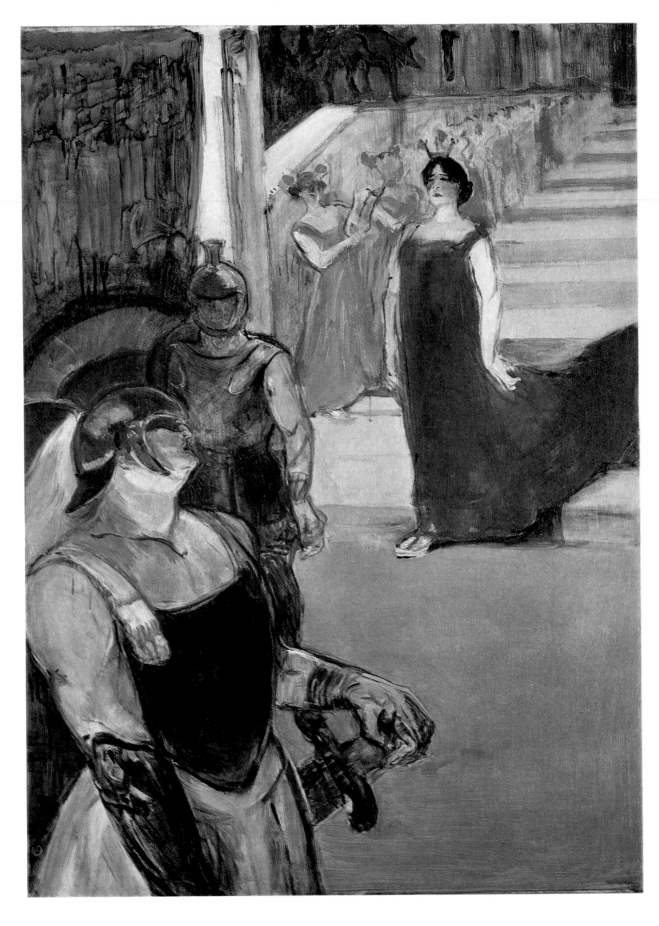

124. SCENE FROM 'MESSALINE' AT THE BORDEAUX OPERA. 1900–1.
Los Angeles, County Museum of Art, Mr. and Mrs. George Gard de Sylva Collection

Notes to the Illustrations

In the notes to the illustrations, reference is made to the following publications: Joyant's two-volume work published in 1926–7 (quoted as 'Joyant I, II'); Loys Delteil's complete catalogue of lithographs in two volumes, published in 1920 (abbr. 'D.'); Jéan Adhemar's complete catalogue of Lautrec's graphic art, based on Delteil's work, published in 1965 (abbr. 'A.'); and Edouard Julien's catalogue of Lautrec's posters, published in 1950 (quoted as 'Julien'). In the two last-mentioned publications some of the entries in Joyant's and Delteil's older and basic lists are frequently corrected. François Lachenal's detailed catalogue of the exhibition *Henri de Toulouse-Lautrec* held in Ingelheim on the Rhine in May–June 1968, contains further amendments, especially with regard to Lautrec's lithographic work (quoted as 'Lachenal').

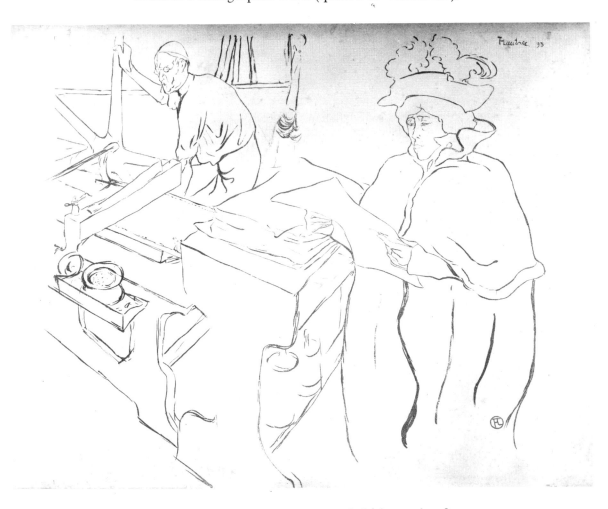

Fig. 33. 'L'ESTAMPE ORIGINALE'. Lithograph, 1893

Notes to the Illustrations

1 THE MAIL COACH AT NICE. 1881
Oil on canvas; 38·5 × 51 cm.; signed lower right: T-L
Souvenir de la Promenade des Anglais. Nice 1881
(Joyant I, p. 254)
Paris, Petit Palais

The coach is driven by Count Alphonse de Toulouse-Lautrec-Monfa, the artist's father.

2 A LABOURER AT CÉLEYRAN. 1882
Oil on canvas; 60 × 49 cm. (Joyant I, p. 256)
Albi, Musée Toulouse-Lautrec

3 COACH AND HORSE. c. 1881
Oil on wood; 32·7 × 23·9 cm.
Philadelphia, Mr. and Mrs. William Coxe Wright

4 FAT MARIA ('LA GROSSE MARIA'). 1884
Oil on canvas; 80·7 × 64·8 cm. (Joyant I, p. 259)
Wuppertal, Von der Heydt-Museum

5 THE ARTIST'S MOTHER AT BREAKFAST.
c. 1883–4
Oil on canvas; 93·5 × 81 cm. (Joyant I, p. 254)
Albi, Musée Toulouse-Lautrec

Lautrec often portrayed his mother, Countess Adèle-Zoë de Toulouse-Lautrec, née Tapié de Céleyran, in his paintings and drawings. Opinions vary as to when this picture was painted; according to E. Julien, 1883 would be the earliest possible date, since the Countess is shown seated in what is presumably the dining hall at the Château of Malromé and she acquired the Château in that year.

6 THE ARTIST'S UNCLE, AMÉDÉE TAPIÉ DE CÉLEYRAN. 1883
Charcoal drawing; 61·4 × 47·3 cm. with illegible, sketchy notes (Joyant II, p. 184)
New York, Charles E. Slatkin Galleries

The subject is the artist's uncle, Gabriel Tapié de Céleyran's father (see Plates 32, 60, 111 and note to Plate 60). This is one of a number of portraits which Lautrec drew of his relatives while he was studying with Bonnat and Cormon. For a long time these drawings were in the Château du Bosc (Dép. Aveyron), which was owned by the Tapié de Céleyran family and where Lautrec often stayed from the time of his childhood. These early works were first shown to the public in 1963–4 at two exhibitions (*Toulouse-Lautrec: Portraits and Figure Studies – The Early Years*) arranged by the Charles E. Slatkin Galleries in New York and the Fogg Art Museum at Harvard University. (For further details of the drawings see the catalogue of these exhibitions and Marie Tapié de Céleyran's *Notre Oncle Lautrec*, Geneva, 1953.)

7 GIRL IN THE ARTIST'S STUDIO (HÉLÈNE VARY) 1888
Tempera on cardboard; 75 × 50 cm.; signed lower right: H. T.-Lautrec (Joyant I, p. 266)
Bremen, Kunsthalle

There are two further portraits of the same model (Joyant I, p. 266).

8 THE LAST FAREWELL ('LE DERNIER SALUT').
Early 1887
Pencil drawing heightened with white on bluish paper; 63 × 48 cm. (Joyant II, p. 190)
Albi, Musée Toulouse-Lautrec

Study for an illustration of *Le dernier salut*, a song by Aristide Bruant, which appeared in No. 34 of his magazine *Le Mirliton* in March, 1887. A similar study is also in the Albi Museum and the final drawing, with the hearse in the background, is in the Herbert Melbye Collection in Copenhagen (Joyant II, p. 190).

9 ARTILLERYMAN AND GIRL. c. 1886
Oil on tracing paper; 57 × 46 cm. (Joyant II, p. 188)
Albi, Musée Toulouse-Lautrec

One of several versions of these figures in the Albi Museum.

10 PORTRAIT OF JEANNE WENZ. 1886
Oil on canvas; 81·3 × 59·1 cm.; signed lower right: HT-Lautrec (Joyant I, p. 261)
Chicago, Art Institute (Gift of Annie Swan Coburn to the Mr. and Mrs. Lewis L. Coburn Memorial Collection)

There is another, later portrait of Jeanne Wenz seated at a round table in a café (*The Absinth Drinker – 'À la Bastille'*, Private Collection; Joyant I, p. 264).

11 PORTRAIT OF MADAME ALINE GIBERT. 1887
Oil on canvas; 62 × 50 cm. (Joyant I, p. 262)
Present whereabouts unknown

12 SUZANNE VALADON. 1885
Oil on canvas; 54·5 × 45 cm.; signed upper right:
T-Lautrec (Joyant I, p. 261)
Copenhagen, Ny Carlsberg Glyptotek

Portrayed here is the artist Suzanne Valadon (1867–1938), the mother of Maurice Utrillo.

13 VINCENT VAN GOGH. 1887
Pastel on cardboard; 54 × 45 cm. (Joyant I, p. 262)
Amsterdam, Stedelijk Museum

Van Gogh made Lautrec's acquaintance in Paris in 1886–7. The two artists met for the last time when Van Gogh visited Paris briefly at the beginning of July, 1890.

14 'À MONTROUGE: ROSA LA ROUGE'. 1888
Oil on canvas; 70 × 47 cm.; signed upper left: Lautrec
(Joyant I, p. 264)
Merion, Pa., Barnes Foundation

The title comes from the name of one of Bruant's chansons that appeared in *Le Mirliton*:
'C'est Rosa, j'sais pas d'où qu'a vient,
Ell a l'poil roux, eun têt'de chien.
Quand a pass', on dit: v'là la Rouge
À Montrouge'
Joyant (I, p. 264 and II, p. 193) mentions a drawing illustrating this chanson which appeared under the title *Boulevard extérieur* in the *Courrier Français* on 2 June, 1889. The same model, Carmen Gaudin, is shown as a laundress in a painting of 1889 (Joyant I, p. 268).

15 THE LAUNDRESS. 1888
Brush-drawing heightened with white, on cardboard; 76·2 × 63 cm.; signed lower right: T-Lautrec (Joyant II, p. 191)
Cleveland, Museum of Art (Gift of Hanna Fund)

Draft for one of the illustrations for Émile Michelet's article *L'Été à Paris*, which appeared in *Paris Illustré* on 7 July, 1888. There is a second drawing in the Albi Museum (Joyant II, p. 191).

16 PORTRAIT OF HENRI SAMARY. 1889
Oil on cardboard; 75 × 52 cm.; signed lower right: Lautrec 89 (Joyant I, p. 266)
Paris, Jacques Laroche

The actor Henri Samary of the Comédie-Française is depicted here in the rôle of Raoul de Vaubert in Jules Sandeau's *Mlle de la Seiglière*.

17 SELFPORTRAIT, CARICATURE. c. 1890
Black chalk drawing; 25·5 × 16 cm. (At the top there is a sketch of a hat or slipper; Joyant II, p. 247, erroneously states that this drawing is owned by the Albi Museum.)
Rotterdam, Museum Boymans-van Beuningen

See E. Haverkamp Begemann in the *Bulletin of the Museum Boymans*, April, 1951, II, No. 2.

18 AT THE NOUVEAU CIRQUE: FIVE STUFFED SHIRTS ('AU NOUVEAU CIRQUE. LA CLOWNESSE AUX CINQ PLASTRONS'). 1891
Oil on cardboard; 60 × 40 cm.; monogram lower left (Joyant I, p. 273)
Philadelphia, Museum of Art

This is a scene at the Nouveau Cirque, with five clowns in evening dress in the background. The picture was made into a stained-glass window at Tiffany's.

19 IN THE CIRCUS FERNANDO: THE RINGMASTER. 1888
Oil on canvas; 100 × 161 cm.; signed lower left: HT-Lautrec (Joyant I, p. 265)
Chicago, Art Institute (Joseph Winterbotham Collection)

20 DÉSIRÉ DIHAU READING IN THE GARDEN. 1891
Oil on cardboard; 55·2 × 45 cm. (Joyant I, p. 270)
Albi, Musée Toulouse-Lautrec

Désiré Dihau was a bassoonist at the Paris Conservatory and Opera, and a composer. He, his brother Henri and his sister, who were also musicians, belonged to Lautrec's circle of friends and were frequently portrayed by him. The garden in the picture is at 'Père Forest' in Montmartre, where Lautrec loved to paint portraits. The same garden is also the setting for another portrait of Désiré, as well as one of Henri. He painted Mlle Dihau playing the piano. (All these portraits are in the Albi Museum; Joyant I, pp. 268, 270.) Désiré is also portrayed twice in Lautrec's illustrations for the Dihau song cycle, *Les Vieilles Histoires* (D.18, 19; A.19, 20) and in the lithograph, *Judic and Dihau* (D.56; A.39). The Dihaus also appeared in some of Degas' paintings which Lautrec particularly admired.

21 WOMAN WITH GLOVES (HONORINE P.). c. 1892
Oil on cardboard; 54 × 40 cm.; signed upper right:
T-Lautrec (Joyant I, p. 272)
Paris, Louvre

**22 STUDY FOR THE POSTER 'MOULIN ROUGE –
LA GOULUE'. 1891**
Tinted pencil drawing; 154 × 118 cm. (Joyant I, p.
273)
Albi, Musée Toulouse-Lautrec

See poster, Plate 23.

23 MOULIN ROUGE – LA GOULUE. 1891
Coloured lithograph (D.339/II; Julien I; A.1); 195 ×
122 cm.; signed lower left: T-Lautrec

Lautrec's first poster. The lettering at the top is by
Lautrec. The upper part of the lettering is only found
in a few copies of the poster, since it had to be added
on a separate strip of paper because of the poster's
large format. The following studies for this work have
been preserved: a drawing in the Albi Museum (Plate
22), a painted study of La Goulue's head (Joyant I,
p. 273) and a gouache of La Goulue's head (Joyant I,
p. 273). The poster was exhibited among others by
Lautrec, at the *Exposition Internationale d'Affiches* in
Reims in November, 1896. 'La Goulue' ('The Glut-
ton', her real name was Louise Weber; 1870–1929)
was the most famous quadrille dancer of her day and
well known in the Paris entertainment world. She is a
particularly important figure in Lautrec's works, and
is described by Lautrec's biographers, in Eugène
Rodrigues' article *La Danse fin-de-siècle*, illustrated by
Legrand (in *Gil Blas*, 1891) and in Yvette Guilbert's
memoirs. She is the central figure of some of Lau-
trec's large-scale paintings and at other times a signi-
ficant background figure. She is never portrayed alone,
however, but rather as one who personified life in
Montmartre. Once in a lithograph, *La Goulue in Court*
(D.148; A.146), Lautrec has even exalted her to the
position of heroine in an imaginary scene. After her
heyday she appeared once more as a dancer and thus
again in Lautrec's work: in 1895, she performed a
Moresque dance in a booth at the Paris fairgrounds
and at her request Lautrec painted two large oil panels
(now in the Louvre; see Plates 72, 73) to decorate the
exterior of her booth. She died in poverty on 30
January, 1929. The grotesque dancer Valentin-le-
Désossé (Jacques Renaudin) was La Goulue's regular
dancing partner at 'The Moulin de la Galette', the
'Élysée Montmartre', the 'Jardin de Paris', and, of
course, the 'Moulin Rouge'. He owned a small café
and he danced every night for his own amusement.

He appears again and again in Lautrec's paintings and
lithographs (as in Plates 57, 61).

24 GIRL ARRANGING HER HAIR. 1891
Oil on wood; 64 × 51 cm.; signed upper left: Lautrec
(Joyant I, p. 271)
Present whereabouts unknown

The pictures leaning against the background indicate
that this was painted in Lautrec's studio. For this
reason it is also called *The Model*. There is a very
similar version in the Louvre (Joyant I, p. 271).

25 IN BED. 1892
Oil on cardboard; 52 × 33 cm.; signed upper left:
Lautrec (Joyant I, p. 282)
Paris, Maurice Exsteens

One of the group of scenes from the *Maisons closes*.
There is a very similar version of the same couple in
the Louvre (Joyant I, p. 283).

26 REINE DE JOIE. 1892
Coloured lithograph (D.342; Julien IV; A.5); 130 × 89·5
cm.; signed left: T-Lautrec

Poster for a book by Victor Joze (pseudonym of the
Polish writer Victor Dobrski). Lautrec also designed
covers and a poster for other books by him, for *Le
Tribu d'Isidore* and *Babylone d'Allemagne* (D.215, 76,
351; A.235, 67, 68). The Albi Museum has a sketch for
the poster *Reine de Joie* as well as some detail studies
(Joyant II, p. 198). The cover for the book was
designed by Pierre Bonnard.

27 'A LA MIE'. 1891
Oil on cardboard; 70 × 50 cm.; signed upper right:
T-Lautrec (Joyant I, p. 271)
Boston, Museum of Fine Arts

The man portrayed is Maurice Guibert, a friend of
Lautrec's (see Plates 32, 72). Lautrec used a photo-
graph by his photographer friend Sescau (see Plate
38) for this, where the two figures were shown in
the same pose as the one in the painting (see Heinrich
Schwarz, *Art of Photography: Forerunners and In-
fluences* in *Magazine of Art*, November 1949, p. 257).

28 AT THE MOULIN DE LA GALETTE. 1891
Oil on cardboard; 80 × 70 cm.; signed lower right:
T-Lautrec (Joyant I, p. 271)
Amsterdam, Stedelijk Museum

There is an oil study dated 1891 of the girl with the
fur stole – *Fille à la fourrure, Mlle J. F.* (Joyant I, p.
271).

29 LA GOULUE AT THE MOULIN ROUGE. 1891–2
Oil on cardboard; 80 × 60 cm.; signed lower left:
Lautrec (Joyant I, p. 275)
New York, Museum of Modern Art

The woman on La Goulue's left is her sister.

30 'DIVAN JAPONAIS'. 1893
Coloured lithograph (D.341; Julien III; A.11) 79·5 ×
59·5 cm.; signed lower right: T-Lautrec

Poster for the famous cabaret in Montmartre. There
is also a drawing and a study in oil (Joyant I, p. 274,
II, p. 198) and a tinted drawing of the woman alone
(Joyant I, p. 279). Represented are Jane Avril (see
note to Plate 39), the music critic Édouard Dujardin
(who can be seen elsewhere in Lautrec's works) and,
on the stage, Yvette Guilbert (who appears here for
the first time in Lautrec's work).

31 AT THE MOULIN ROUGE. 1892
Detail from Plate 32.

32 AT THE MOULIN ROUGE. 1892
Oil on canvas; 122·9 × 140·4 cm.; monogram lower
left (Joyant I, p. 275)
Chicago, Art Institute (Helen Birch Bartlett Memorial
Collection)

Although this picture, like the *Salon* (Plate 69) and
Marcel Lender in 'Chilpéric' (Plate 92), appears to
depict with true realism a scene of the moment, yet
it is at the same time the spontaneous artistic expres-
sion as well as the summation of a whole life-time's
experience. Seated around the table from left to right
are Édouard Dujardin (see Plate 30), the dancer La
Macarona, the photographer Paul Sescau (see Plate
38), and Maurice Guibert (see Plates 27, 32, 72). In
the right foreground is 'Mlle Nelly C.' (this figure is
on an added piece of canvas); in the background, on
the right is La Goulue with a partner, and on the left
are Toulouse-Lautrec and Gabriel Tapié de Céleyran
(see Plates 60, 111).

33 DANCE AT THE MOULIN ROUGE. 1892
Oil on cardboard; 93 × 80 cm.; signed upper left:
Lautrec 92 (Joyant I, p. 275 f.)
Prague, National Gallery

This painting, which in 1897 reappeared as a litho-
graph (D.208; A.258), is also known as *Les deux
valseuses*. Of the two women dancing, the one on the
right is supposed to be the clowness Cha-U-Ka-O (see
Plates 79, 80, 81, 82); the woman with her back

turned, on the right, is Jane Avril; the man at the
extreme right is the English painter Charles Conder
(1868–1909), a friend of Lautrec's; and on the extreme
left is the painter François Gauzi, who had been a
fellow-pupil at the Atelier Cormon and of whom
Lautrec painted several portraits.

34 QUADRILLE AT THE MOULIN ROUGE. 1892
Gouache on cardboard; 80·1 × 60·5 cm.; monogram
lower right (Joyant I, p. 275)
Washington, D.C., National Gallery of Art (Chester
Dale Collection)

35 LA GOULUE AND 'MÔME FROMAGE' AT THE
MOULIN ROUGE ('AU MOULIN ROUGE: LA
GOULUE ET SA SOEUR'). 1892
Coloured lithograph (D.11; A.2); 45·8 × 34·7 cm.

There is also a painted version (Joyant I, p. 275).
According to Adhémar, the title *La Goulue and her
Sister*, originally given by Delteil, is incorrect.
Adhémar believes that it is not La Goulue's sister but
a dancer in her circle with the nickname 'Môme
Fromage'. According to Sagot, she is another dancer:
'Grille d'Égout'.

36 THE ENGLISHMAN AT THE MOULIN ROUGE
('L'ANGLAIS AU MOULIN ROUGE'). 1892
Coloured lithograph (D.12; A.3); 47 × 37·2 cm.

There is an oil-sketch for this lithograph (Joyant I,
p. 275) and a study for the head of the Englishman,
W. T. Warrener, who was a friend of Lautrec's (see
Plate 37). He is also seen in the background of the
picture of Jane Avril dancing (Plate 39). In one of the
sketchbooks preserved at the Albi Museum there is a
sketch of his head (Joyant II, p. 198); and in the
Bibliothèque Nationale in Paris there is a slightly
different lithographic version with wash (Joyant II,
p. 198, plate next to page 56; such lithographic ver-
sions are not catalogued by Delteil).

37 HEAD OF MR. WARRENER. 1892
Oil on cardboard; 58 × 48 cm.; monogram lower right
(Joyant I, p. 275)
Albi, Musée Toulouse-Lautrec

Portrait study for the lithograph *L'Anglais au Moulin
Rouge* (Plate 36).

38 PORTRAIT OF PAUL SESCAU. 1891
Oil on cardboard; 73·5 × 51·5 cm.; signed lower left:
T-Lautrec 91 (Joyant I, p. 270)
New York, Brooklyn Museum

The photographer Paul Sescau was one of Lautrec's close friends and appears repeatedly in Lautrec's works: for example, in the lithograph *Promenoir* (D.290; A.324); in the painting *At the Moulin Rouge* (Plate 32); and among the spectators in *La Goulue, Dancing* (*Danse de l'Almée*; Plate 73). In 1894, Lautrec designed a poster for the photographer, who had his studio in the house at 9, Place Pigalle (D.353; Julien XV; A.69).

39 JANE AVRIL, DANCING. C. 1892
Oil on cardboard; 85·5 × 45 cm.; signed upper right: T-Lautrec (Joyant I, p. 274)
Paris, Louvre

Jane Avril, nicknamed 'La Mélinite' ('The Bomb'), was one of Paris' most famous dancers. Lautrec portrayed her frequently in paintings, lithographs and posters (e.g., Plates 30, 40, 42, 43; see her biography, written as a novel by Jose Shercliff: *Jane Avril of the Moulin Rouge*, London, 1952). In the background of this picture, in the box, is the Englishman, Mr. Warrener (see Plates 36, 37).

40 JANE AVRIL. 1893
Lithograph (D.28; A.28); 26·5 × 21·3 cm.

First page of the album *Le Café-Concert*, which contains eleven lithographs each by Lautrec and Ibels illustrating a text by Georges Montorgueil (see Plate 52). For a description of Jane Avril, see note to Plate 39.

41 LOÏE FULLER. 1893
Lithograph, hand-coloured by Lautrec (D.39; A.8); 43 × 27 cm.
Paris, Bibliothèque Nationale

One of the lithographs, each coloured differently and sprayed with gold, at the Bibliothèque Nationale and the Bibliothèque d'Art et d'Archéologie in Paris. An oil-sketch for this lithograph is in the Albi Museum (Joyant I, p. 277). The versatile American actress and singer Loïe Fuller first appeared in Paris in 1892 in veil dances with coloured light effects. She was also portrayed, dancing, by the sculptor Raoul Larche (1860–1912) in a well-known bronze statue.

42 PROMENADE IN THE MOULIN ROUGE. 1891
Oil on cardboard; 80 × 65 cm.; signed lower left: T-Lautrec (Joyant I, p. 272)
Present whereabouts unknown

Jane Avril is doing a solo dance in the background.

43 JANE AVRIL LEAVING THE MOULIN ROUGE 1892
Oil on cardboard; 86 × 65 cm.; signed lower left: Lautrec (Joyant I, p. 274)
Hartford, Conn., Wadsworth Atheneum

The man in the background is the English painter Charles Conder (see Plate 33).

44 WOMAN WITH A BLACK FEATHER BOA. c. 1892
Oil on cardboard; 53 × 41 cm.; signed lower right: T-Lautrec (Joyant I, p. 282)
Paris, Louvre

45 MONSIEUR E. DELAPORTE IN THE 'JARDIN DE PARIS'. 1893
Oil on cardboard; 76 × 70 cm.; signed lower right: Pour M. Delaporte, Lautrec (Joyant I, p. 277)
Copenhagen, Ny Carlsberg Glyptotek

There is a sketch for this portrait in the Albi Museum.

46 THE LAST JOURNEY ('ULTIME BALLADE'). 1893
Lithograph (D.23/I; A.22), 26·5 × 18 cm.

No. 9 of the illustrations for *Vieilles Histoires* by Goudezki and Dihau (see note to Plate 20). Besides Lautrec, his fellow artists Henri Rachou and Henri-Gabriel Ibels also contributed to the series.

47 'ARISTIDE BRUANT DANS SON CABARET'. 1893
Coloured lithograph (D.348/II; Julien X; A.15); 127 × 92·5 cm.

There is also an oil-sketch for this poster (Joyant II, p. 200), one of four posters that Lautrec designed for the cabaret artist. Aristide Bruant (1851–1925), the 'Folksinger' of fin-de-siècle Paris, poet and composer, was closely related to Lautrec and Lautrec's art through his songs and ballads about the Paris suburbs, slums and the criminal underworld, which he made famous by his unique interpretations. As soon as his cabaret 'Le Mirliton' opened in 1885, Lautrec became a regular guest and drew several illustrations for Bruant's magazine of the same title, started in the same year (e.g., the illustration for *À Saint-Lazare*, Fig. 6). Drawings and paintings by Lautrec decorated the walls of 'Le Mirliton'. Lautrec portrayed Bruant frequently: as already mentioned, in four posters (D.343–4, 349; Julien V, VI, X; A.6–7, 71); then in two studies for a poster which was never completed (Joyant I, p. 273); and in several other studies. For a biography of Bruant, see Oscar Méténier's book, *Le Chansonnier Populaire Aristide Bruant* (Paris, 1893), and the relevant chapter in Yvette Guilbert's memoirs.

Bruant's songs and monologues were published in a collection under the title *Dans la Rue*, illustrated by Steinlen.

48 'EN QUARANTE!'. 1893
Lithograph (D.42; A.45), 28 × 23 cm.

This lithograph – the meaning of its title has never been explained – appeared as the third of twelve illustrations which Lautrec drew for the magazine *L'Escarmouche* (No. 3; 26 November, 1893). The lithographs appeared in the magazine as reproductions, and an edition of a hundred original lithographs were published simultaneously. Each reproduction in the magazine carries the motto 'J'ai vu ça', taken from the inscription ('Yo lo vi') on one of Goya's etchings in his series *Disasters of War* (see Plates 55, 56, 64, 65, 67).

49 'EROS VANNÉ'. 1894
Lithograph (D.74/II; A.81); 27·5 × 20 cm.

Cover illustration for a poem by Maurice Donnay which was recited by Yvette Guilbert. In the lithograph's fourth state only the injured figure of Eros appears. A study, a pen drawing in sepia, is in the collection of F. M. Gross in London.

50 YVETTE GUILBERT TAKING A CURTAIN CALL. 1893
Water-colour; 41·9 × 23 cm.; monogram lower left (Joyant II, p. 206)
Providence, R.I., Museum of Art, Rhode Island School of Design

This water-colour study depicts the 'diseuse' in the same gesture of a final bow as the last marginal illustration of Gustave Geffroy's book on Yvette Guilbert (*French Series*, see Fig. 22), and is presumably a study for this lithograph. There is a coloured photograph of the picture in the Albi Museum, possibly coloured by the artist himself (Joyant I, p. 280, mistakenly taken for the original – an error still found in the literature today). Yvette Guilbert (1868–1944) appears more frequently in Lautrec's work than any other stage artist of the time. He drew her very often (see Plates 30, 51, 52, 106, 107) but there is no known painted portrait of her. Yvette Guilbert has described her personal relationship with the artist in detail in her memoirs, *Chanson de Ma Vie* (Paris, 1927).

51 YVETTE GUILBERT. 1894
Pencil and oil on paper; 186 × 93 cm. (Joyant I, p. 280)
Albi, Musée Toulouse-Lautrec

Study for a poster which was never completed.

52 YVETTE GUILBERT. 1893
Lithograph (D.29; A.29); 24·9 × 19 cm.

From the album *Le Café-Concert* (see Plate 40).

53 YVETTE GUILBERT'S GLOVES. 1894
Oil on cardboard; 62·7 × 37·3 cm. (Joyant I, p. 280)
Albi, Musée Toulouse-Lautrec

Study for the cover (D.79; A.86) of Gustave Geffroy's album *Yvette Guilbert*, with the marginal illustrations by Lautrec (*Série française*; see Plate 50). The Print Room at the Louvre has a number of quick sketches of Yvette Guilbert on the stage (Figs. 23, 24), some of which are obviously related to the illustrations for Geffroy's book (see Fritz Novotny, *Drawings of Yvette Guilbert by Toulouse-Lautrec*, The Burlington Magazine, June 1949).

54 M. PRAINCE. 1893
Tempera and oil on cardboard; 51 × 36 cm.; monogram HT-L lower right (Joyant I, p. 279)
New York, André and Clara Mertens

This study was intended as one of the illustrations for Gustave Geffroy's article *Le plaisir à Paris – Les restaurants et les cafés-concerts des Champs-Élysées* in *Figaro Illustré*, where it was reproduced as a coloured etching in the July issue, 1893.

55 SARAH BERNHARDT IN 'PHÉDRE'. 1893
Lithograph (D.47; A.50); 34 × 23·1 cm.

Appeared in No. 7 of *L'Escarmouche* on 24 December, 1893 (see Plates 48, 56, 64, 65, 67). Sarah Bernhardt (1846–1923) is portrayed also a second time in Lautrec's lithographic work, in the series of thirteen portraits of actors (D.150–62; A.166–78). Adhémar points out that the lithograph depicts one of the performances of *Phèdre*, in which Marcel Proust saw Sarah Bernhardt, whom he named 'La Berma' in his novel *À la recherche du temps perdu*.

56 RÉJANE AND GALIPAUX IN 'MADAME SANS-GÊNE'. 1894
Lithograph (D.52; A.56); 34 × 26·5 cm.

This lithograph was intended for the magazine *L'Escarmouche* (see Plates 48, 55, 64, 65, 67), which in the meantime, however, was discontinued.

57 DANCE AT THE MOULIN ROUGE. 1890
Oil on canvas; 115 × 150 cm.; signed upper right: Lautrec 90 (Joyant I, p. 268)
Philadelphia, Henry P. McIlhenny

Besides Valentin 'le désossé', who is dancing with a partner, the following can be identified among the spectators: in the background on the right are M. Verney, Maurice Guibert, Paul Sescau, and the painters François Gauzi and Marcelin Desboutin; on the left is Jane Avril.

58 THE LETTER ('EN MEUBLÉ'). 1890
Oil on cardboard; 54 × 48 cm. (Joyant I, p. 269)
Present whereabouts unknown

59 THE CARDPLAYERS. c. 1893
Oil on cardboard; 58 × 46 cm.; signed lower right: H TLautrec (Joyant I, p. 284)
Bern, Professor Hans R. Hahnloser

60 PORTRAIT OF GABRIEL TAPIÉ DE CÉLEYRAN. 1894
Oil on canvas; 110 × 56 cm. (Joyant I, p. 281)
Albi, Musée Toulouse-Lautrec

Gabriel Tapié de Céleyran, a cousin of Lautrec's and one of his closest friends, studied in Paris under Dr. Péan, the surgeon. He appears frequently in Lautrec's works. In addition to this monumental painting, there are caricature drawings of him (Fig. 34) and paintings of group scenes in which he is in the background, as, for example, in the painting *At the Moulin Rouge* (see Plate 32, also Plate 111).

61 LA GOULUE AND VALENTIN WALTZING. 1894
Lithograph (D.71/I; A.77); 29·8 × 23 cm.

In its second state this lithograph was used as a cover for the music for the waltz *La Goulue* (published by A. Bosc). For a description of the subjects, see note to Plate 23. A drawing for the figure of La Goulue is in the collection of F. M. Gross in London.

62 THE MILLINER: RENÉE VERT. 1893
Lithograph (D.13/I; A.17); 35·5 × 25 cm.

In the second state of the lithograph there is an additional printing of the menu for a dinner given by the Société des Indépendants on 23 June, 1893. The Bibliothèque Nationale in Paris owns a preliminary pen drawing for the lithograph and the Louvre has a sketch. The woman portrayed later became the wife of the artist Adolph Albert, a colleague of Lautrec's at the Atelier Cormon. She may also be the subject of one of Lautrec's last paintings, *La Modiste* (1900, Joyant I, p. 301), although as a rule this picture is considered to be a portrayal of Mlle Margouin.

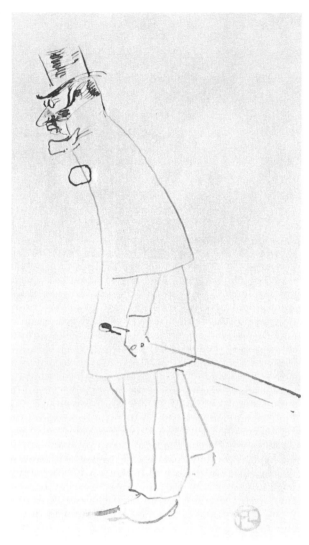

Fig. 34. GABRIEL TAPIÉ DE CÉLEYRAN. Drawing, 1894. Albi, Musée Toulouse-Lautrec

63 CONFETTI. 1894
Coloured lithograph (D.352; Julien XIV; A.9); 54·5 × 39 cm.
Poster advertising confetti manufactured by the London firm J. & E. Bella. An oil study dated 1894 is in the Bührle Foundation, in Zurich (Joyant I, p. 280)

64 AT THE GAIETÉ-ROCHECHOUART: NICOLLE AS A GIRL OF THE STREETS. 1893
Lithograph (D.48; A.51); 36·7 × 26 cm.

Appeared in No. 8 of the magazine *L'Escarmouche*, on 31 December, 1893 (see Plates 48, 56, 65, 67). According to Joyant it was originally intended for the series *Le Café-Concert* (see Plates 40, 52).

65 BARTET AND MOUNET-SULLY IN 'ANTIGONE'. 1893
Lithograph (D.53/11; A.59); 45·8 × 26·8 cm.

This lithograph was intended for *L'Escarmouche* (see Plates 48, 56, 64, 67) but never appeared in it.

66 LELOIR AND MORÉNO IN MOLIÈRE'S 'LES FEMMES SAVANTES'. 1893, appeared in 1894
Lithograph (D.54; A.60); 37·5 × 26·3 cm.

The accuracy of the alleged title is doubtful: the copy of the lithograph in the Albertina in Vienna bears the inscription, in pencil, *Truffier dans les Femmes Savantes* and Joyant (I, p. 92) calls it *Truffier et Moréno*. Depicted is the scene in which Trissotin recites a poem to the 'Précieuses Ridicules' in a performance at the Comédie-Française.

67 MLLE LENDER AND BRASSEUR. 1893
Lithograph (D.41/11; A.44); 34 × 24 cm.; signed lower left: Nº 10 T-Lautrec

Appeared in No. 2 of *L'Escarmouche* on 19 November, 1893 (see Plates 48, 56, 64, 65). Joyant mentions a study for this lithograph (II, p. 183). Marcelle Lender (1862–1926) was one of the great personalities of the Paris art world whom Lautrec portrayed particularly frequently (see Plates 67, 92, 93). This is the first time she appears in his work. Albert Brasseur was also often portrayed by Lautrec in stage scenes (Plate 78).

68 THE FRIENDS. 1894
Oil on cardboard; 47 × 33 cm.; signed lower left: HT-L (Joyant I, p. 285)
Albi, Musée Toulouse-Lautrec

A scene in the 'Maison Close' in the Rue des Moulins. Here Lautrec studied the life of the prostitutes, particularly during the years 1892–5, and produced a great number of pictures (see Plates 58, 59, 68–71, 76, 90, 95, 96, 99, 105).

69 THE SALON IN THE RUE DES MOULINS. 1894
Pastel; 111·5 × 132·5 cm.; monogram lower left (Joyant I, p. 287)
Albi, Musée Toulouse-Lautrec

A replica, in the same size, of this brothel scene (in oil, Joyant I, p. 287) is also in the Albi Museum. Both pictures, if only by their large size, represent a kind of final summation and artistic climax of this type of subject, rather like the later cycle of lithographs, *Elles* (Plates 80, 90, 95, 96, 99). Joyant refers to oil studies and drawings for these pictures, most of which are in the Albi Museum (I, p. 286; II, p. 203 f.).

Fig. 35. CARICATURE OF FÉLIX FÉNÉON. Drawing, c. 1896. New York, Prof. John Rewald

70 WOMAN PULLING UP HER STOCKING. c. 1894
Oil on cardboard; 58 × 46 cm. (Joyant I, p. 286)
Paris, Louvre

Scene in one of the brothels.

71 THE LAUNDRYMAN ('LE BLANCHISSEUR DE LA MAISON'). 1894
Oil on cardboard; 67 × 45 cm. (Joyant I, p. 285)
Albi, Musée Toulouse-Lautrec

An everyday scene in the brothel in the Rue des Moulins.

72 LA GOULUE DANCING WITH VALENTIN LE DÉSOSSÉ. 1895
Oil on canvas; 298 × 316 cm.; monogram lower right (Joyant I, p. 290 f.)
Paris, Louvre

One of two panels painted at La Goulue's request for her booth at the Foire du Trône (see Plate 73). They were later discovered cut up, at various art dealers, but it was possible to piece them together again. The dancing couple appear, in a similar form, in an oil sketch in a private collection in Winterthur. Besides the two central figures, Lautrec's friend Maurice Guibert can be seen in the left background (see Plates 27, 32) and a Mr. Dufour appears as the conductor.

73 LA GOULUE DANCING ('LA DANSE DE L'ALMÉE'). 1895
Oil on canvas; 285 × 307·5 cm.; monogram and 1895 lower right
Paris, Louvre

The pendant to the preceding panel. A drawing for the central figure is in the Albi Museum (Joyant I, p. 290). Among the spectators in the right foreground is Félix Fénéon (see Plate 74), Lautrec is next to him, and then Jane Avril, M. Sainte-Aldegonde, and Gabriel Tapié de Céleyran; behind them are Maurice Guibert and Paul Sescau (see Plate 38), and the pianist, M. Tinchant.

74 FÉLIX FÉNÉON. 1895
Detail from Plate 73

Félix Fénéon (1861–1944), art critic and collector, and friend of many artists of the decade around 1900, is also portrayed in the theatre programme lithograph for *Le Chariot de Terre Cuite* (D.77; A.109) as well as in caricature in a drawing (Fig. 35) owned by Professor John Rewald in New York and in another drawing (Joyant II, p. 225). For a biography of Fénéon, see John Rewald's 'Félix Fénéon' in 'Gazette des Beaux-Arts', Vols. XXXII, XXXIII, 1947 (II), 1948 (I).

75 PORTRAIT OF OSCAR WILDE. 1895
Gouache on cardboard; 58·5 × 47 cm.; signed lower left: T-Lautrec (Joyant I, p. 288)
Vienna, Dr. and Mrs. Conrad H. Lester

Joyant (II, p. 208) mentions a study (pen drawing) for this portrait. The Thames, the Houses of Parliament and 'Big Ben' are in the background. Almost identical to this picture is the portrait of Wilde in the programme for the Théâtre de l'Œuvre of Wilde's *Salomé* and Romain Coolus' *Raphaël* of February, 1896 (D.195; A.186 see Fig. 36). Lautrec met Oscar Wilde briefly during one of his visits to London.

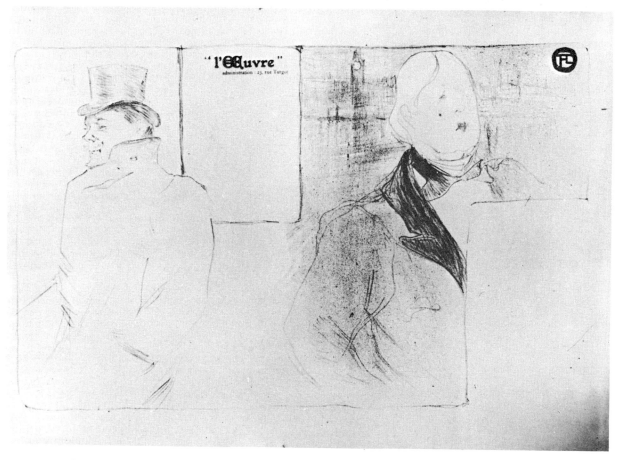

Fig. 36. OSCAR WILDE AND ROMAIN COOLUS. Lithograph, 1896

76 WOMEN IN A BROTHEL ('CES DAMES AU
RÉFECTOIRE'). 1895.
Oil on cardboard; 60·3 × 80·5 cm.; signature lower
left: T-Lautrec (Joyant I, p. 283, here dated 1893)
Budapest, Museum of Fine Arts

The three women in the foreground and the fourth
visible in the mirror on the left, appear in other
pictures of the brothel in the Rue des Moulins (*Au
Salon*, Plate 69; *Le Divan*; Joyant I, p. 285). See
István Genthon, *Un tableau de Toulouse-Lautrec au
Musée des Beaux-Arts*, in the *Bulletin du Musée
Hongrois des Beaux-Arts*, No. 26, Budapest, 1965; this
article includes illustrations of two portrait drawings
which, like the painting, belonged to the author
Arsène Alexandre, a friend of Lautrec's.

77 ALFRED LA GUIGNE. 1894
Oil on cardboard; 65·6 × 50·4 cm.; signed lower right:
Pour Méténier, d'aprés son 'Alfred la Guigne' H T-
Lautrec (Joyant I, p. 280)
Washington, D.C., National Gallery of Art, Chester
Dale Collection

The book about Aristide Bruant, referred to in the
note to Plate 47, was written by Oscar Méténier.

78 BRASSEUR'S ENTRY IN 'CHILPÉRIC'. 1895
Lithograph (D.110; A.126); 37·2 × 25·9 cm.

A study of Brasseur's head is mentioned in Joyant's
catalogue (II, p. 213). The performances of the
operetta *Chilpéric* by F. R. Hervé (1825–92) at the
Théâtre des Variétés in February, 1895, were the
inspiration for one of Lautrec's most important stage
scenes (Plate 92) and for a number of lithographs.
Romain Coolus tells how Lautrec took him to several
performances of *Chilpéric*. At the sixth visit, Coolus
asked Lautrec why he went to see the operetta so
often. Lautrec answered that it was only because of
Marcelle Lender's marvellous back (which became the
subject of a lithograph; D.106, A.127).

79 THE ENTRY OF CHA-U-KA-O AT THE MOULIN
ROUGE. 1896
Blue crayon drawing; 63 × 50 cm.
Cambridge, Mass., Fogg Art Museum

A very similar drawing in the Albi Museum (Joyant
II, p. 219) was reproduced as a woodcut in the issue of
Le Rire dated 15 February, 1896. The clowness Cha-
U-Ka-O (according to F. Lachenal a play on the
words 'Chahut' and 'k.o.'; according to Huisman-
Dortu from 'Chahut' and 'Chaos') appears in
Lautrec's paintings, drawings and lithographs in the

early and, even more frequently, the mid-nineties
(see Plates 80, 81, 82).

80 THE CLOWNESS CHA-U-KA-O, SEATED. 1896
Coloured lithograph (D.180; A.201); 52 × 40 cm.

From *Elles* (see Plates 90, 95, 96, 99). An oil study
also exists (Joyant I, p. 189). Compare the other
portrayals of the Clowness (Plates 79, 81, 82).

81 THE CLOWNESS CHA-U-KA-O. 1895
Oil on cardboard; 64 × 49 cm.; signed lower right:
T-Lautrec 95
Paris, Louvre

82 THE CLOWNESS CHA-U-KA-O. 1895
Oil on cardboard; 81 × 60 cm.; signed lower left: T-
Lautrec (Joyant I, p. 289)
Cannes, Mrs. Frank J. Gould

The Clowness (see Plates 79, 80, 81) is evidently
portrayed here in the wings of the stage during the
interval of a performance. The portrait medallions
leaning against the ladder (left, centre) may be related
to the sixteen oval portraits which Lautrec painted of
the inmates of the *Maison close* in the Rue d'Am-
boise and which were hung in ornate wall panels
(Joyant I, p. 283).

83 MAY BELFORT. 1895
Oil on cardboard; 80 × 60 cm.; signed lower right:
T-Lautrec (Joyant I, p. 290)
Cleveland, Museum of Art, Leonard C. Hanna, Jr.
Estate

The Irish singer, May Belfort, was frequently por-
trayed by Lautrec; mostly, as in this painting, on the
stage in a baby costume, often with a cat in her arms
(see Plate 84). In one lithograph (D.123; A.124) she
can be seen in her own normal clothes in the 'Irish and
American Bar'.

84 MAY BELFORT. 1895
Coloured lithograph (D.354/II; Julien XVI; A.116);
78·8 × 60 cm.

There is an oil study for this poster (Joyant I, p. 290)
which appeared in the poster exhibition in Reims in
1896. Adhémar mentions a proof of the poster – in the
Print Room of the Copenhagen Museum – which
shows coloured stripes on the dress. A pencil sketch is
in the Print Room of the Basle Museum. The song
which May Belfort sang in this costume, with a cat in
her arms, includes the line 'I've got a little cat, I'm
very fond of that . . .' (see Plate 83).

85 MAY MILTON. 1895
Coloured lithograph (D.356/II; Julien XVIII; A.149); 78·5 × 59·7 cm.

This poster for the English dancer was also exhibited in Reims in 1896. A drawing in the Yale University Art Gallery in New Haven shows the outline of the body through the loose dress (see Fig. 8). There is also another oil study for this poster as well as a portrait painting of the dancer in street clothes (Joyant I, p. 288).

86 CÉCY LOFTUS. 1894
Lithograph (D.116; A.105); 36·9 × 24·6 cm.

The date, given by Delteil as 1895, has been corrected by Adhémar. Cécy (Cissie) Loftus, whose real name was Mary-Cecilia McCarthy (1876–1931), started as a mimic in English Music Hall, then came to Paris and continued her career on the English and American stage.

87 LUCIEN GUITRY AND JEANNE GRANIER. 1895
Oil on cardboard; 54 × 42 cm. (Joyant I, p. 288)
Albi, Musée Toulouse-Lautrec

The actor and actress are portrayed here (and in another version mentioned in Joyant I, p. 288) in a scene of Maurice Donnay's *Amants* in a performance on 5 November, 1895, in the Théâtre de la Renaissance. Both were frequently portrayed by Lautrec, as in the lithographic series of actors and actresses entitled *Treize Lithographies* (D.150–62; A.166–78). The name of the famous actor, Lucien Guitry (1860–1925), a friend of Lautrec's, also appears in connection with the artist on other occasions: towards the end of 1900, Lautrec designed a programme for a performance of Zola's *L'Assommoir* in the Théâtre de la Porte-St.-Martin, which Guitry directed. Two studies for this have been preserved (Joyant I, p. 300 and II, p. 242). Jeanne Granier is portrayed several times in the series *Treize Lithographies*.

88 MISIA NATANSON SKATING. 1895
Pencil and oil on paper; 148 × 105 cm. (Joyant I, p. 287)
Albi, Musée Toulouse-Lautrec

One of two studies for the poster for *La Revue Blanche* (D.355; Julien XVII; A.115; Joyant I, p. 287), the voice of the symbolists. The subject was the wife of Thadée Natanson, who edited this magazine with his brothers Alexandre and Louis-Alfred. The Natansons belonged to Lautrec's circle of friends. There are other portraits of Misia Natanson painted by Lautrec.

89 'CHOCOLAT' DANCING. 1896
Drawing in blue crayon and Indian-ink heightened with white on paper; 77 × 61 cm.; monogram lower left (Joyant II, p. 219)
Albi, Musée Toulouse-Lautrec

The Negro 'Chocolat' performed at the Nouveau Cirque. He is portrayed with his partner, the Clown Footit, in a lithograph for *La Revue Blanche* (D.98; A.108). Here he is shown dancing at the 'Irish and American Bar' in the Rue Royale and singing 'Sois bonne, ô ma chère inconnue . . .' In the background are the bartender Ralph and the Rothschild's coachman (see Plate 103). The drawing was reproduced in colour in the magazine *Le Rire* on 28 March, 1896 (like all these drawings, in woodcut with lithographic tint).

90 WOMAN COMBING HER HAIR. 1896
Oil on cardboard; 54 × 40 cm.; monogram lower left (Joyant I, p. 293)
Albi, Musée Toulouse-Lautrec

A study for one of the lithographs in the album, *Elles* (D.186; A.207). See Plates 80, 95, 96, 99.

91 NUDE IN FRONT OF A MIRROR. 1897
Oil on cardboard; 63 × 48 cm.; signed upper left: Lautrec 97 (Joyant I, p. 294)
New York, Mrs. Ira Haupt

92 MARCELLE LENDER DANCING THE BOLERO IN 'CHILPÉRIC'. 1895
Oil on canvas; 150 × 145 cm. (Joyant I, p. 294)
New York, Mr. John H. Whitney Collection

Of all Lautrec's works on the theme of the theatre this picture is the greatest both in size and in significance. There is also an oil study for it, dated 1896 (Joyant I, p. 294). Besides the central figure of Marcelle Lender, whom Lautrec portrayed on several other occasions in this role (see note to Plate 78), the following people can be identified (from left to right): Lassouche, Vauthier, Brasseur fils, Baron, Amélie Dieterle and Simon.

93 MARCELLE LENDER, STANDING. 1896
Coloured lithograph (D.103; A.134); 35 × 24 cm.

94 AT ARMÉNONVILLE. 1896
Crayon and pen (Indian-ink); 65 × 49·5 cm.; monogram lower left (Joyant II, p. 218)
Minneapolis, Institute of Arts (John De Laittre Memorial Fund)

According to Joyant, the central figure may be the singer Lona Barrison.

95 TITLE-PAGE FOR 'ELLES'. 1896
Coloured lithograph (D.179; A.200); 51 × 39 cm.

The album *Elles* comprised ten lithographs and a title-page, with scenes from the life of prostitutes. It was published in Paris in 1896 by Gustave Pellet. Originally the title was to be *La Fille*. See Plates 80, 96, 99.

96 'AU PETIT LEVER'. 1896
Coloured lithograph (D.187; A.208); 40 × 52 cm.

From the Album *Elles* (see Plates 80, 90, 95, 99). The names of the two models are known: Juliette Baron (see Plate 103) and 'Mademoiselle Popo'.

97 'DÉBAUCHE'. 1896
Coloured lithograph (D.178/II; A.212); 23·5 × 32 cm.

This lithograph was intended as the cover of a catalogue of artistic posters (*Catalogue d'Affiches Artistiques*). There is an unpublished lithographic version of this scene, in which the artist Charles Conder (see Plate 33) is supposed to be depicted. In this lithograph either Maurice Guibert is depicted, or – as is more frequently accepted – the painter and designer Maxime Dethomas (1868–1928). Lautrec was a close friend of Dethomas' and portrayed him in one of his best-known paintings: as a spectator at the opera ball, a picture painted in 1896 (Joyant I, p. 294). Sketches for the lithograph *Débauche* are in the Albi Museum (Joyant II, p. 222).

98 YAHNE AND ANTOINE IN 'L'ÂGE DIFFICILE'. 1895
Lithograph (D.112; A.117); 33 × 26 cm.

Lautrec also drew another scene of Jules Lemaître's play *L'Âge Difficile* at the Théâtre Gymnase with the actress Léonie Yahne (D.113; A.114). She is portrayed in still another lithograph of the same year, *Yahne in her Dressing-room* (D.111; A.113). André Antoine (d. 1943) was one of the most important actors of the time and founder of the Théâtre Libre, which was named after him. He appears several times in Lautrec's lithographs.

99 WOMAN LYING ON HER BACK ('LASSITUDE'). 1896
Coloured lithograph (D.189; A.210); 41 × 51 cm.

Last page of the album *Elles* (see Plates 80, 90, 95). Joyant mentions several sketches for this lithograph (II, p. 220–1) and there is an oil study in the collection of Mrs. Frank Jay Gould.

100 PASSENGER ON A YACHT ('LA PASSAGÈRE DU 54' or 'PROMENADE EN YACHT'). 1896
Coloured lithograph (D.366/I; Julien XXVIII; A.188); 60·8 × 40·7 cm.

The subject is a passenger Lautrec saw during a trip he made with Maurice Guibert on the steamer 'Le Chili' from Bordeaux to Lisbon. The lithograph was later used as a poster for the group 'Salon des Cents'. Delteil mentions a sketch for this lithograph made on board ship and Joyant (II, p. 223) discusses two sketches for the poster, one of them being in the Albi Museum.

101 PROFILE OF A WOMAN (MME LUCY). 1896
Oil on cardboard; 56 × 48 cm.; signed lower left: T-Lautrec (Joyant I, p. 292)
Paris, Louvre

102 IDA HEATH. 1896
Lithograph (D.165; A.104); 36 × 26·5 cm.

There is a drawing in the Albi Museum (Joyant II, p. 213). The English dancer Ida Heath appears in another of Lautrec's lithographs, executed in 1894 (Jean Adhémar believes 1895): *Ida Heath in the Bar* (D.59; A.125).

103 'LA GRANDE LOGE'. 1897
Coloured lithograph (D.204; A.229); 51 × 39·5 cm.

The title by which this lithograph is known was chosen because of another lithograph, *La petite loge*. There is a painted version in a private collection in Switzerland (Joyant I, p. 296). The man in the background is the Rothschild's English coachman, Mr. Tom, who occasionally appears in Lautrec's drawings and paintings (see Plate 89). One of the women is Armande Brazier, the owner of the bar 'Le Hanneton', and the other, according to Adhémar, is 'perhaps Miss Baron', who is portrayed in lithographs in the album *Elles* (see Plate 96).

104 YVETTE GUILBERT: 'À MÉNILMONTANT'. 1898
Lithograph (D.255; A.311); 30 × 24 cm.

Page IV of the *English Series* (see Plates 106, 107)

105 ELSA, CALLED 'LA VIENNOISE'. 1897
Coloured lithograph (D.207; A.232); 58 × 40·5 cm.

There is also a portrait drawing of the same model (Joyant II, p. 227), a woman from the brothel in the Rue des Moulins. (The lithograph is slightly larger than the portion reproduced here.)

106 YVETTE GUILBERT: 'LINGER LONGER LOO'. 1898
Lithograph with tint-plate (D.259; A.315); 30 × 24 cm.

Plate VII of the series of representations of Yvette Guilbert on the stage, called the *English Series*, published in 1898 by Bliss and Sands in London, with a text by Arthur Byl (D.250–60; A.206–316; see Plates 104, 107). The text of the chanson, which was also a popular number of the Barrison Sisters (see Plate 94), is as follows:

> Linger longer Lucy
> Linger longer Loo
> Linger longer, longer linger
> Linger long at you.
>
> Listen what I say,
> I tell you, I am true.
> I linger longer, longer linger
> Linger long at you.

An illustration of Yvette Guilbert interpreting this song also appeared in *Le Rire* on 24 December, 1894. An oil study for this illustration exists in two versions (Joyant I, p. 281).

107 YVETTE GUILBERT: 'LA SOÛLARDE'. 1898
Lithograph with tint-plate (D.258; A.314); 30 × 24 cm.

Plate VI of the *English Series* (see Plates 104, 106). *La Soûlarde* (The Drunkard) by Jules Jouy was one of Yvette Guilbert's most famous interpretations.

108 WOMAN KNEELING ON A SOFA. 1897
Oil on cardboard; 60 × 45 cm.; signed lower left: Lautrec 97 (Joyant I, p. 296)
Paris, Maurice Exsteens

109 WOMAN AT HER TOILET 1896
Oil on cardboard; 52 × 40 cm.; signed lower right: Lautrec (Joyant I, p. 292)
Paris, Louvre

110 PORTRAIT OF A GENTLEMAN. 1900
Oil on canvas; 81 × 62 cm. (Joyant I, p. 299)
Munich, Bayerische Staatsgemäldesammlungen

111 AT THE CONCERT. 1896
Coloured lithograph (D.365/II; Julien XXVII; A.199); 35 × 27 cm.

Poster for the American paint-and-ink firm Ault & Wiborg Co. There is an oil study for this poster (Joyant I, p. 293). Portrayed here are probably Misia Natanson and Lautrec's cousin, Gabriel Tapié de Céleyran (see Plates 32, 60, 88).

112 'AT THE FOOT OF SINAÏ': BARON MOÏSE. 1897
Lithograph (D.236; A.241); 17·2 × 14 cm.

One of the sixteen illustrations for Georges Clémenceau's book *At the Foot of Sinaï* (*Au Pied du Sinaï*; D.235–47; A.237–51), which appeared in 1898 and which was a collection of stories from the life of the Jews in the Polish ghettos (see also Fig. 27).

113 PORTRAIT OF MONSIEUR LAURADOUR. 1897
Oil on cardboard; 81 × 65 cm.; signed lower right: T-Lautrec (Joyant I, p. 295)
Present whereabouts unknown

114 AT THE CIRCUS: PONY AND BABOON. 1899
Red-chalk drawing; 50 × 32 cm.; monogram lower right (Joyant II, p. 234)
Chicago, Art Institute (Gift of Tiffany and Margaret Black)

One of a long series of drawings (pencil, red chalk and crayon) which Lautrec drew during his stay in Dr. Sémelaigne's sanatorium in the Avenue de Madrid in Neuilly-sur-Seine. These drawings are now in various collections and are reproduced in coloured collotype in two albums: the first, published in 1905, by Goupil in Paris, has twenty-two reproductions and an introduction by Arsène Alexandre; the second, with seventeen reproductions, was published in 1932, by the Librairie de France. (See Plates 120, 121 and Figs. 30, 31.)

115 IN THE BAR. 1898
Oil on cardboard; 81·5 × 60 cm.; signed lower right: T-Lautrec (Joyant I, p. 296)
Zurich, Kunsthaus

This picture is also known by the title *Le gros consommateur et la caissière chlorotique* (*The Fat Visitor and the Anaemic Cashier*).

116 MADAME POUPOULE. 1900
Oil on wood; 60 × 49 cm.; signed upper right: Lautrec 1900 (Joyant I, p. 300)
Private Collection

117 THE SPHINX. 1898
Oil on cardboard; 80 × 50 cm.; signed lower left: T-Lautrec 1898 (Joyant I, p. 297)

The origin of the romantic title of this picture is not known. According to Joyant, the subject is a 'femme de Maison'. In the study *Études sur Toulouse-Lautrec* (in the *Bulletin du Musée Hongrois des Beaux-Arts*, No. 28, Budapest, 1965) Marianne Haraszti-Takacs stresses, not completely convincingly, the physiognomic similarity of the woman with Misia Natanson (see Plate 88), especially in the painting *Misia Natanson at the Piano* (Joyant I, p. 295) and the two drawings for it. In the article, a red-chalk drawing in Dresden (Joyant II, p. 213) – said to be Marcelle Lender, although her features appear sharper in other portrayals by Lautrec – is compared with *The Sphinx*, which gives the impression that it is in fact the same model. This illustrates, as is so often the case, the inevitable uncertainty of physiognomic comparisons and identifications.

118 TÊTE-À-TÊTE SUPPER ('EN CABINET PARTICULIER'). 1899
Oil on canvas; 55 × 46 cm.; signed upper right: T-Lautrec (Joyant I, p. 298)
London, Courtauld Institute Galleries

This picture is also known under the titles *Au 'Rat mort'* and *Au Restaurant de Nuit*.

119 MLLE COCYTE AS 'BELLE HÉLÈNE'. 1900
Pencil and red-chalk drawing; 33·5 × 24 cm.; signed lower left: T-Lautrec (Joyant II, p. 241)
Present whereabouts unknown

One of several studies (Joyant II, p. 241) which Lautrec made of this actress in the title rôle of Offenbach's *Belle Hélène* at the Bordeaux Opera in December, 1900. Some time before, Lautrec had drawn a scene from a Paris performance of *Belle Hélène* (Lithograph D.114; A.321), but the date of this is not certain.

120 IN THE CIRCUS: THE LEVADE. 1899
Crayon drawing; 35·5 × 25 cm. (Joyant II, p. 235)
Present whereabouts unknown

From the series of circus drawings (see Plates 114, 121, Figs. 30, 31).

121 THE TRAPEZE ACT. 1899
Pencil drawing; 50 × 32·5 cm.; monogram upper left (Joyant II, p. 235)
Cambridge, Mass., Fogg Art Museum (Bequest of Grenville L. Winthrop)

From the series of circus drawings (see Plates 114, 120, Figs. 30, 31).

122 THE JOCKEY. 1899
Coloured lithograph (D.279; A.365); 51·5 × 36 cm.

This lithograph, together with others, was supposed to appear in an album of scenes from the race track; besides this sheet, however, only three lithographs were completed (see Fig. 26). For this lithograph of 'The Jockey', there are also an oil study and a copy of a black proof touched up with water-colour (Joyant II, p. 231).

123 AT THE RACES. 1899
Oil on canvas; 53 × 45 cm.; signed lower left: Lautrec (Joyant I, p. 298)
Albi, Musée Toulouse-Lautrec

124 SCENE FROM 'MESSALINE' AT THE BORDEAUX OPERA. 1900-1
Oil on canvas; 100 × 73 cm. (Joyant I, p. 300)
Los Angeles, County Museum of Art (Mr. and Mrs. George Gard de Sylva Collection)

Besides this picture, Lautrec painted five other stage scenes of the performance of Isidore de Lara's opera *Messaline* in Bordeaux during his last stay there in the winter of 1900-1 (Joyant I, p. 299 f.). There are several related drawings (Joyant II, p. 241). The leading rôle was played by Mademoiselle Ganne.

List of Text Illustrations

1. SELF-PORTRAIT CARICATURE. c. 1890
Pen and ink drawing; 14·5 × 12 cm.
Private Collection

Fig. 2. THE ARTIST'S UNCLE: COUNT CHARLES DE TOULOUSE-LAUTREC. 1882
Charcoal drawing; 59·5 × 46 cm.; signed and dated lower right: T-L-Monfa, 82

Albi, Musée Toulouse-Lautrec

(See notes to Plates 5 and 6, and Figure 5)

Figs. 3 and 4. DRAWINGS FROM AN EARLY SKETCH-BOOK. 1880-81
Chicago, Art Institute

Fig. 5. PORTRAIT OF THE ARTIST'S MOTHER. 1882–3
Charcoal drawing; 56·3 × 44·8 cm.; signed lower right: T-Lautrec
New York, Charles E. Slatkin Galleries

(See notes to Plates 5 and 6, and Figure 2)

Fig. 6. 'À SAINT-LAZARE'. 1885
Lithograph after a drawing by Toulouse-Lautrec (D. 10) 14, 8 × 16, 2 cm.

This drawing is usually considered to be Lautrec's first lithograph. However, as François Lachenal has shown recently in great detail in the catalogue to the Lautrec exhibition in Ingelheim-am-Rhein, we are dealing here with a reproduction of a drawing which Lautrec made for Aristide Bruant's journal *Le Mirliton*. Later, this drawing was re-lithographed by E. Dupré. There is also a study for it in oil in the Robert Lehman Collection in New York. In an illustrated edition of Aristide Bruant's *Chansons* by Steinlen, which appeared in Paris under the title *Dans la Rue* in 1889, Steinlin has included Lautrec's drawing for *À Saint-Lazare* as a '*Hommage à Lautrec*'.

Fig. 7. PORTRAIT OF CHARLES MAURIN. 1898
Etching; (D. 3). 19·9 × 9·8 cm.

Charles Maurin (1856–1914) portrayed Lautrec in a well known etching in 1890.

Fig. 8. MAY MILTON DANCING. c. 1895
Crayon drawing on brownish paper; 72·7 × 57·7 cm.
New Haven, Conn., Yale University Art Gallery

Study for a poster (see Plate 85).

Fig. 9. Pierre Bonnard: FRANCE-CHAMPAGNE. 1891
Poster; 78 × 50 cm.

Fig. 10. 'LA GITANE'. 1900
Coloured lithograph; (D. 368; Julien XXXI; A. 366). 69·4 × 64 cm.

Lautrec's last poster.

Fig. 11. A LADY AND A GENTLEMAN. 1893
Coloured lithograph; (D. 15; A. 148). 32 × 23·8 cm.

Programme for *L'Argent*, a comedy by Émile Fabre, which was put on at the Théâtre-Libre.

Fig. 12. 'L'ARTISAN MODERNE'. 1894
Coloured lithograph; (D. 350; Julien XII; A. 70). 90 × 64 cm.

The 'craftsman' in the background is the jeweller and medallist Henri Nocq, who was also portrayed by Lautrec in two paintings (Joyant I, p. 295).

Fig. 13. JANE AVRIL AT THE JARDIN DE PARIS. 1893
Coloured lithograph; (D. 345; Julien XII; A. 12). 130 × 94 cm.

There is an oil study for this poster (Joyant I, p. 279). The poster itself was exhibited at the Rheims exhibition in 1896. (See also Plates 39, 40, 43)

Fig. 14. AT THE RESTAURANT 'À LA MAISON D'OR'. 1897
Lithograph; (D. 222; A. 270). 20·5 × 20·5 cm.

Delteil does not date this lithograph, but includes it among those produced in 1897. According to him it may be an illustration for an unknown novel.

Fig. 15. HEAD OF MAY MILTON
Detail of Plate 85

Fig. 16. MME ABDALA. 1893
Lithograph; (D. 33; A. 35). 27 × 19·7 cm.

From the series *Le Café-Concert*. Georges Montorgueil's text for the album gives a description of Mme. Abdala as well as of the other stars of the Café-Concerts. (See also Plates 40, 52 and Figure 19)

Fig. 17. ARISTIDE BRUANT. 1893
Lithograph; (D. 34; A. 38). 26·5 × 20·8 cm.

(See note to Plate 47)

Fig. 18. BRANDÈS AND LE BARGY IN 'CABOTINS'. 1894
Lithograph; (D. 61; A. 65). 42 × 33 cm.

The actress Marthe Brandès is shown here in one of her outstanding roles, in Edouard Pailleron's play *Cabotins* at the Comédie Française.

Fig. 19. 'DUCARRE AUX AMBASSADEURS'. 1893
Lithograph; (D. 36, A. 33). 25·9 × 19·5 cm.

From the series *Le Café-Concert*. Pierre Ducarre was the director of the Café-Concert des Ambassadeurs, one of the oldest and best-known Café-Concerts in the Champs-Élysées. (See also Plates 40, 52 and Figure 16)

Fig. 20. SCENE FROM THE TRIAL OF ARTON 1896
Lithograph; (D. 191; A. 192). 35·5 × 47 cm.

Lautrec made three lithographs of the Arton trial, which was the result of the Panama scandal (for an account of the trial see G. Mack, *Toulouse-Lautrec*, New York 1938, p. 238ff). The Albi Museum has a number of portrait-sketches for the trial scenes. (Joyant II, pp. 217, 221). Delteil has given the present sheet the title 'The Hearing of Dupas'; according to Adhémar, however, it is the 'Hearing of Arton'.

Fig. 21. 'AU HANNETON'. 1898
Lithograph; (D. 272; A. 290). 38 × 27·5 cm.

The restaurant *Au Hanneton* in the Rue Pigalle was one favoured by lesbians. Another title of the lithograph is *À la Brasserie*. Joyant lists three sketches for it (Joyant II, pp. 227, 228) and suggests that it is a portrait of Armande Brazier. (See also Plate 103)

Fig. 22. YVETTE GUILBERT BOWING. 1894
Lithograph; (D. 95). 26·5 × 17·8 cm.

(See note to Plate 50)

Figs. 23 and 24. IMPRESSIONS OF YVETTE GUILBERT. 1894
Pen drawings; 21·1 × 15·8 cm.; 15·5 × 10·8 cm.
Paris, Louvre, Cabinet des Dessins

(See note to Plate 50)

Fig. 25. THE SPIDER. 1899–1901
Lithograph; (D. 308; A. 344). 20 × 16 cm.

Plate XI of Jules Renard's *Histoires Naturelles*.

Fig. 26. JOCKEY ON HIS WAY TO THE SCALES. 1899.
Lithograph; (D. 282; A. 363). 38·1 × 27·8 cm.

Fig. 27. AT THE FOOT OF SINAÏ: SCHLOMÉ FUSS IN THE SYNAGOGUE. 1897
Lithograph; (D. 239)

One of the seventeen illustrations for Clemenceau's book *Au Pied du Sinaï* (see Plate 112).

Fig. 28. ANTOINE AND LELOIR IN 'UNE FAILLITE.' 1893
Lithograph; (D. 63; A. 41). 36·5 × 29·5 cm.

Adhémar accepts Delteil's dating of 1894 and suggests that the actor in Björnson's *Une Faillite* is Gémier and not Leloir.

Fig. 29. 'MÉNU HÉBRARD'. 1894
Lithograph; (D. 66). 27 × 33 cm.

Drawing for a menu for a dinner given by Adrien Hébrard, editor of the journal *Temps*, on April 26, 1894.

Figs. 30 and 31. THE REHEARSAL; PAS-DE-DEUX. 1899
Drawings for the series *The Circus*.
New York, Alex Hillman Corporation; Present whereabouts unknown.

(See notes to Plates 114, 120, 121)

Fig. 32. GIRL WITH DOG ('AU BOIS'). 1897(?)
Lithograph; (D. 296; A. 255). 54·8 × 37 cm.

Fig. 33. 'L'ESTAMPE ORIGINALE'. 1893
Coloured lithograph (D. 17, A. 10). 64 × 56·5 cm.

A study for the figure on the left, a pen and pencil drawing, is mentioned by Joyant (II, p. 202) at the same time as a study for the figure of the woman. Works of the most important French illustrators of the time were published in the magazine *L'Estampe Originale* (Maurin, Anquetin, Ibels, and others). This cover lithograph shows the printer 'Père Cotelle' at the hand press of Ancourt, the lithograph workshop favoured by Lautrec in the Rue Faubourg St. Denis. The woman watching the proofing is Jane Avril.

Fig. 34. GABRIEL TAPIÉ DE CÉLEYRAN. 1894
Pen drawing on tinted paper; 31·8 × 19·8 cm.
Albi, Musée Toulouse-Lautrec

(See note to Plate 60)

Fig. 35. CARICATURE OF FÉLIX FÉNÉON. c. 1896
Pen and brush drawing; 30 × 19 cm.
New York, Professor John Rewald

(See note to Plate 74)

Fig. 36. OSCAR WILDE AND ROMAIN COOLUS. 1896
Lithograph; (D. 195; A. 186). 30 × 49 cm.

(See note to Plate 75)

Facing p. 18. THE ENGLISH GIRL FROM THE 'STAR' AT LE HAVRE. 1899

Oil on wood; 41 × 32 cm.; signed upper right: Lautrec 1899 (Joyant I, p. 298)
Albi, Musée Toulouse-Lautrec

There is also a drawing for this painting of Miss Dolly, a waitress in the English Café 'Star', in Le Havre (Joyant II, p. 231). Lautrec always stopped at this inn in the port of Le Havre when he travelled to Bordeaux, and he also drew several quick sketches there (Joyant II, p. 231).

Bibliography

This list represents only a small part of what has actually been published about Toulouse-Lautrec up to date; it includes the most important publications, some of which contain full bibliographies. Exhibition catalogues and mere picture-books have not been listed.

Jean Adhémar, *Toulouse-Lautrec*, Paris 1965, simultaneous English and German edition. Catalogue raisonné of the lithographs.

Merete Bodelsen, *Toulouse-Lautrec's Posters* (in *Det danske Kunstindustrimuseum/Virksomheit 1959–1964*, III, Copenhagen 1964).

Douglas Cooper, *Henri Toulouse-Lautrec*, London 1954.

Gustave Coquiot, *Henri Toulouse-Lautrec*, Paris 1913.

Loys Delteil, *Henri Toulouse-Lautrec*, Paris 1920 (*Le peintre-graveur illustré*, Vol. X/XI).

G. Dortu, *Toulouse-Lautrec*, Paris 1952.

G. Dortu – Ph. Huisman, *Lautrec par Lautrec*, Lausanne 1964. Small reproductions of all lithographs as well as of those drawings which also appeared as illustrations.

Theodore Duret, *Lautrec*, Paris 1920.

Hermann Esswein – A. W. Heymel, *Toulouse-Lautrec*, Munich 1904 (*Moderne Illustratoren*, Vol. III).

Gotthard Jedlicka, *Henri Toulouse-Lautrec*, Berlin 1929, second edition Zurich 1943.

F. Jourdain – J. Adhémar, *T-Lautrec*, Paris 1952.

Maurice Joyant, *Henri Toulouse-Lautrec 1864–1901*, Vol. I (*Peintre*) Paris 1926; Vol. II (*Dessins-Estampes-Affiches*) Paris 1927.

Édouard Julien, *Les Affiches de Toulouse-Lautrec*, Monte Carlo 1950.

Jacques Lassaigne, *Toulouse-Lautrec*, Paris 1939.

Paul Leclercq, *Autour de Toulouse-Lautrec*, Paris 1921, second edition Lausanne 1954.

Gerstle Mack, *Toulouse-Lautrec*, New York 1938.

Thadée Natanson, *Un Henri de Toulouse-Lautrec*, Geneva 1951.

Pierre MacOrlan, *Lautrec, peintre de la lumière froide*, Paris 1934.

Henri Perruchot, *La Vie de Toulouse-Lautrec*, Paris 1958.

Willi Rotzler, *Affiches de Henri Toulouse-Lautrec*, Basle 1946.

The Author and Publishers wish to thank all who have helped with the publication of this book, in particular M. Jean Lapeyre and M. Jean Devoisins of the Toulouse-Lautrec Museum in Albi, Dr. François Lachenal who was responsible for the important Toulouse-Lautrec Exhibition in Ingelheim-am-Rhein in 1968, as well as all public institutions and private collectors who have made photographs available and given their kind permission for reproduction.

List of Collections